Architectures
of Excess

Architectures
of Excess

Cultural

Life

in the

Information

Age

Jim Collins

Routledge
New York London

Published in 1995 by

Routledge
29 West 35 Street
New York, NY 10001

Published in Great Britain in 1995 by

Routledge
11 New Fetter Lane
London EC4P 4EE

Copyright © 1995 by Routledge

Printed in the United States of America.

All photos taken by the author except: figure 1, courtesy of Quilan Terry;
figure 5, courtesy of Simon Watson; figure 6, courtesy of Shin Takamatsu;
figure 7, courtesy of Shin Takamatsu (photographed by Nacasa &
Partners); figure 8, courtesy of Shin Takamatsu (photographed by
Hiroshi Fujiwara); figure 9, courtesy of Shin Takamatsu (photographed
by Nacasa & Partners); figures 10, 11, 12, 13, courtesy of Metro Pictures;
figures 16 and 22, courtesy of Museé des Arts Decoratifs de Montreal.

Library of Congress Cataloging-in-Publication Data

Collins, Jim
 Architectures of excess: cultural life in the information age / Jim
 Collins
 p. cm.
 Includes bibliographical references and index.
 ISBN 0-415-90705-5 (cloth) —— ISBN 0-415-90706-3 (paper)
 1. Postmodernism 2. Popular culture. 3. Technology and the arts.
 I. Title
NX456.5.P66C64 1995 94-27417
700'.1'05—dc20 CIP

for
Steven M. Rosen
1953–1993

"No, no! I'll take no less
Than all in full excess"

—Handel, *Semele* Act III

"Dieu, qui nos coeurs sincères
As fait les coeurs de deux frères,
Accepte notre serment!
Nous mourrons en nous aimant!

Soyons unis pour la vie et la mort!"

—Verdi, *Don Carlos* Act I

Contents

Acknowledgments

This book would have never been completed without the generous support of a number of institutions and friends. I'd like to thank the Mellon Foundation at the University of Pittsburgh and the Institute for Arts and Letters at the University of Notre Dame for providing the necessary funding for this project. I owe a special debt of gratitude to Charles Jencks and my colleagues at the Portrack Seminar (Margaret Rose, Thomas Docherty, Maggie Keswick, Steven Connor, Walter Truett Anderson, Charlene Spretnak) for helping me refine many of the ideas advanced here. I want to thank my department chair, Mark Pilkinton, who was most supportive at every stage of this book's development, and all the people who read earlier versions of some of these chapters and offered invaluable suggestions, especially Randy Rutsky, Stephanie Bevacqua, and William Krier. I would like to express my appreciation to Indiana University Press and Polity Press for permission to reprint portions of chapters two and five. Bill Germano, Eric Zinner and Adam Bohannon at Routledge were extremely helpful in ironing out problems and providing much appreciated advice.

Without the unending emotional support of my parents and my daughters Ava and Nell I would never have been able to finish this book.

I also want to thank Steven and Ava for all the reasons only they know.

Introduction

After the End of Early Postmodernism
The Pragmatics of Excess

Don't ask me why I play this music,
'Cause it's my culture so naturally I use it.
 —Living Colour, "Time's Up" (1991)

My answer machine is feelin' lonely and blue
'Cause it ain't had a message in an hour or two
And my fax machine has tears in its eyes
'Cause there ain't no words running through its wires.
Hey like Elvis said, "We're going separate ways"
I'm gonna wash my hands of you.
 —Carlene Carter, "Little Love Letter #1" (1993)

The title of this chapter is, in true postmodern form, only *half* ironic. In juxtaposing *after, end* and *early*, I'm obviously parodying the obsession with making pronouncements about the death of this or the end of that, a modernist obsession with progress measured in successive waves by the various fashion industries of the twentieth century—the art world, haute couture, critical theory, interior design and so on. This obsession has become thoroughly institutionalized, yet the very proliferation of institutions, each insisting on its ability to make once-and-for-all pronouncements, undermines the force of any such claims, since that very proliferation suggests both a widespread dispersal of cultural authority and the fragmentation of the "public" that was once

subject to such authority, all of which is emblematic of *postmodern* culture. Moreover, the most distinctive stylistic features of postmodernism—radically eclectic forms of textuality that demonstrate a hyperawareness of the transnational, transhistorical nature of media-sophisticated cultures which define themselves increasingly in terms of heterogeneity and difference—now seem more prevalent than ever across the entire spectrum of cultural production. Puig's *Kiss of the Spider Woman*,[1] a canonic example of the postmodern novel in the eighties, is now a smash Broadway musical, its popularity equalled only by *Angels in America*,[2] Tony Kushner's decidedly appropriative, radically eclectic, "gay fantasia on national themes." The sort of hyper-self-reflexivity about the nature of popular culture that once distinguished the work of Laurie Anderson, Robert Longo, Cindy Sherman and other New York scene artists is now ubiquitous *within* popular culture, from supermarket book rack best-sellers like Anne Rice's Vampire Chronicles[3] and Stephen King's *The Dark Half*[4] to mall movies like *Wayne's World* and *The Last Action Hero*. According to *Time* magazine, "Today everyone from Shandling to Schwarzenegger is a postmodernist,"[5] and producer Lorne Michaels says, of the relentless quotation of film, television and rock intertexts in *Wayne's World*, "We live in a time when nothing will ever go away again. [Everything is] on a channel somewhere. All cultural references are, to a ten-year-old, perfectly familiar."[6]

The overwhelming force of the "already said" that was given shape through the intertextual pyrotechnics of Umberto Eco's *Name of the Rose*,[7] Ridley Scott's *Blade Runner*, or John Zorn's *Spillaine*[8] has become, in the early nineties, quite literally child's play in the form of a best-selling children's book like Jon Scieszka's and Lane Smith's *The Stinky Cheese Man and Other Fairly Stupid Tales*,[9] in which a number of fairy tales are deconstructed and reassembled both narratively and typographically, as Chicken Licken and company are killed by a falling Table of Contents, an irate Giant insists on becoming the storyteller and pieces together his own narrative by cutting random phrases out of other fairy tales, and Jack, in order to free himself from the continuous-loop narration he must perpetuate *à la* Scheherazade in order to stay alive, moves up the endpapers of the book to fool the Giant into a premature closure. Likewise, James Stirling's

Stuttgart Galerie has by now become a textbook example of the post-modernism of the eighties in its juxtaposition of styles drawn from the history of architecture, making the museum itself a cultural intersection; but developments in information technologies have complicated the notion of the museum even more fundamentally, as computer termi-nals, CD players, cable television and VCRs can now transform offices and living rooms into instant ad hoc archives where such juxtapositions are a matter of perpetually reconfigurable random access.

To see such transformations as a kind of trickle-down postmodernism, where the formerly avant-garde becomes popular for general audiences, is to completely misunderstand the nature of the postmodern cultural terrain. The idea that what used to be called postmodernism is "dead" or vulgarized is based on the misguided notion that post-modernism was the next avant-garde rather than the fundamental refashioning of that very category vis-à-vis "the rest" of cultural production. The discontin-uous evolution of postmodernism has not followed the usual pattern of style evolution, for instance, becoming passé at the "cutting edges" as it becomes popular in the "mainstream." While professional trend spotters like the photography critic of the *New York Times* or the architecture critic of the *Chicago Tribune* may have gleefully pronounced it dead, just what postmodernism might mean is still being discovered in other contexts, notably in such disparate realms as economic theory, African-American and Asian-American fiction, and the radical pedagogy movement with-in the academy.

To make this uneven development still more complicated, many of the characteristics once thought to be synonymous with postmodernism have now acquired new labels; what was once described as radical eclecti-cism or appropriationism is now labeled *deconstructive* design or *neomodernism*. *Elle* magazine, for example, describes Martin Margiela's fashion design as deconstructive, even though their characterization of his cutting edge style sounds suspiciously like postmodernism:

> Antique costumes that looked as if they had been scavenged from
> flea markets were ripped apart, reworked and combined long-

sleeved T-shirts, flowing skirts and tailored jackets. In Margiela's
hands, an antique embroidered dress was retooled for the 21st
century—an 18th century vest was teamed with a long denim
shirt. Quoting from the past, Margiela is fashioning a strikingly
inventive vocabulary for the future.[10]

In much the same way, the "semiotic overload" or the "bombardment
of signs" that was a theme of so much theorizing and artistic practice is
now being characterized in the popular press as the "info highway"
according to a recent cover of *Time*, which takes its title from a campaign
speech by Clinton and Gore, who made building a "'data superhighway' a
centerpiece of their program to revitalize the U.S. economy, comparing it
to the government's role in creating the interstate highway system in the
1950s."[11] The differences between semiotic overload and info highway are
hardly just semantic variations; both serve as shorthand descriptions of
more or less the same phenomena—how information technologies
(computers, cable television, digital recording), which have expanded the
range and accessibility of available information, have affected all aspects
of cultural life, including, most especially, how we envision ourselves and
each other through that array. One could, of course, attribute the differ-
ences between descriptions like "bombardment of signs" and "data
superhighway" to differences between fashionable French nihilism and
all-American can-do technophilia, but the situation cannot be accounted
for in such an easy dichotomous way since each buzz phrase comes from
a different period in the development of postmodern cultures, the for-
mer epitomizing the initial technophobic responses to the "glut of
information," the latter representative of the more contemporary
response of mastering the array of information which now forms the fab-
ric of day-to-day life. The cyberpunk fiction of William Gibson appears to
be profoundly influenced by the first wave fear of information technolo-
gies, creating hyperreal, simulated spaces, yet most of his characters seem
not only adept, but delighted to engage in the "dance of data." Louis
Shiner describes the transition in reference to the evolution of science fic-
tion, arguing that the previous generation of science fiction writers were
afraid of drowning in technology—"we should surf on it."[12] The shift in

metaphors from overload, bombardment, glut, to highway, dance and surfing suggests a profound reconceptualization of both "all that information" and how individuals manipulate it.

My title, then, is only half ironic because, despite its uneven development and the ongoing labeling mania that relentlessly renames it or pronounces it dead, postmodernism as a style and as a condition has indeed evolved from the terror of pure excess to the manipulation of available information. The artistic and theoretical work that defined the contours of postmodernism in the seventies and eighties articulated the failure of modernist paradigms to envision contemporary cultural experience, a period when the shock of the new gave way to the shock of excess. The architecture, interior design, television programs, films and novels produced in the later eighties and early nineties reflect another transformation—when the shock of excess gives way to its domestication, when the *array* of signs becomes the basis for new forms of art and entertainment that harness the possibilities of semiotic excess.

The chief limitation of the majority of attempts to theorize the impact of information technologies is their emphasis on technological innovation to the virtual exclusion of how those innovations are culturally mediated. The presuppositions remain thoroughly techno-determinist, that is, all human behavior being necessarily shaped, absolutely, in terms of the modes of transmission and their ownership. What is consistently left out of the equation is the *mediation* of those innovations; the medium may indeed be the message, but twenty minutes into the future the radically new development is already in the process of being absorbed, being made to respond to the exigencies of specific cultural contexts. The various predictions that are issued regularly by the academy and the popular media, in which the effects of this semiotic excess will necessarily emancipate or annihilate identity, language, knowledge, all insist on an ever-accelerating rate of technological innovation, but still cling desperately to nineteenth century notions of the individual and what he or she is/was able to process, a problem complicated by the alleged disinterestedness of that "individual" in the face of pure information. Yet as the rate of technological innovation accelerates, so does the rate of cultural medi-

ation, technologies of innovation being matched, virtually stride for stride, by technologies of absorption and domestication.

The main goal of this book is to explore the forms of contemporary textuality that have emerged in response to this excess, this seemingly unmanageable array of signs — how popular film, architecture, literature, television, and interior design have all developed ways of structuring that excess and envisioning the effect it has on domestic and urban space, personal and racial history, artistry and entertainment, and the nature of cultural identities. The analysis of "techno-textuality" has thus far focused on those phenomena—cyberpunk science fiction, digital sampling, hypertext, virtual reality—that are allegedly "the future" of textual production, phenomena that render earlier and/or current forms of writing and recording obsolete. The end result is a blindered conception of contemporary cultural production, its complexity reduced to a single binary opposition in which there are only the futuristic and the anachronistic. These radically new forms of textual production are obviously constitutive elements of the Age of Information, but in order to understand the complex interaction of cultural expression and information technology, we need to examine how excess of information and its accessibility have affected all those other "anachronistic" low-tech arenas of cultural activity as well. This is not just a matter of recognizing the sophisticated forms of resistance to the semiotic excess that have developed alongside radically new technologies, that for every twenty-first century info-hip form of artistic creation which embraces the excess of available information there appears to be a "neoclassical" low-tech form of expression which rejects that excess in favor of a lost purity and authenticity. It also involves recognizing the ways in which both deconstructive and neoclassical architecture, both industrial rock and "neotraditionalist" country music are reactions to the same semiotic excess, and their realizations depend on their ability to access and refashion the "already said," which is now most decidedly the *still being said* due to the technologies of information storage and retrieval. In other words, the Age of Information is defined not just by the ongoing struggle between the futuristic and anachronistic (which is in and of itself not suf-

ficiently appreciated by techno theory), but even more importantly, by the ways in which that very opposition is being reconceptualized in cultures defined by the simultaneous presence of phenomena like cyberpunk fiction and neo-neoclassical architecture, but also "cutting-edge" Early Music ensembles. The recent recording of Handel's *Messiah* by Nicholas McGegan and the Philharmonia Baroque (Harmonia Mundi, 1991) exemplifies this *high-tech antiquity*. Listeners can program their CD players in such a way that they can reconstruct six different performing editions of the oratorio produced by the composer during the 1740s and 1750s.

The same digital technology and increasingly sophisticated delivery systems now mobilized by the "Music Industry" gives rise to both hyper-self-conscious rock about rock and a sudden mania for Gregorian chant. Pavement's "Crooked Rain" album (Matador, 1994), which reflects directly on the excesses of the contemporary rock scene, tops *Rolling Stone's* "Alternative Music" chart (May 19, 1994), the same week that "Chant— The Benedictine Monks of Santo Domingo di Silos" (Angel) goes platinum, reaching No. 5 on *Billboard's* Pop chart, and *The New York Times* covers both developments in different articles on the same day (May 8, 1994). While "Crooked Rain" addresses the current obsession with discovering the next new alternative band, "Chant" represents a rejection of all such promotion. In his attempt to explain the popularity of Gregorian chant, James R. Oestreich quotes St. Basil's fourth-century assessment of chant, "A psalm is a city of refuge from demons, a means of inducing help from the angels...it rids the marketplace of excesses." The members of Pavement and the Benedictine monks both incorporate the same technologies of access, capitalizing on their seemingly contradictory perspectives on the excess that such access produces.

Trying to make sense of the cultural "Big Picture" that these architectures of excess form in all their discontinuous simultaneity necessitates a mode of analysis that moves beyond the scope of the microcultural without slipping into the comfortable fictions that a *Zeitgeist* model always provides. One of the central problematics of Early Postmodernism was the debate concerning master- and micronarratives

that generally led to the same theoretical impasse; that is, master-narratives may provide powerful characterizations of national identity and the course of history, but they minimize or just plain ignore cultural difference and specificity, while micronarratives capture specificity, but only by surrendering all explanatory power beyond a merely particular context. Yet it is possible to develop models of cultural analysis that can yield some kind of Big Picture without homogenizing all texts and audiences in the process. By focusing on the divergent ways that forms of cultural expression interact with information technologies, this book formulates a sense of *aggregate narratives*, which try to envision a Big Picture of the Age of Information, but in so doing reveal that no one master-narrative or aesthetic can encompass the cultural dissonance that defines that age. If anything, the technologies of information and absorption that continue to emerge at an ever-accelerating rate only intensify the heterogeneity of all semiotic activity, which makes this an age without a *Zeitgeist*, an age which may be characterized by the proliferation of technologies, but technologies that fail to determine with any overwhelming consistency what is delivered, or how it will be put to use. If the designation Age of Information is to be at all useful in describing the particularity of the contemporary period, it is an "age" that is closer to being the antithesis of the Age of Enlightenment or the Age of Reason than the current version of the same category, since it refers not to a hegemonic worldview or set of intellectual paradigms, but modes of transmission, storage and retrieval that destabilize the temporal delimitation and ideological cohesiveness essential for any *Zeitgeist*. This is not to suggest that we have reached the end of "history," but rather to propose the proliferation of histories, the successful negotiation of the present depending in large part on the invention or recovery of lost histories of specific subcultures, whose very self-definition is grounded on the construction of a history that can map the present. Nor is this to suggest that information technologies are somehow ideologically neutral; on the contrary, their status as "advancement" is itself ideological, but the medium is no longer the message when the "medium" fragments into diverse functions, in which case is the message the transmis-

sion, or is the message the storage ability, or is the message the retrieval system? Is the message in the *excess* or in the *access*?

The answer is both all of the above, and none of the above—all, insofar as each one involves ideological values regarding the status of knowledge, personal expression and critical evaluation, but none insofar as no one phase or component determines its own ideological resonance since it is so thoroughly mediated by its cultural functions. As a way of illustrating the uneven development of the postmodern vis-à-vis information technologies, and demonstrating the utility of aggregate narratives to envision the comparability, but also the discontinuity, of different architectures of excess that have emerged within the past few years, I want to discuss two representative figures, the cyberpunk and the opera queen, the former synonymous with the futuristic dimensions of the age of information, while the latter appears to be the epitome of anachronistic throwback. Yet the complicated nature of each of these phenomena exposes how antiquated such distinctions are, particularly when the "technological" is articulated in terms of cultural difference.

Of Cyberpunk Cowboys and Digital Opera Queens

"Cyberpunk" science fiction has become for many popular and academic critics the paradigmatic example of textuality in the age of information overload, the veritable cutting edge of the literature of the twenty-first century. But cyberpunk is not, as it has been contended, the "apotheosis of the postmodern."[13] It is far more productive to characterize it as one of those cultural phenomena that marked the emergence of the postmodern, its internal contradictions making it a transitional development in which certain paradigms were indeed postmodern, while others remained relentlessly modernist.

The determination of writers such as William Gibson, Bruce Sterling and Lewis Shiner to rework the conventions of science fiction writing in order to come to terms with information technologies did indeed mark a significant break from both the dystopian, often quasi-Luddite visions of the future that epitomized the "New Wave" science fiction writers of the sixties and seventies, as well as the more utopian technophilic perspec-

tives of earlier periods. The need to master emergent technologies and to speculate about their effects on the nature of language, geopolitical boundaries and corporate capitalism signal a significant paradigm shift in science fiction writing, one that parallels concomitant developments in other media that attempted to come to terms with media-sophisticated cultures that were increasingly transnational and hybridized. In his interview with Larry McCaffery, Gibson emphasizes a number of issues that were ubiquitous in initial theorizing devoted to postmodernism:

> The idea that all this stuff is potentially grist for your mill has been very liberating. The process of cultural mongrelization seems to be what postmodernism is all about. The result is a generation of people (some of whom are artists) whose tastes are wildly eclectic—people who are hip to punk music and Mozart, who rent these terrible horror and SF videos from the 7-Eleven one night and then invite you to a mud-wrestling match or poetry reading the next.... I don't have a sense of writing being divided up into compartments, and I don't separate literature from the other arts. Fiction, television, music, film—all provide material in the form of images and phrases and codes that creep into my writing in ways that are both deliberate and unconscious.[14]

Bruce Sterling, in his often quoted preface to *Mirrorshades: The Cyberpunk Anthology*,[15] adds another dimension to that hybridity in his insistence that cyberpunk integrates "the overlapping of worlds that were formerly separate: the realm of high tech and the modern pop underground. This integration has become our decade's crucial source of cultural energy" (p. xi). This particular coupling has given cyberpunk its caché as "outlaw" fiction, but this pairing also reveals a reliance on certain paradigms that suggest the persistence of modernism rather than the apotheosis of postmodernism. Sterling makes two crucial points in this preface regarding the nature of technology: that technology "has reached a fever pitch, its influence has slipped control and reached *street level*...the technical revolution reshaping our society is based not in hierarchy but in *decentralization*" (italics mine) and that "technology is visceral. It is not the bottled genre of remote Big Science; it is pervasive, utterly intimate. Not

outside us, but next to us" (p. xiii). In stressing the street-level dimension of information technologies in the contemporary period, Sterling begins to address the absorption of technological developments, the ways in which they are rendered commonplace as individuals become increasingly intimate with their potential uses. Yet it is precisely in regard to this issue of absorption and incorporation that cyberpunk theorists begin to fall back on all too familiar paradigms regarding just who is able to incorporate and just what form incorporation takes.

While Sterling quite rightly contends that information technologies are now commonplace features of daily life, he nevertheless characterizes the current situation in terms of "sensory overload," a semiotic excess that can be tamed, seemingly only by the outlaw cowboy hacker. But if sophisticated computer and media technologies have indeed reached "street level," why continue to conceive of the situation in terms of an "overload," especially one that only alienated outsiders can manipulate for their own purposes? Here cyberpunk seems inescapably modern, unable to recognize the ways that technology is absorbed, mediated and secondarized when it hits the street and forms the fabric of day-to-day life, by all kinds of individuals, not just the outlaw-hard-rocker-cowboy-avant-gardist. The avant-gardization of cyberpunk is nowhere more obvious than in McCaffery's and Richard Kachey's "Cyberpunk 101: A Schematic Guide to *Storming the Reality Studio*," in which they repeatedly situate cyberpunk heros in reference to the traditional avant-garde through explicit comparisons. In their account of the Sex Pistols (a prime cyberpunk influence, according to this guide), they argue "If they had had access to electric guitars and amplifiers, those dadaists would have sounded like this." In their appreciation of another member of the extended cyberpunk family, Kathy Acker, they insist that "If Genet had sung for Black Flag, he might have sounded like this." Amidst all these avant-garde rocker cowboys, they also include in this "roughhouse gang" Fredric Jameson, (where we encounter yet again the dreaded "sensory overload") Guy Debord, and who else but *the Boss* of the Hyperreal, Jean Louis Baudrillard. In their discussion of Debord, they quote the opening sentences of *Society of the Spectacle*:

"In societies where modern conditions of production prevail,
all of life presents itself as an immense accumulation of
spectacles. Everything that was directly lived has moved away
into representation." From there we are only a hop, skip, and a
jaunt to Baudrillard's "simulation," Rucker's software, and
Gibson's cyberspace. (p. 20)

That very interconnectedness makes cyberpunk seem, in many ways,
already antiquated, since it uses such thoroughly modernist notions of
subjectivity and cybernetics to describe life in the twenty-first century,
futuristic visions conceptualized in terms of overload and saturation, for-
mulations which were the product of the first hysterical reactions to
information technologies. "Overload" in reference to what? Saturated in
reference to whom? The relative, historically contingent nature of these
terms is seldom if ever entertained within this discourse, which prefers
to present them as timeless, as intrinsic features of ahistorical conceptions
of self, media and technology. Or to put it another way, by paraphrasing
Debord...in microsocieties where modernist conceptions of cultural the-
ory still prevail, complex semiotic environments will be presented in
terms of sensory overload. Everything that is directly lived will be moved
away into an antiquated paradigm in which only a few brave outsiders will
escape the clutches of simulation, and they will engage in endless self-
congratulation. The sky above this will be the color of the academy,
tuned to a sixties rerun.

The central paradox of cyberpunk—that even as it posits sensory over-
load and media saturation, it domesticates that overload by narrativizing
it in such conventional terms (for example, the avant-gardist cowboy ver-
sus the System, the hard-boiled loner carving out some provisional sense
of justice, the urban landscape as labyrinth). A number of critics have
identified the more conservative aspects of cyberpunk: Andrew Ross and
Claire Sponsler[16] have discussed its masculinist "boys' club" prejudices;
Paul Alkon[17] has argued convincingly that Gibson's success in: "achiev-
ing a remarkably coherent and powerful science fictional mixture of such
disparate forms of the fairy tale, pulp adventure story, and realistic novel
in the self-reflexive mode of film noir is greatly enhanced by the use of

the marvelous" (p. 78). Gibson himself has acknowledged the "retro" dimension of his own fiction "since I wrote *Neuromancer* very much under the influence of Robert Stone—who's a master of a certain paranoid fiction—it's not surprising that what I wound up with was something like a Howard Hawks film."[18] The envisioning of the semiotic excess of a cyberspace future in terms of a forties film noir exemplifies the strategies of domestication used to tame that excess, a domestication that some of the critics of cyberpunk see as its failure to realize a truly futuristic vision. Sponsler, for example, insists: "If one of the aims of cyperpunk is to give symbolic coherence to our desires, fears, and anxieties about technological trends, then it falls seriously short at narrating new patterns of human action within this radically charged landscape" (p. 634). While her point is well taken, what are the presuppositions of such a critique? That as visionary fiction it must necessarily develop new stylistic paradigms that can be judged successful only if they represent a radically new aesthetic, a kind of seamless, wall-to-wall, futuristic vision? The expectations of this critique of cyberpunk would seem even more problematic than the supposed shortcomings of these novels because they depend so fundamentally on a modernist myth of progress, predicated on the most even sort of development, one in which the familiar is necessarily tainted and only the bold, new, visionary form is considered acceptable. The modernist prejudices of Sponsler's essay are nowhere more obvious than in her judgment that "Unlike Alain Robbe-Grillet in *The Erasers*, Tom Stoppard in *The Real Inspector Hound*, or Italo Calvino in *If On A Winter's Night A Traveler*, Gibson unfortunately does not problematize the adventure-detective plot" (p. 637). Yet Sponsler does not problematize the expectations of modernist criticism that only privileges the radically new and the brave new readers needed to appreciate it. If cyberpunk fiction is indeed an attempt to give expression to *our* desires, fears and anxieties, should it be faulted for utilizing familiar narrative conventions alongside the radically new in order to envision that radically changed landscape? The sort of uneven mixture of familiar and futuristic would not be seen as a failure if coping with fears and anxieties were truly an acceptable aim; here the higher priority remains the invention of new narrative paradigms, *à la* Robbe-

Grillet, which might ensure an acceptable *nouveau roman/tization* of the future.

If cyberpunk can be "faulted" for anything, it is the failure to recognize the ways in which narrativization of what it posits as sensory overload or semiotic saturation is already being tamed and domesticated through its utilization of ready-made conventions of the hard-boiled and avant-garde. If cyberpunk can be said to be the apotheosis of anything, it might be the initial stage of postmodernism in which it became obvious that most modernist precepts and dictates had begun to seem dated in reference to cultures that were becoming ever more fragmented, dissonant and transnational, that this "shock of the new" no longer offered quite the same *frisson* when the already said, already imaged, and already played was subject to immediate random access, and the immediacy of that access provided another kind of shock value. But as in any transitional phase, the present, and in this case the future, are still often framed according to the paradigms of the past, as evidenced by the reliance on categories such as overload, alienated outsiders and corporate conspiracy theories. The chief limitations of the techno-textuality of the eighties were the inability to envision the rapidity of the incorporation of technology, and a similar shortsightedness regarding the way that the systematicity of cultures was imagined. Cyberpunk fiction at its best opened up the range of possibilities for imagining the effects of computer and media technology, but at its weakest, it offered a hard-rock, bad-boy version of the same old scenario—overloaded individuals struggling against the System, conceived of as a malevolent Totality.

Despite their fascination with the outlaw, terroristic arts of renegade hackers, too many cyberpunk authors still posit a systematicity to information production, circulation and repetition, a matrix that makes everything far more manageable, narratively and ideologically. The need for the all-encompassing systematicity of information flow, and by extension all semiotic activity, surfaces repeatedly in Gibson's *Mona Lisa Overdrive*.[19] In this novel, characters try to imagine the shape of the *matrix*, which leads to a consideration of its spiritual dimensions. One character, Slick, initially "didn't think cyberspace was anything like the universe

anyway; it was just a way of representing data" (p. 76). Another, Angie, questions whether the matrix is God, but is told by *Continuity*, an artificial intelligence responsible for continuity within the matrix, that "Cyberspace exists, insofar as it can be said to exist, by virtue of human agency" (p. 129). Gentry is determined to discover "the Shape" of cyberspace, and covets an aleph because, as a "solid lump of biochip," he could contain "an approximation of everything" (p. 154), which is later revised to "an abstract sum of the total of data constituting cyberspace" (p. 210). The debates about the nature of cyberspace, then, approximate traditional theological questions concerning the nature of a supreme being, a point that Gibson seems to be making especially explicit at the end of the novel: "When the matrix attained sentience, it simultaneously became aware of *another* matrix, another sentience" (p. 308). Do the theological dimensions of this inquiry into "the Shape" lead to a discursive foreclosure in which, whatever it is, cyberspace can only be conceived of as systematicity, totality and continuity? The one position that remains unarticulated in these dialogues is that this cyberspace, rather than being imagined as a sum total or a shape, might be more productively thought of in terms of discontinuity, a dissonant cacophony resulting from different technologies being put to radically different uses. Any such emphasis on discontinuity would of course undermine the binary opposition between cowboys and corporations, but even more fundamentally, the terms by which "the Shape" is discussed reflect the rather dubious semiotic dimensions of cyberspace.

Conspicuously absent from the notion of cyberspace that now enjoys such wide circulation is any sense of recent developments in semiotic/cultural theory that have elaborated notions of signification predicated on difference, on the conflicted, heterogeneous nature of the encoding and decoding of messages that are as "postmodern" as the proliferation of new information technologies. While cyberpunk fiction and the criticism devoted to it began to conceptualize the force of these emergent technologies, the failure to bring to bear parallel developments in semiotic and cultural theory leads to internal contradictions regarding who has the agency to manipulate information and how that might affect "con-

tinuity," for instance, how aspects of cultural difference intersect with information technologies, and how that interaction affects the "Big Picture."

One of the distinguishing features of the next phase of postmodernism, then, is the attempt to recast the relationship between information technologies and a semiotics of discontinuity. In this book I will focus on the diverse forms of cultural production that begin from a different set of first principles, still in the process of being formulated—texts in which a "sensory overload" has been replaced by strategies of absorption and secondarization, texts which envision the entirety of the Big Picture not in terms of systematicity, of a unitary Shape, but as a discontinuous array of messages and technologies that are decidedly unstructured, in and of themselves. Bruce Sterling is quite correct: computer and media technologies which were hitherto thought of as *out there*, in the control of Others, have indeed reached the street level, but when that occurs, when those technologies are mastered not just in the street, but also in the living room, their functions and cultural resonances change fundamentally, as should our understanding of the permutations of individual agency when the manageability of the information technologies at the local level increases just as the unmanageability of "all that information" at a global level increases apace.

While the cyberpunk cowboy represents one of the first attempts to develop new forms of techno-textuality in the early eighties, other figures have come to epitomize the ways that the "excess" of information is now being handled in reference to cultural difference, specifically in regard to race, gender and sexual preference, which necessarily factor into the pragmatic, personalized uses of information technology. Cyberpunks often insist on the comparability of computer hacking and the digital sampling of African-American music, but their mutual consideration also yields significant differences. For the sake of brevity, I will use an especially rich example of digital sampling in order to pursue this comparison as economically as possible—the music of the band Living Colour, specifically their song "Elvis is Dead." The inability to appreciate those technologies of absorption that have developed alongside technologies

of information has led to hysterical predictions across the political spectrum that the excess of signs results in cybernetic chaos, a cultural noise that signifies only the end of meaning. Contemporary rap and hip-hop music are frequently cited examples of "techno-barbarism," pure noise in which all is cacophony and digital sampling, and absorption is conceived of solely in terms of annihilation. The music of Living Colour provides a useful case in point here, because it exemplifies both digital technology and the highly selective, pragmatic use of dissonant signs. Vernon Reid and his band embrace technological sophistication as a way of addressing issues of racial prejudice, absorbing and refashioning elements of the array, producing their own reconfigured musical array. Throughout their album, "Times Up," they employ multitrack recording to produce a mixture of found noises and musical rhythms. In a song entitled "History Lessons," for example, a series of voices and rhythms are layered together to emphasize the central repeated quotations, "In Africa music is not an art form as much as a means of communication." In the song "Elvis is Dead," they take on the Elvis phenomenon, attacking the cult of personality that the tabloids continue to fuel and insisting on the African-American origins of his style, which was then bastardized when Elvis went Vegas. Midway through the song, a barrage of speaking voices, black and white, are introduced, each making some kind of evaluation of Elvis more or less simultaneously, which gives way to an argument between the lead singer and Little Richard, playing the role of background rapper. The appropriation of Elvis is made even more complicated in the song's conclusion, which states, "I have reason to believe we all won't be received at Graceland." At this point we have re-articulation of a re-articulation, Living Colour appropriating Paul Simon's appropriation of Elvis, whose own music is not the original, but an appropriation of black rhythm and blues—a point made very explicitly by the lyrics of "Elvis is Dead," but also by the inclusion of Little Richard and the James Brown Horns as part of the mix. The invocation of the black music tradition through the inclusion by performance, on tape or by citation, of Nat King Cole, Dexter Gordon, Sara Vaughan, Sammy Davis, Jr., Jimi Hendrix, and contemporary rappers Queen Latifah and Doug E. Fresh, is crucially

important in and of itself because it involves the construction of a meaningful continuity out of the push-button choices these musicians have become subject to in the random access of the array. But the mix is not limited to that tradition, since it also includes heavy metal, particularly the conventions of speed metal, which until the formation of the Black Rock Coalition was thought to be exclusively a white-boy phenomenon. The end result is a dissonant mix emblematic of the noisy array of electronic culture, a mixture of hard rock, jazz, funk, and rap, which redirects the listener by reconfiguring the array according to an explicit political agenda, and forefronts its self-referentiality and technological sophistication, but also references a very concrete set of social problems, which can resonate powerfully only if as musicians they *enter the fray of the array*. The interdependence of merging technologies of cultural production and their virtually simultaneous absorption reflect a high degree of cultural dissonance, but also the capacity to manipulate it. This point is made most lucidly by Living Colour in their song "Pride." "Don't ask why I play this music, / Cause it's my culture so naturally I use it"

The gay appropriation of the opera might seem profoundly anachronistic in comparison with the pyrotechnics of cyperpunk and digital sampling, yet the opera queen exemplifies the complicated interplay of technology and identity politics as it has evolved over the past several decades. Wayne Koestenbaum's compelling study of this appropriation, *The Queen's Throat*[20] describes the complex interconnections between opera, homosexuality and what he calls the "mystery of desire." While the fetishizing of dead opera singers may seem far removed from the worlds of Gibson and Reid, the gay re-articulation of opera depends on many of the same features which form the basis for a pragmatics of excess—appropriation as self-constitution, the centrality of choice and the primacy of technology.

According to Koestenbaum, "Opera seemed campy and therefore available to gay audiences only when it had become an outdated art form" (p. 145). The outdated, anachronistic dimension was intensified by the fact that, for the author and perhaps the majority of opera queens, the adored object is dead, accessible only through the technology of recording, first

on the various forms of vinyl recording, and now on CD, which has made the ability to access the rare recording of the long-dead diva relatively effortless, due to the glories of the CD reissue. Koestenbaum devotes an entire chapter to the documentation of this technology, entitled "The Shut-In Fan: Opera at Home." Here he argues, "Home bent to accommodate opera. And opera's meaning altered too; an art of excess and display, exteriority, it became an art of interpretation and interiors…just at this moment that opera became a museum piece and an object of domestic pleasure, it invited gay appropriation" (p. 47). Here the domestication of the spectacle of excess cannot be accomplished except through technological means, means which are themselves appropriated and intensely personalized in reference to a specific subcultural identity in the making. The nostalgic dimension of this appropriation is motivated by a very particular form of retro taste, a sexuality that "demands a ceaseless work of recollection: because queers do not usually have queer parents, queers must invent precedent and origin for their taste." The need to invent the defining antecedent from which some sort of originary tradition may be constructed ad hoc is a recurring feature of texts and audiences without "provenance" but it is crucially important to recognize that both that ad hoc tradition and the sense of the imagined community which it helps consolidate are now often unachievable except through technological means.

The invention of legitimacy makes *choice* the key determinant of value in a world of semiotic excess. As Koestenbaum argues, "We don't have much choice about our sexual feelings. Nor can we choose our race. Nor in most cases our class. But for the collector, the drama of choice is supreme" (p. 63). Whereas choice in postmodern cultures has all too often been written off as a matter of spurious product differentiation, a choice between false differences, Koestenbaum rightly insists on the constitutive nature of the act of choosing, on this "drama of choice" in defining and maintaining difference. Against the fixity of class, race and gender, "there arises a fervent belief in retaliatory self-invention; gay culture has perfected the art of mimicking a diva…to help the stigmatized self imagine it is received, believed and adored" (p. 133). The notion of

retaliatory self-invention also describes the activity of the cyberpunk cowboy and African-American rocker, since in each case, choosing is a matter of getting even, a way of defining identity that necessitates semiotic warfare. The key point here is that, while semioticians may have recognized the relationship between signification and identity formation decades ago within the confines of the academy, now that knowledge has become commonplace, perceived not just as part of the structure of feeling that forms everyday life, but as a structure of survival, as the basis for strategies that guarantee the integrity of sexual, racial and gender identity. To choose with a vengeance is a way of gaining mastery over the excess of signs and the identities they entail. To take control, at least in semiotic terms, is to insist upon authority, even if the basis of that authority must be invented. For Koestenbaum:

> The expert is such an entrenched part of opera culture, gay and otherwise, no wonder the happy fixture of the Texaco Metropolitan Opera broadcasts has been Opera Quiz. Love of opera is reduced to a matter of knowledge, trivia; you prove your love by completely *knowing* the dead body of opera, its static dinosaur bulk. When will a fan mail this question to Opera Quiz: How many gays and lesbians are listening to this broadcast? (p. 34)

The drama of choice complicates the standard definition of camp— that the text, star or icon must be an artistic failure in order to be "camped up" effectively. The sophisticated forms of re-articulation that characterize gay opera culture depend instead on a failure on the part of the mainstream public to appreciate that artistic object:

> The camp sensation is produced by our own joy in having discovered the object, in having been *chosen*, solicited, by it…. When we experience the camp rush, the delight, the savor, we are making a *private airlift of lost cultural matter*, fragments held hostage by everyone else's indifference. (p. 117. Italics mine)

To camp does not necessarily mean to engage in ironic play with for-

gotten kitsch; as a form of cultural airlifting, camping can mean the re-investment of value conceived of in the most genuine, nonironic sense.

> Though it may seem sacrilegious to call Callas's musically com-pelling creations *camp*, she performed the same kind of reversal that camp induces: she shattered the codes that separate dead from living works of art. To crosscut rapidly between yesterday and today is an effect that, in different circumstances, we recog-nize as camp. Callas "camped" Lucia not by mocking it (Lucia is too easy to mock) but by taking it seriously. Resuscitating Lucia, Callas challenged our belief that history's movement is linear, that there is a difference between past and present, and that modern reality is real. (p. 45)

In complicating the camp gesture, then, Koestenbaum recognizes the variability of appropriative strategies, and also recasts the relationship between appropriation and appropriated: "The sound originates in the diva's throat, but it emerges on the other side of the Victrola as the opera queen's" (p. 48). At this point, the technological nature of the exchange changes. Just as computer technology takes on a physical dimension that the cowboy engages in a symbiotic relation with when he "jacks in," the technology of recording becomes interactive, the "auraless," mass-pro-duced commodity becoming invested with intense personal resonance. "Listening is a live factory: one produces that potion, 'love,' from the raw material of one's own attentiveness. 'I love Callas's voice' is another was of saying 'Callas's voice loves me'" (p. 33).

This intimacy is made possible by the technological, a reversible inti-macy exemplified by the following exchange between two opera queens in Terence McNally's *Lisbon Traviata*[21]: Stephen suggests that Mendy, the Callas fanatic, answer an ad in the personals from "a 5'10" hairy weight lifter who's into rare Renata Tebaldi tapes."

> STEPHEN: Why don't you call him? Maybe he's nice.
> MENDY: If he likes Tebaldi, I doubt it. They're a mean little bunch. It was a Tebaldi fan who threw radishes at Maria at the first Saturday matinee of *Norma*. Tebaldi fans belong in a soccer stadium.

STEPHEN: You never run into them anymore.
MENDY: It's true. After Renata stopped singing, it was as if they had vanished from the face of the earth. We, on the other hand, are still everywhere. I sometimes think we're increasing. Maria lives through us. We've kept her alive, or maybe its vice versa. We're some kind of survivors. (p. 58)

The corporeality of this technologically based experience throws into question the traditional distinction that so many histories of art and technology rest on—that art had an aura before the advent of mechanical reproduction, and then lost it as it became reproducible and widely accessible (leading to the vulgarization or democratization of art depending on whether the critic in question lined up on the Adorno or Benjamin side of the aisle). The absorption of the technological, the ways in which it has become increasingly easy to manipulate, reconfigure and invest with personal expression, necessitates a thorough-going reexamination of the issue of aura vis-à-vis technology and evaluation. The Adorno-Benjamin debate[22] that took place in the thirties is all to frequently still presented as directly applicable to the present, when it should instead be framed as a very important debate in the history of art and technology that describes the relationship of one to the other in the High Modernist period. While Adorno and Benjamin may have cast their arguments in absolute terms characteristic of this period, in which there was the past and the timeless present (that is, from this point on art will always be thus), those arguments must now be considered historically delimited and therefore likely to lead to mischaracterization of the current situation, where aura is now often a matter of personal projection that cannot be realized *without* technological intervention.

The historically delimited nature of the Adorno-Benjamin debate is thrown into sharp relief by the contemporary opera queen. Despite their theoretical differences concerning the impact of the mass reproducibility of art, both are remarkably similar in one regard—-neither considers how gender, race or sexual preference might come into play *between* mass production and art, altering the cultural functions of both in the process. This is not to suggest that either critic should be faulted for failing to

forsee how significant categories of cultural difference would become sixty years later, but their silence in this regard does, nevertheless, reveal just how dated that debate has become, no matter how important it once was in the history of media theory. Unfortunately, the preconceptions that were operative in that debate (especially the notion of aura) have been adopted in wholesale fashion by too many contemporary critics in their attempts to theorize about the effects of digital recording according to some sort of Frankfurt fundamentalism. Andrew Goodwin, for example, has argued that in the age of digital reproduction the only remaining forms of genuine aura are the "physical presence of the star(s)" and the "fetishization of original performance" facilitated by "consumerist practices of hi-fi."[23] In each case, aura is inseparable from presence and that presence, is conceived of exclusively in reference to performance. While Goodwin's argument might help explain the continuing popularity of live performance and live recordings, this notion of aura would appear to be solely the result of encoding, decoding factored into the equation only as a matter of bearing witness. But this position fails to recognize that in the age of digital reproduction *and digital access*, aura has everything to do with the projection of value *onto* recordings, that the category of *presence* must be rethought in reference to the circumstances of decoding, namely, the ways in which listeners' age, race, sexual preferences determine *which* live recordings are to be valued, *when* CD technology is a matter of cultural airlifting and when its simply a matter of recycling the same old kitsch. Terence McNally's autobiographical account of his own coming of age through opera recordings is a case in point:

> Like most people, I first heard the voice of Maria Callas on a record…. The year was 1953, the recording was *Lucia de Lammermoor* and I was a high school student in Corpus Christi, Texas who bussed tables at Robin Hood cafeteria in order to buy opera records. I was fifteen, a dreamer, and I thought she was singing just for me. It is a conversation with her and, finally, ourselves. Callas speaks to us when she sings. She tells us her secrets—her pain, her joys—and we tell her ours right back.[24]

The reproducibility of voice, word or image must be considered in reference to parallel technological developments in the accessibility and storability of information, all of which involve economic and cultural dimensions that have yet to be factored into academic understanding of the relationship between art and technology. What can be accessed and stored, by whom, and where, to what ends depends on economic factors (specifically the cost of such access), but the impact of accessibility cannot be understood without the concomitant institutional changes regarding the nature of the archive or the museum and just who functions as archivist. The concept of aura in art as it is defined by John Berger[25] in *Ways of Seeing* depended on the stability of the art object (that is, one had to make the pilgrimage to visit the site), but also on the stability of the museum, church or library archive as an institutionalized repository of valued knowledge. Yet the nature and function of aura changes as it becomes variable according to location and channel. The opera queen, lost in the reverie of private listening in the home, depends on the massive projection of aura that turns the recording into holy relic, but the same fan, when hooked into a computer billboard on the subject of operatic recordings is just as likely to engage in an ironic discourse that seems bent on devastating the very idea that any recording could possibly have anything ever remotely resembling transcendent value (particularly any recording by Renata Scotto). The computer billboards devoted to opera (in which opinions are exchanged about definitive recordings, the life of Maria Callas, or Sinead O'Connor's decision to become an opera star) are a paradigmatic incarnation of the architecture of excess—making full use of high technology to appreciate an "anachronistic" art form (grand opera) while engaging in another utterly contemporary art form (computer cross talk), alternately projecting and stripping away "aura," formulating reverential or ironic opinions backed up by extensive private libraries of music written primarily before 1900 and recorded also exclusively before 1960, digitally remastered in the 1990s.

Within the initial debates concerning the fate of art in the age of mechanical reproduction, aura was a quality that was inevitably lost; the

only point of disagreement was whether this loss should be conceived in terms of vulgarization or democratization. Mechanical reproduction did inevitably lead to the elimination of aura—so long as aura was conceived in terms of production rather than introjection, as intrinsic characteristic of artwork and museum rather than the complex interplay of mass distribution at its most anonymous and personal investment at its most intimate. A theory of the art of cultural evaluation in the age of digital reproduction must begin from a different premise—that rather than being *eliminated* by ever more sophisticated forms of distribution and access, the production of "aura" has only *proliferated* as it has been dispersed through the multiplication of information technologies and agents responsible for determining value.

Popular Archivization and the Dispersal of Taste-making

The emergence of new repositories of information such as the computer network and the living room exemplify the widespread reformulation of what constitutes an archive, and just as importantly what constitutes an archivist. The institutional borders of both were formerly delimited according to site and level of education. But now, as the accessibility of the already said, the already sung, and the imagined has changed the storability, and by extension the manipulability of information, the nature of cultural authority that once guaranteed the sovereignty of the archive and archivist is in the process of destabilization and relegitimization through other evaluative criteria.

In a recent feature story devoted to the anniversary of the CD, the *Chicago Tribune* asked its music critics to reflect on its impact. Especially striking about this series of commentaries was the emphasis placed on the recovery of lost recordings that would allow the dedicated fan to assume the role of private archivists. The rock, jazz and classical critics listed the most significant "Recordings that Exist Because of the CD." According to jazz critic Howard Reich:

> For anyone who treasures great music in the American vernacu-
> lar—specifically jazz, classic pop songs, landmark musical

theater—the advent of the CD represented a kind of deliverance. For roughly 20 years (60s to the 80s), brilliant jazz musicians, pop singers and songwriters gradually were banished from the recording scene. The international record conglomerates, tantalized by the possibility of unprecedented worldwide profits, turned to music favored by teenagers— rock.... With the advent of the CD, record companies found themselves hard-pressed to turn out enough product to meet swiftly rising demand. Out of necessity, they looked in their vaults and found long-forgotten jazz and pop masterpieces. The reissues were cheap to produce (since the master tapes were already paid for and ready to go) and they caught on. Single-album reissues and historic boxed sets devoted to the life-work of Frank Sinatra, Judy Garland, Robert Johnson and others sold in the hundreds of thousands.[26]

The terms Reich uses to describe this historical development reflect a widespread recharacterization of the parties involved in technological reproduction. The manufacturer of the commodity is depicted as the profit-crazed conglomerate, which, forced by economic necessity, decides to do the right thing artistically, and the genuine form of *vernacular* music (music of the folk, by the folk, for the folk) reappears, delivered from the bondage of the recording industry by the new recording technology. The splitting of technology from "the Industry" represents a fundamental rewriting of the traditional scenario in which technology was considered inseparable from industry, and together they depersonalized everything in their path. Here CD technology takes on a life of its own, positioned as the ally of the fan, who alone can recognize its true potential, its ability to recover the lost masterpiece from the vault and deliver it to its rightful place in the appreciative listener's private archive, where it will be treasured, never to be forgotten again. The sentiments expressed here bear an uncanny resemblance to Koestenbaum's definition of gay camp—a rescue operation, a cultural airlifting of treasures imprisoned by indifference—with CD technology functioning as the extension of the dedicated listener's taste.

This is not to suggest that collecting began with CD technology, only that new information technologies like the compact disk, the VCR and

the personal computer all change the nature of collecting by increasing exponentially what is available to the individual at lower costs with infinitely greater convenience and ease, all of which alters the function and status of collecting. According to Terence McNally:

> With the advent of the CD, record collecting has become a relatively simple and inexpensive passion...once scarce and very expensive imported recordings have now been transferred—15 or so arias apiece to "budget" recital disks, which shops like Tower and HMV display with a profligacy unthinkable even 10 years ago, and at price a fraction of those charged for shellac pressings with which most older collectors began. In fact, the thrill of the hunt is gone, but the availability of these once scarce treasures is a happy recompense.[27]

The changes McNally describes inevitably alters the nature of collecting, moving it from the realm of the moneyed connoisseur (and the aristocratic vestiges of collecting as the "thrill of the hunt") to the popular archivist. John Von Rhein, classical music critic for the *Chicago Tribune*, describes the situation quite succinctly: "The CD, it would seem, has made completists out of everyone." The notion that every listener is now a *completist* suggests a massive, ongoing reconceptualization of who can assume the role of archivist and what belongs in the archive. In the *Chicago Tribune*'s treasury of recordings that exist because of the CD, one finds the expected classical rarities, like *Jussi Bjoerling: The First Ten Years* (featuring, we are told, recordings virtually unavailable outside music archives since the 78rpm era) but also *The Complete Billie Holiday* (ten CDs), *Lefty Frizzell: Life's Like Poetry* (twelve CDs), *Hank Snow: The Thesaurus Transcriptions* (five CDs), *Phil Spector: Back to Mono 1958–1969* (four CDs) and *Rhino DIY*, a history of Punk and New Wave (nine CDs). This archivizing of jazz and country music from the forties and fifties, pop from the sixties, and punk from the seventies, none originally intended to be archived, yet all now meticulously presented for the completist of every age and taste, results in a vast reservoir of recorded material *and* passionate archivists.

The popularization of taste-making has been one of the most signifi-

cant developments in the evolution of aesthetics since the advent of mechanical reproduction, but the popularization of *archivization* involves more than just who has a right to pass judgment on what should be considered disposable culture— it means that distinctions between what is and isn't disposable, what is and isn't worthy of *preservation* are determinations now made by a host of figures, often in antagonistic relationships with one another. This dispersal of cultural authority is not simply a matter of taste-cultures in conflict, but rather the splitting of other relationships that once held of art, critical evaluation, education and the technology of reproduction together through mutual confirmation, that is, classical record labels representing themselves as guardians of cultural history by recording works judged masterpieces by musical historians and the properly initiated audience. While that scenario remains solidly institutionalized (as does the equally cohesive connection between the popular label furnishing the requisite hits of the moment and the audience who craves nothing more) the determination of cultural value is now, just as often, arrived at through far more discordant relationships, situations in which the taste of Dedicated Listeners, aided by their ally CD technology, manages to prevail against the the Indifferent General Public and their minions, the greed-driven Record Labels, and rescue the lost art that only the properly initiated audience can appreciate, an appreciation obtainable only *outside* the academy and *despite* the Music Industry. Here cultural value rests not on an imagined consensus of like-minded parties within the same "taste-culture" but on antagonistic relations between parties motivated by antithetical notions of cultural capital—a point at which taste, as well as textuality, becomes an architecture of excess.

The following chapters are organized around clusters of interconnected questions which I believe either have gone unasked or have been answered much too simply in the public discourse on semiotic excess and its ramifications:

How do individuals develop a satisfying sense of identity by locating

themselves, spatially and historically, in reference to the array of information and information technologies?

How has appropriation, now so ubiquitous in art and entertainment, evolved from the emergence of Pop Art in the late fifties through the Meta-Pop of the nineties?

How have both the structure and function of narrative been altered by the seemingly endless recirculation of stories that are always-already-told-subject-to-random-access?

What happens to the relationship between tradition and innovation, especially when that which was once synonymous with the "cutting edge" is now brought back as "classic" in the Retro-Modernism now so popular in architecture and interior design?

How does the array of information effect critical evaluation, particularly in regard to what constitutes cultural authority? What sort of impact should that destabilizing of cultural authority have in the realm of radical pedagogy?

Home, Home on the Array

Does it matter if the space cannot be mapped if I can still
describe it?
> —Jeanette Winterson, *Sexing the Cherry* (1989)

In that case I'll be at the mercy of either God or his antithesis,
not the Devil, since I don't believe in the Devil, but Chaos,
against which the only weapon God has ever given us is
memory.
> —Steve Erickson, *Arc d'X* (1993)

Location, Location, Location…
> —Real estate proverb

It has by now become commonplace to insist that one of the
ramifications of living in the information-saturated cultures of the
nineties is that individuals have lost any sense of identity, because that
excess of signs has necessarily destroyed any coherent sense of space and
time. The most troubling assumption in this position is not that identity
depends on self-location, or that this dissonant array of information has
had a massive impact on the conceptualization of space and time. Both
of these assumptions appear to be quite accurate—identity does indeed
seem to be inseparable from a sense of location conceived of in either a
geographic or historical sense, and the excess of information has forced
an all-pervasive rethinking of spatial and temporal demarcation. While

these conditions or circumstances may be the case, it does not necessarily follow that the ability or, more precisely, the will to develop a coherent sense of identity *out of* this array has been extinguished in the process. The argument that individual subjects are helpless, drowning in a sea of information, depends on one very problematic assumption—that semiotic environments have changed profoundly in the latter decades of the twentieth century but the individual's ability to negotiate those environments has remained unchanged since the Enlightenment. Semiotically speaking that argument is untenable because it imagines a subject outside language, or more precisely, a subject half inside and half outside language, capable of acquiring a vocabulary and a grammar but entirely incapable of achieving fluency in the processing of information, even though he or she may possess the "cybernetic street smarts" a subject would inevitably acquire as a native speaker in a world of semiotic excess.

In this chapter I will explore, paraphrasing the opening quotations, the determination to describe and the weapons used to establish geographic and historical reference points within an allegedly unmappable terrain. I will be focusing on phenomena that, in some cases, have been given considerable critical attention but have yet to be considered in tandem as simultaneous manifestations of this need to construct a sense of self-location. This cross-disciplinary approach will consider how this need has been articulated in contemporary urban theory; in the architectural debates between deconstructivists and neo-neoclassisists; in the "K Mart Realism" or "Strip-Lit" of recent American fiction; in the photography, fiction and theatre of the "New Black Aesthetic"; in the recent proliferation of British metahistoriographic novels by writers as different as Peter Ackroyd and Jeannette Winterson; and in the figural *psychotectures* being developed by Shin Takamatsu and Steve Erickson. The goal of this comparative analysis will be the creation of *aggregate narratives* which, I hope, will suggest the complexity of the "Big Picture" without *zeitgeisting* this disparate activity into one or two themes that might make it all somehow more manageable.

By presenting an amalgamation of what have thus far remained isolated, self-enclosed exercises in postmodern cultural cartography, I want

to generate a productive cacophony, a dissonant mix of master- and micronarratives which resist any attempts to harmonize them but are, nevertheless, better understood through juxtaposition, in all their noisy simultaneity. I am purposely mixing spatial and auditory metaphors here, because one of the central concerns of this chapter will be the shifting relationship between metaphoric trope and experience-to-be-mapped-envisioned-narrativized-choreographed-negotiated, how the choice of spatial, temporal or figural metaphors reflects, implicitly or explicitly, a host of interconnected ideological assumptions regarding the nature of cultural experience and how it may be manipulated. Through an interdiscursive, interinstitutional analysis of the flash points in the debates concerning identity politics, architectural theory, information technology and canonicity (both inside and outside the academy) I hope to piece together the still-emerging agenda for cultural theory in the nineties, an agenda which suggests that "cultural analysis" itself needs to be remapped and rehistoricized just as fundamentally as the terrain it hopes to chart.

Cultural Geography and Ethnographic Mapping, or
chacun à son theme park

The term "mapping" has become a theoretical shorthand used to describe the activity of envisioning cultural space in such a way that individual subjects might develop some meaningful sense of location within a foreign terrain that was once familiar but has now been rendered virtually incomprehensible by the forces of postmodernism (the arrival of information technologies allegedly having demolished traditional categories of time and space). Despite its currency, the term remains a slippery one due to a certain confusion regarding the stakes as well as the strategies involved in this mapping of that-which-is-allegedly-unchartable. A brief discussion of the evolution of the term is necessary at this point, in order to better understand how different theoretical agendas have shaped its application, and how those agendas generate very particular forms of cartography that predetermine the contours of what is mapped and who qualifies as a cartographer.

Kevin Lynch introduced the term "imageability" in 1960 in regard to the overall legibility of urban space, the ability that certain cities had to generate strong visual impressions in the minds of their inhabitants, thereby providing them with vivid comprehensible images of their environments.[1] While his use of the term was restricted to urban planning, his argument concerning the positive values resulting from such vivid "holdable" images remains a compelling one for all cultural theorists, because it directly addresses the relationship between self-identity and self-location. Fredric Jameson, for example, expanded Kevin Lynch's notion of "cognitive mapping," arguing that "the mental map of the city explored by Lynch can be extrapolated to that of the mental map of the social and global totality we carry around in our heads in variously garbled forms."[2] The problem, for Jameson, is that mapping our place within what he calls "the great global multinational and decentered communicational network" can only be accomplished by a radically new aesthetic which maps the flow of multinational capital, an aesthetic he stresses does not yet exist. "I am not even sure how to imagine a kind of art I want to propose here, let alone affirm its possibility, it may well be wondered what kind of an operation this will be, to produce a concept of something we cannot imagine" (p. 347).

While I agree with both Lynch's and Jameson's contention that the imageability of cultural life is crucially important in determining a sense of self-location, I want to give their presuppositions closer scrutiny and suggest that a successful realization of what they hope might be achieved depends on a profound reconsideration of what imageability entails. The yet-to-be unveiled aesthetic that Jameson calls for is already operational; a wide range of texts in a variety of media have undertaken the project of imaging postmodern cultures in order to make that terrain more comprehensible to its inhabitants, but in doing so they throw into question the very notion of totality that Jameson insists must be the basis of an acceptable cartography. Making sense of these attempts to make that environment more legible also necessitates a comparable reformulation of Lynch's presuppositions. Lynch makes the interaction between physical structure and individual perception the basis for his definition of image-

ability, arguing that "we are able to develop our image of the environment by operations on the external physical shape as well as by an internal learning process" (p. 12). What is missing from this definition is a third factor, the intervention of institutionalized image-making which mediates that relationship between structure and perception, popular images and narratives that provide frameworks for envisioning both cultural space and self-identity that massively affect that learning process. Lynch makes the key point that "since image development is a two-way process between observer and observed, it is possible to strengthen the image either by symbolic devices, by the retraining of the perceiver, or by reshaping one's surroundings" (p. 11). One might add: or by reconceptualizing one's critical presuppositions in order to understand how those perceivers have already begun to learn how to make sense of their environments—begun to discern the "hidden forms" within the sprawling, discontinuous cultures of everyday life. The excess of images which makes imageability more complicated than ever before also means that the activity of the perceiver is not simply a matter of recognition of formal contours but a choosing between semiotic alternatives, a process of self-situation in which *grounding* is inseparable from the process of choosing between alternative imagings.

The need to envision environments in such a way that they become locally meaningful and somehow more legible must be distinguished from the need to map the flow of multinational capital as a fixable totality because, despite their potential complementarity, they are decidedly not coterminous—if anything, the two come closer to being mutually contradictory since the former involves a subjective, highly contingent sense of cultural experience, depending on a "structure of feeling" in Raymond Williams's sense of the term, but the latter suggests an Althusserian notion of "scientific knowledge" which contradicts the original premise of Lynch's notion of imageability that made *individual subjective* perception one of its two fundamental components. The latter posits the existence of a critical space somewhere outside the realm of ideology and representation, from which the "whole" may be perceived and evaluated axiomatically. Just how anyone gains access to that pure knowledge is

obviously perplexing, but the contention that it is somehow attainable serves as the basis for the rejection of any invalid attempts to envision cultural life, most especially popular texts distinguished only by their impurity as commodified "mass culture."

The crux of the problem here is the issue of professionalism and who constructs the "valid" map. In David Byrne's film *True Stories* the narrator tells the viewers (in the section of the film entitled "Architecture") that Texas leads the nation in the production of metal buildings, structures which realize the dream of early Modernist architects to construct low-cost buildings efficiently, but they don't count because "it doesn't take an architect to design one." In much the same way, it doesn't take a critical theorist to envision a culture in ways that are locally meaningful, but attempts by nonprofessionals can be easily written off if they fail to map according to the proper critical discourse. The question, then, of who is qualified to do this mapping leads directly to the problem of totality vis-à-vis agency, especially since the totality of the future seems for Jameson, to be, like his conception of history, "a single vast unfinished plot" (or, as Samuel Weber has described Jameson's conception of history, "a story waiting to be told once and for all, in one and only one way").[3] Telling such a story or constructing such a map appears to be the responsibility either of "the collective," or of a master visionary who, like some latter-day Balzac, envisions the *comedie postmoderne* in all its totalizable glory. Weber is especially critical of the former option because he believes that "To continue to conceive of the collective or community in terms of a 'self—sufficient intelligible unity' is merely to universalize the individual, held to be the source and goal of its being" (p. 54). The figure of the individual subject as cartographer and the "microgroup" remain two of the great structuring absences of Jameson's conception of mapping, and their absence jeopardizes the realization of the yet-to-be-formulated aesthetic he hopes will eventually emerge, because the agents of its production remain unspecified and the members of "the collective" remain in a kind of Marxian limbo, not really evil, but unable to affect their own liberation.

As a critical term, "mapping" is further complicated by the confusion

of ultimate goals. The highest priority in Jameson's notion of cognitive mapping appears to be not the individual's successful negotiation of his or her environment, but "how to imagine utopia." But *imaging* a particular cultural terrain and *imagining* a utopia involve profoundly different epistemological and ideological agendas. While a "global social totality" conceived of in Marxian terms might be a vital component of socialist utopian discourse, it is hardly mandatory for developing a meaningful, localizable sense of identity and community, especially in a world where the status of that discourse has been rendered rather problematic by the very "*History*" it has always appealed to as the guarantee of its legitimacy. Jameson insists that, "It is unlikely that anyone who repudiates the concept of totality can have anything useful to say on this matter, since for such persons it is clear that the totalizing vision of socialism will not compute and is a false problem within the random and undecidable world of microgroups." The most troubling aspect of this formulation is, of course, the either/or option—either the world is made comprehensible by a socialist metalanguage dedicated to totalization, or it remains an undecidable mass of swirling fragments. Yet there are other options—ways of envisioning the self in relation to the array of contemporary cultural production from the vantage point of specific structures of feeling, forms of cartography and history-writing that are grounded in gender, racial, sexual and national identities in which very little remains random or undecidable, forms in which those identities are framed in reference to geographies and histories that are massive in scope.

The imageability of any cultural space is not simply the residue of structural and economic determinism operating in semiotic vacuum—the development of a sense of self-location, whether that self belongs to a radical African-American photographer or an archconservative British architect, depends upon the negotiation of cultural landscapes that come to us already imaged. The effects of these various envisionings, in which ideological values aren't merely projected onto a particular cultural terrain but actually shape that terrain by determining its most significant contours, remain largely unexplored. Urbanists have either remained solidly locked within asemiotic phenomenological frameworks in which

there are only raw structural form and even rawer individuals, or they have adopted an even more limiting approach, one which insists that physical space no longer has any meaning at all because the mass media, specifically television as the chief weapon of consumer capitalism, have immersed us all in a world of electronic simulation that vaporizes "real" space.

Michael Sorkin's collection of essays, *Variations on a Theme Park*,[4] exemplifies the latter approach, which contends that traditional notions of space and time have been rendered obsolete by information technologies that have absconded with the real world and left a counterfeit reality in its place, a duplicate so convincing that only a few enlightened essayists can spot the the deception. In his introduction Sorkin articulates the main themes of this approach—that cities are now "ageographical" because they have no "sense of place" and that this is all the fault of television, telephone and computer technologies which generate a simulated real, depriving cities of those qualities which made them places of "human connection." He states all this in the most sweeping terms, "This new realm is a city of simulations, television city, the city as theme park," (p. xiv) "Liberated from its center and its edges by advances in communication and mobility and by a new world order bent on a single citizenship of consumption, the new city threatens an unimagined sameness even as it multiplies the illusory choices of the TV system" (p. xiii).

Sorkin's insistence that everything is now part of a singular "TV system" is a perfect example of a master-narrative which must totalize at all costs, a totalization scenario that fails to recognize how categories of cultural difference might affect the meanings generated by any landscape. He cranks out the old "mass culture critique" one more time, but he manages to out-totalize even Adorno and Horkheimer by insisting that not only is all of mass culture the same, everything is mass culture. The only significant categories are, quite predictably, the same binary oppositions which have served as the basis for the foundational mythology that has been the mass culture critique since its inception—the demonized present versus. the better, "realer" used-to-be ("this book pleads for a return to a more authentic urbanity" p. xv); the monolithic System and

the cultural dupes it enslaves versus critical outsiders who somehow managed to escape this mass conspiracy. Throughout these essays it would appear that there are only two ways to envision urban space, through the discourse of California real estate boosterism (which constructs only a universe of simulation) and a "Baudrillard boosterism" (which tells us *the truth* about "living in sim"-ulation). One could, of course, say *chacun à son theme park* at this point, but that seems much too easy, no matter how tempting it might be to imagine the fantasyland in which Sorkin and company dwell, wrapped as tightly as they are in a seamless web of self-congratulation. What is very conspicuously absent from their mythology is any sense of how the actual inhabitants make the landscape into their life-scapes, how they develop what de Certeau refers to as the local "ways of operating" in which they *take place*, developing their own geographies that make their environments legible in their own terms.[5] In another essay in *Variations on a Theme Park*, Edward Soja argues along virtually the same lines in his analysis of Orange County, an exemplar of what he calls an *exopolis*, a term which he feels captures their "city-full non-city-ness." Not surprisingly, after quoting him implicitly and explicitly throughout the article he confesses, "I could not help but think of Jean Baudrillard's reflections on California"(p.110). Genuine "city-ness" appears to depend entirely on the intrinsic quality of certain structural features without which there can be no real city, no matter how determined the inhabitants might be to treat it as such. This results, in both Sorkin and Soja's essays, in a "single citizenship" which they themselves manufacture through their own discourse, a sameness secured through the panopticism not of the city but the critic's own totalization scenario.

In his masterful critique of Soja's decidedly *modernist* geography,[6] Derek Gregory argues that his analysis of California is:

> astonishingly univocal. We never hear the multiple voices of those who *live* in Los Angeles.... Although he claims to "have been looking at Los Angeles from many different points of view"—more accurately, I should say from many different viewpoints—these do

not provide different "ways of seeing," as he seems to think:
rather they all provide the same way of seeing...his master-narra-
tive is sometimes so authoritarian that it drowns out the voices of
other people engaged in making their own human geographies."
(p. 86)

Gregory relates this inability to hear other voices to Soja's privileging
of geographic over and against historical paradigms. While Soja's argu-
ment that social theory has, to a very great extent, privileged temporality
to the detriment of spatiality is a persuasive one, he produces only a coun-
terextreme by presenting a geography stripped of the narratives projected
onto specific landscapes, narratives which increase the legibility of those
landscapes. Imagining "History" outside of spatial relations is, of course,
problematic, but imagining "Space" without any sensitivity to the narra-
tivizations which also map the terrain as a lived environment produces a
mode of analysis that comes closer to a *geometry* than a geography. Gregory
argues:

Soja's postmodern geography as a whole seems indifferent to the
importance of ethnography and in particular to the experiments in
"polyphony" which have so vigorously animated postmodern
ethnography. I suggest that this is, in part, a direct consequence of
the visual metaphoric through which Soja conceives of spatiality.
(p. 71)

Gregory counters this spatial exclusivity with a quotation from James
Clifford, "once cultures are no longer prefigured visually...it becomes
possible to think of a cultural poetics that is an interplay of voices"(p.
71).

While Clifford's introduction of vocal metaphors is a very productive
move, I believe it needs to be nuanced differently in reference to cultures
which are prefigured by a *profusion* of visual images, all of which envision
the same or overlapping spaces in such a way that they form a "cacopho-
nous" mixture. The imageability of Los Angeles, for example, depends on
personal navigation by its inhabitants, but also on the successive layers of
conflicting popular mappings produced by films such as *Boyz 'N the Hood*

(1991), *Grand Canyon* (1992), *South Central* (1992), *Menace II Society* (1993), and *Falling Down* (1993), which cannot be "factored out" of that landscape for the viewers of those films. They constitute a "visual polyphony," a mixed metaphor which suggests how these films map, envision, give voice and narrativize simultaneously: they generate multiple perspectives of, for example, South Central that are at times mutually contradictory (young African-American males envisioned alternately as victims of an economic system in *Boyz 'N the Hood* and *Menace II Society* or as predators in the urban jungle in *Grand Canyon* and *Falling Down*) and at other times remarkably similar (both *Menace II Society* and *Falling Down*, for example, feature not just similar street scenes complete with ethnic murals and gang members but also greedy Korean shopkeepers, the breakdown of the nuclear family as cause of dislocation, and the watching of personal videotapes as a form of self-mirroring). Trying to discern the Big Picture of Los Angeles cannot be accomplished from any single vantage point, because the city as lived environment is that cacophony of voices formed by the private narratives of its inhabitants and the popular films, rap songs and television images that circulate in, around and through those personal narratives. One could imagine a giant diorama in which all these films and songs might be projected and played simultaneously, thereby suggesting the contours of the discontinuous "whole" that is Los Angeles, but to offer such an all-encompassing vision as anything other than a methodological construct would be to create only another false totality, since the viewer's position for such a spectacle would inevitably be an artificial one, divorced from the specific strategies of self-location employed by individual subjects as they sift through this array of images that forms their cultural terrain. This is not to suggest that methodological composites cannot be enormously useful in envisioning patterns or salient juxtapositions, but that such envisionings should not be taken as *definitive* maps because they serve very different purposes that often have little or anything to do with the project of self-location.

The absence of any significant ethnographic dimension in the panoptic urbanist theory practiced by Sorkin and Soja is most obvious in the subtitle of *Variations*, "The New American City and the End of Public

Space." This "public space" has now ended unilaterally because bucolic downtowns (the same ones demonized as "labyrinths" in the nineteenth century in reference to the genuine communities found in the country) have been replaced by shopping malls which are privately owned and therefore unable to serve a truly public function. Here the master-narrative is at its most systematic—all meanings are determined by the rule of one univocalic paradigm, a consumerism which can only have uniform effects as it annihilates any sense of community. Yet their insistence that malls are inherently pernicious contradicts the ostensibly materialist perspective of this panoptic urbanism—the social value of malls, like any other commodity, is not a matter of intrinsic essence but of their use and exchangeability. Rob Shields has argued very convincingly that community and consumption are far from mutually exclusive, that the "public-ness" of any space does not depend on transcendent qualities conceived of as intrinsic to certain structures. In his own ethnographic mapping of shopping malls he insists that:

> These people, so-called 'shoppers' but in reality a heterogeneous crowd with diverse purposes, are not actors paid to simulate the interaction of a public space. While an urban built-environment can be simulated in plaster and plastic, social centrality only occurs if a space is appropriated as public by people. A shopping centre is 'analysable,' then, according to its purely political-economic function of the property circuits of capital intersecting with global commodity-exchange (Gottdiener, 1986). However, a less Cartesian approach reveals that the factor which accounts for the success of shopping centres is their development as sites of social centrality. A less fragmented approach to the subject reveals that commodity exchange is more thoroughly than ever interlaced with symbolic and dialogic elements.[7]

Shields details the various ways in which malls have taken on functions once performed by town squares and ends by arguing:

> it cannot be concluded that we are witnessing or should fear the

> death of reciprocity, friendship or community. Instead it is only the pain of discarding a modernist regime of value and a logic of identity already laid aside by those who frequent the spaces of sociality. (p. 111)

The relationship between the panoptic and ethnographic approaches to urban theory might be most effectively understood in terms of the differences between Baudrillard and Venturi and Scott Brown regarding how one *learns* about contemporary cultural landscapes. For Baudrillard, understanding seems to be a matter of recognition—"the masses" that inhabit America fail to recognize what the visiting poststructuralist *sees* upon arrival. Either one is helplessly lost inside the simulacra or one stands apart by virtue of some sort of innate ability to escape the mass-conspiracy (how one achieves the "Look-Ma-*I'm*-not-interpellated" position remains a mystery). But these static categories are precisely what Venturi, Scott Brown and Izenour have consistently rejected in their work, beginning with their landmark study, *Learning from Las Vegas*[8]. Mapping the new urban geography is a dynamic process in which everything is learned, nothing operates according to preordained categories, in regard to neither urban forms nor individual agency. They began their analysis of the Las Vegas strip with the by now legendary statement, "Learning from the existing landscape is a way of being revolutionary for an architect." When it was first published in 1972, "existing" appeared to be the crucial word since it signaled such a fundamental break with the hegemonic Modernist aesthetic but now, over twenty years later, the very notion that mapping urban form (and by extension cultural geography) can be matter of learning instead of axiomatic value judgments based on static categories, seems not just revolutionary but practically *unthinkable* according to the master-narrative of panoptic urbanism. In making the communicative potential of architecture their highest priority, they necessarily deemphasize the Olympian "personal vision" that only the architect or critic supposedly possesses. This shift from Romantic to semiotic values provides the foundation for an expanded notion of imageability, because it allows for a redefinition of imaging that exceeds the disciplinary gaze of the architect and/or the urban theorist. By argu-

ing that architectural design can learn a great deal that can be put to civic use about communication from the language of commercial persuasion, Venturi and Scott Brown *change the subject* of the imaging process, which now includes the architect, the inhabitant/user, and a host of other figures, from the advertising copywriters to film directors, artists and illustrators producing the reservoir of images that resonate in particular ways in specific semiotic communities. Imaging here becomes a dispersed, but cumulative activity, and its values and goals are redefined in the process.

That mass-produced cultural forms, whether they be strips, malls, movies or television programs, may be *learned* as they are *made meaningful* through appropriation by individuals who invest them with intensely personal meanings has been investigated by urbanists like Shields and popular culture theorists such as John Fiske who, for example, argues that once appropriated (he prefers the term "excorporated") the mass cultural text can be converted to folk-cultural phenomenon exhibiting all the spontaneous and organic qualities associated with the latter.[9] While this is an essential argument, the distinction between the mass and folk cultural has become far more complicated through these diverse mappings of landscapes defined by their semiotic excess. The concerns of urban and media theory should indeed dovetail at this point for two reasons: first, because the mediation of physical landscapes by popular culture is inseparable from that terrain, and second, because what individual subjects are thought to be able to *do* with and in their landscapes involves issues of personal agency that parallel similar questions concerning what those same subjects are thought to be able to do with media images which function both as maps and as a terrain-to-be-mapped. The "Wild, Wild Life" sequence in Byrne's *True Stories* exemplifies how complicated the relationship between "folk" and "mass" culture has become as they combine in hybrid forms which become a significant factor in imaging these hybrid spatial environments that are both mainstream and marginal, homespun and technologized. The basic activity, lip-syncing at the local nightclub, would in itself appear to be the final victory of the homogenizing mass culture that has so thoroughly eliminated authentic,

spontaneous expression of the real folk that they can only mouth the words of songs as the ventriloquist's dummies of the culture industry. It is exactly this kind of facile reading of popular culture that is rejected here. Each performer makes the song his or her own through the styles of performance, which differ according to race, gender and generation. This diversity is intensified by the fact that some performers resort to parodies of Billy Idol, Prince, traditional country and western, New York neurotic rock, all further emphasizing the simultaneity of involvement and distantiation from the media message and its complicated effect on the imaging of self and community. The *mise-en-scène* of the nightclub itself forms another mass-folk hybrid; the performers are backed by a wall of monitors, but the performers quite literally circulate between stage and audience, thereby restoring the standard features of folk culture—the interchangeability of performer and audience, the sense of spontaneous interaction between the two, the improvisation on the formulaic, and so on. Here the high-tech nightclub meets a church sing-along, just as later, in the "Puzzling Evidence" sequence, the church service call and response gives way to a zapper's montage of television images. In each case, the primacy of the electronic apparatus suggests a mass-mediated culture that allegedly destroys all sense of community and belonging, but the appropriation of that apparatus within the context suggests only the reverse.

The need to develop hybrid forms of representation that envision or map this changing cultural terrain (and in the process allow for a sense of self-location within it) is one of the distinguishing features of what is often refered to as "K Mart Realism" or what I prefer to call "Strip Lit." The limited theorizing devoted to the work of Bobbie Ann Mason, Frederick Barthelme and Ann Beattie has thus far omitted its central problematic—the characters' navigation of the highly mediated cultures they inhabit, a process of learning from the existing landscape that becomes constitutive of their sense of identity. In Bobbie Ann Mason's story, "Love Life,"[10] that landscape is a hybrid mixture of native Southern and contemporary television cultures. The opening scene features Opal, a retired high school algebra teacher, sitting in her recliner watching MTV with remote control in hand. As she adjusts to her retirement, her

young niece Jenny moves in with her, a free-spirited young woman who is "full of ideas" and apparently sexually liberated. Her boyfriend, Randy, is a go-go real estate salesman whose van (his mobile office) features "a little shingled roof raised in the center to look rustic" and a message painted on the side "REALITY IS REAL ESTATE." The expected thematic opposition between Old and New South, each character representing a whole way of life, is thus set in motion by Mason, but then substantially reversed. Jenny, instead of being a promiscuous swinger obsessed only with the future, is fascinated by family history and pesters Opal to show her the family "burial quilt," in which that history has taken material form, expressed in traditional American craft-art. It is instead Opal who is dismissive of the quilt. "Do you know what that quilt means to me? A lot of desperate women ruining their eyes." When they spread out the burial quilt, "Jenny looks like someone in love as she gazes at the quilt. 'It's gorgeous,' she murmurs. 'How beautiful.' 'Shoot,' says Opal. 'It's as ugly as homemade sin'." When Jenny leaves with the quilt, "Opal feels relieved, as though she has pushed the burden of that ratty old quilt onto her niece. All those miserable, cranky women straining their eyes sticking on those dark scraps of material."

Rather than seeing herself as an inheritor of that tradition, Opal prefers to envision herself in an MTV video, or more precisely in her own willful introjection of a video, in which her reading of the images appears to be working directly at cross-purposes with its intended message. The story concludes with a description of a video that features a typical classroom revolt scene, complete with singing rocker, gyrating students and outraged teacher. But as the narrator tells us, "The teacher at the blackboard with her white hair in a bun looks disapproving, but the kids in the class don't know what's on her mind. The teacher is thinking about how, when the bell rings, she will hit the road to Nashville." That she prefers to see herself in terms of a hijacked media image instead of an authentic folk-cultural craft exemplifies the profound reformulation of the formerly static relationship between folk and mass culture. Opal's self-location depends on her rejection of the limitations of her inherited culture and the appropriation of media culture, which may be "foreign" and "inva-

sive," but only until it is introjected and refashioned in the process. The realism of K Mart Realism depends on exactly this sort of recognition— that the "real world" now comes to us always already imaged and the nature of self-imaging changes accordingly, becoming a matter of selection, introjection, and re-articulation.

The temporal dimension that this activity adds to the purely spatial conception of mapping necessitates the reintegration of a historical dimension alongside the geographic, since the domestication of the Age of Information and the cultural landscapes it produces depends not just on identifying the appropriate stage and *mise-en-scène* but also on what constitutes significant action within it—cultural mapping is inseparable from cultural mythology. The belief that certain physical structures possess inherently transcendent properties that must serve as the fundamental reference points in the mapping of this terrain is not restricted to panoptic urbanism. One finds a parallel determination to invest particular forms with mythic qualities in the ongoing architectural debates in Britain between the Neo-Modernists and the Neo-Neo-Classicists, where certain forms and materials are judged intrinsically classical or futuristic, and are deemed inherently valuable, dangerous or irrelevant based on those transcendent qualities. What may ostensibly be spatial forms are articulated in reference to ideological agendas which envision those forms as manifestations of historic or futuristic "world spirits" which form the basis for their cultural legitimacy. In each case, whether the argument is made by Prince Charles or Richard Rogers, the "technology" of the contemporary landscape is demonized or sanctified in reference to a historical continuum which is appealed to as the ultimate arbiter in the ongoing taste-war that will seemingly determine the fate of British culture.

A number of architects, critics and theoreticians in this debate have argued for the intrinsic values that exist within the basic form vocabulary of classical architecture. This position has been advanced most notoriously by Prince Charles, whose own envisioning of the landscape, entitled appropriately enough, *A Vision of Britain* (1989), centers on the restoration of those forms which once made English cities so glorious. He sets this

classicism in direct opposition to the technological present:

> As a result of thirty years of experimenting with revolutionary
> building materials and novel ideas, burning all the rule books and
> purveying the theory that man is a machine, we have ended up
> with Frankenstein monsters, devoid of character, alien and largely
> unloved, except by the professors who have been concocting these
> horrors in their laboratories. [11]

This same distinction between the inherently *alien* nature of the technological and the just as inherently *natural* quality of the classical is also made by Clive Aslet, architectural critic and editor of *Country Life* magazine, who contends that "real architecture" will have returned by the year 2000:

> What is real architecture? It is architecture that ordinary people
> recognize as being architecture, where buildings are not only
> beautifully finished and nobly proportioned but articulated,
> ornamented and expressed. In other words it is classicism. It is
> an architecture of rules and and erudition. But unlike all the
> forms of Modernism and its descendants it is *instinctively*
> *recognized and understood* by ordinary people, having evolved as
> part of the *common* language of civilization over 3,000 years.[12]
> (italics mine)

These sentiments are echoed by archclassicist architect Quinlan Terry, who attributes this instantaneous, instinctive recognition of this common language of civilization to a higher power. The transcendence of classical style, according to Terry, is due to the simple fact that artistic talent, when put to classical ends, is "a creative gift given by God the Creator" and it is now being threatened by a godless technophilia conceived of in equally theological terms: "We are victims of a voracious technology, ruthlessly consuming the resources of the earth."[13] His appeal to the intrinsic transcendence of classical form as a manifestation of the spirit of another age (an *antique* spirit presented as *timeless* nonetheless) could hardly be more explicit:

So is our position today without hope? Are we of all men the
most miserable? By no means! As in theology, so in architecture,
there is always a remnant whose sights are fixed on another
world. And as we toil below through this uncertain earthly life,
we can at least attempt to recreate something of his creation...as
in theology, so in architecture, there is nothing new worth having.
As Solomon said 'the thing hath been is that which shall be, and
that which is done is that which shall be done and there is no
new thing (worth having) under the sun. Is there anything
whereof it may be said 'See this is new?' It hath already been
before us in old times' (Ecc 1/9). (p. xxiv)

Here the envisioning of the contemporary landscape that is saturated
in technology can be a relatively simple affair, provided one conceives of
that landscape as a recreation, or more precisely a manifestation of a
divine blueprint, and then factors out the godless clutter. As absolute as
this position may be, the rhetoric of the "other side" in this debate
depends upon a comparable foundational mythology which envisions the
relationship between design, technology and history in one interlocking
relationship. In his attack on the classicism advocated by the Prince
Charles, Richard Rogers (who is the foremost proponent of "High-Tech"
architecture) frames the evolution of architectural history in terms of
technological advances, arguing that many of the designs the classicists
hold as exemplary architecture—St. Paul's, Gothic cathedrals,
Renaissance palazzi—owe their greatness to the fact that "they embodied
new building techniques and distinctive architectural forms quite unlike
anything ever seen before."[14] The best Modern buildings "have celebrated
the technology with which they have been built," a value that should be
preeminent now more than ever, according to Rogers, since:

Today we are living through a period of enormous scientific and
technical advance; perhaps a second industrial revolution which
offers architects an extraordinary opportunity to evolve new
forms and materials. The computer, micro-chip, transputer, bio-
technology and solid state chemistry could lead to an enhanced

environment, including more rather than less control and fewer uniform spaces. The best buildings of the future, for example, will interact dynamically with the climate in order to better meet the user's needs. Closer to robots than to temples, these chameleon-like apparitions with their changing surfaces are forcing us to rethink the art of architecture. (p. 67)

Rogers laments the loss of a public realm, and concedes that "the great centres of civic life have become urban jungles where the profiteer and the vehicle rule," but he maintains an unbridled faith in high technology as the potential savior of all urban culture. Yet the binary choice implicitly offered here—temples or robots—suggests that Rogers considers the intrinsic values of a High-Tech form vocabulary to be every bit as transcendent as Terry's classical aesthetic. Prince Charles's question: "this is very much the age of the computer and the word processor, but why on earth do we have to be surrounded by buildings that look like machines?" could be just as easily asked of either side—why should buildings *have to* look like *either* temples *or* robots?

Both Terry and Rogers map their respective universes according to unitary principles which function like some sort of cultural DNA that they will into existence, forms which explain the genesis of all normal human activity against which all aberrations may be judged unnatural. Where Terry grounds his artistic theology on the firm conviction that there is nothing new under the sun (therefore classicism is "timeless"; see figure 1) Rogers's position would appear to be there is nothing good which is not a technological advance (therefore techno-futurism is timelessly timely; see figure 2). The peculiar temporality involved in this *Retro-Modernist classicism* will be discussed in greater detail in Chapter Four, but at this point Rogers' aesthetic is perhaps best described by David Hallett in his glowing appreciation of Rogers's body of work, which he feels exemplifies, "the Modern ethos...while the clothing may change, the spirit is timeless and of immutable relevance in the 20th century."[15] There is no better evidence that this taste-war boils down to a battle between *immutable relevancies* than the opposing plans put forth for the Mansion

House site in Cheapside—the classicists promoting revivalist designs in keeping with the Georgian and Victorian surroundings and the Neomodernists, led by Peter Palumbo, advocating what they felt was a truly contemporary structure in the form of a single, twenty-five-story glass tower originally conceived of by Mies van der Rohe for another site.[16] The relevance of the Mies design is taken for granted because it is imagined to be immutably contemporary, yet it functions more as a monument to Modernism than a vision of the future.

This monumentalization of Modernism as well as classicism is significant in and of itself because the monument represents the conflation of spatial and historical trajectories. The monument gives spatial dimensions to the transcendent historical moment; if only as a marker, it provides a reference point in both the physical and mythological landscape simultaneously. The deconstructionist architecture of Peter Eisenman is especially relevant in this context, because it represents another form of mapping (explicitly conceived of as such) which attempts to envision geographic and historical relations in a way that resists any such monumentalization. I have discussed Eisenman's aesthetics at length elsewhere[17] but here I will concentrate on what many consider his supreme achievement—the Wexner Center of Visual Arts at Ohio State University— which as museum space takes on the issue of monumentality very self-consciously (see figures 3 and 4). In his appreciation of the Wexner Center, Anthony Vidler argues that Eisenman's design is an exercise in "counter-monumentality" but, as such, it must confront public resistance; "How might the critical premises of counter-monumentality survive in the face of the human will to force meaning onto objects whatever the objections of their makers?"[18] Eisenman's design features elements that have traditionally signified monumentality but, in each case, that monumentality is "deconstructed"—the turret is broken in half and its strength undermined even further by glass panels that form its interior walls, the magnificent arch is likewise "interrupted" as well as sunken, and the elaborate gridwork that runs alongside the central "structure" is, according to the design statement, an attempt to suggest permanent "scaffolding," giving the entire site a sense of impermanence.

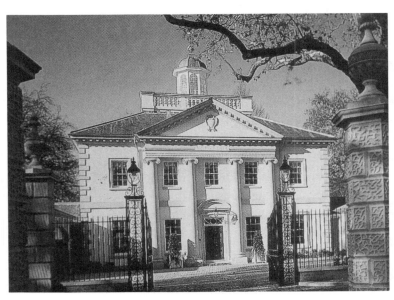

Figure 1: Terry, *The Ionic Villa*

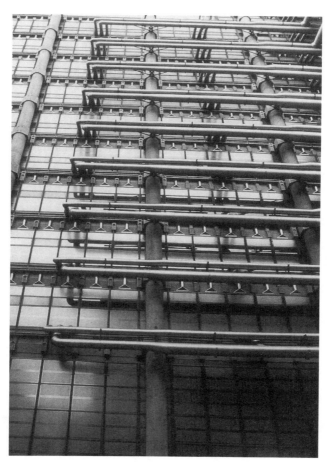

Figure 2: Rogers, *Lloyd's Headquarters*

Vidler considers this gridwork to be the most significant aspect of the design because it functions neither as an instrumental grid (as used in the drafting of a building) nor as a structural one (as in the abstract "essence" of architecture). He insists that:

> the Wexner grid stands as the merciless demonstration, as it were, of conflict in the mapping of the real, while it definitively rejects any essentialist message with regard to the structural or spatial nature of architecture...the grid seems to hover between the infinite and the bounded, ambiguous and refusing all narratives of a single point of origin.... The conceptual field is thus composed of so many possible human errors of mapping, and is no longer a "universal" in the transcendental sense offered by classicism or modernism...behind the Eisenman/Trott grids lie the ruins of modernist grids, ruins that are by no means suppressed like a trauma, but that are brought into the light of their own contradictions (p. 35–36).... Reading Eisenman's schizophrenic grids in this light, we might be tempted to see the conflation of conflicting fragments, evidence of a deliberate evocation of a schizographic condition (inherent in the world more than in the author) that works with the methods of a paranoiac in order to reveal a "real" disturbingly disturbed. (p. 37)

But in offering Eisenman's grids as an alternative to the transcendental mapping practiced by classicists and Modernists, Vidler's own reading of the Wexner Center presents only another binary opposition—single point or schizophrenic mapping—with both options under the control of the architect and the critic who understands his intentions correctly. His reading is narrative presented from a "single point" which is universalized as the experience of the site anyone should have. For all of his references to Bataille and Lacan, the notion of signification that floats through Vidler's argument seems remarkably old-fashioned. Despite Eisenman's rejection of the certainties of the monument, he is still imagined to have absolute control over the viewer's response to the center—the visitor must necessarily experience some sort of schizo-

phrenic panic in these Modernist ruins because Eisenman has willed so through his decentered mapping. The notion that the author's intentions necessarily determine the viewers' reactions has been widely disputed by poststructuralist theoreticians who have argued for the polysemic nature of signs, but there appear to be two kinds of polysemia—one willed into existence by brave avant-gardists and the other the inevitable result of a sign taking on different meanings as it circulates. The former merely perpetuates the High Modernist/Late Romantic mythology of artistic genius as singular *invention*, but the latter involves a fundamentally different conception of how meaning is produced, one which considers the multiplicity of meanings that any structure might generate, a multiplicity that includes the mappings that users of the center produce, as well as those of its designer.

In suggesting that Eisenman's gridwork "thwarts" attempts to make sense of it according to the decoding strategies employed by visitors to the center, Vidler seems intent on preserving only the more manageable form of polysemia; that is, the one safely in the hands of artists who have read their Lacan and know a good paranoiac panic when they see one. What of those visitors to the site who fail to experience this panic, those students at Ohio State, for example, who see not the ruins of Modernism, but a temple of experimental art, a structure they take great pride in as example of how "cutting-edge" a Midwestern state university can be when it wants to make a bold statement about its commitment to contemporary art?

The Wexner Center is not mapped from a single point; it is a complicated piece of architecture but what makes it an especially complicated *text* is its nature as a public institution which offers a number of different decoding strategies simultaneously. I'm referring here not just to the design statement, the critical essays in the books about the center displayed so prominently, or the guided tours, offered daily, that promise to explain "why the Wexner Center looks the way it does." I'm referring to all the ways in which visitors are encouraged to treat the center as a *monument* to experimental art throughout the twentieth century, from its placement in a university campus arts complex, to the bookstore at *its*

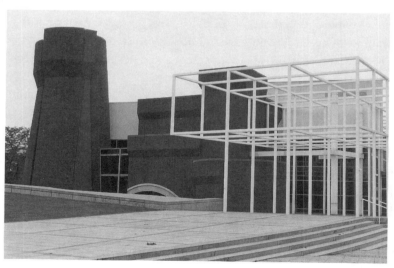

Figure 3: Eisenman, *Wexner Center*

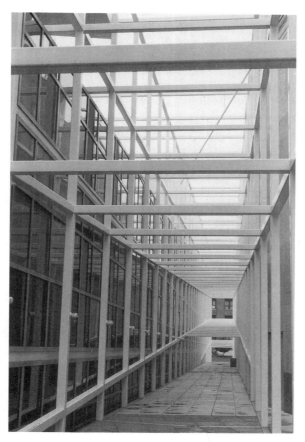

Figure 4: Eisenman, *Wexner Center (detail)*

center where visitors encounter the "art books" about the Wexner along-side other "art books," all devoted exclusively to the great European avant-gardes, along with T-shirts featuring more of the avant-garde's greatest hits, most especially Russian Constructivism. As a design concept, the Wexner may indeed attempt to induce a schizophrenic panic of one sort or another as Modernist ruin, but as a dynamic text which becomes the intersection of multiple mappings, it also encourages visitors to regard it as a Modernist shrine—just as Canton, Ohio has its Professional Football Hall of Fame, Columbus has a Professional Avant-Garde Hall of Fame, complete with the appropriate T-shirts. To return to Vidler's question: How might counter-monumentality survive in the face of, oh, horrors! the human will to force meaning onto objects whatever the objections of their makers? The answer would seem to be, it can't...unless you're in the right critical theme park. This counter-monumentality that would thwart individual attempts to project the *wrong* sort of meanings depends upon the successful elimination of any historical resonances, making counter-monumentality an atemporality. In his interview/debate with Eisenman,[19] Jencks pinpoints the problem with the ahistoricism implicit in Eisenman's obsession with "present-ness"—Eisenman may claim to be refusing to engage in nostalgia, but he also refuses to consider the validity of the need to maintain cultural memory. Very tellingly, Eisenman responds, "I am not against memory as a tissue of forgetting" (p. 54). But if counter-monumental design is a tissue of forgetting, is it still a form of cultural mapping, or a theoretical game played out in terms of architectural geometry?

Taking Time: English Music and Afro-Baroque Blues

The persistence of the desire to monumentalize suggests the insufficiency of exclusively spatial metaphors to describe the process of making sense of one's cultural terrain, that "mapping" in the context of self-location is inseparable from "narrating." This narrativization inevitably introduces historical dimensions, whether those histories are framed in reference to racial, institutional or national traditions, long established or invented ad hoc. The notion that contemporary cultures can be mapped most suc-

cessfully according to different forms of *cultural DNA* depends on the historicity of certain structural forms so thoroughly encrusted with cultural associations that they may be presented as natural, intrinsic and/or transcendent. In this section I will focus on those texts that have grounded the activity of self-location primarily in the terrain of cultural memory, and will envision that "DNA" in divergent, even contradictory ways. Given the enormous number of subcultural histories that have appeared within recent years, from memoires, autobiographies and oral histories, to films, television miniseries, and best-sellers, any kind of comprehensive study of the various forms this historizing has taken is well beyond the scope of this book. Here I will concentrate on works that exemplify representative strategies for developing a coherent sense of self-location in the present through a critical revaluation of how a common national and/racial heritage has already been institutionalized.

In his Afterword to *Dead Certainties*, Simon Schama begins his discussion of the difficulties involved in recovering the past by quoting Henry James's *The Sense of the Past*, in which the young historian Ralph Rendrel says, "recovering the lost was at all events...much like entering the enemies lines to get back one's dead for burial."[20] Schama argues that this passage epitomizes the "habitually insoluble quandary of the historian; how to live in two worlds at once; how to take the broken, mutilated remains of something or someone from the 'enemy lines' of the documented past and restore it to life or give it a decent interment in our own time and place." While Schama's quandary is presented in terms of the habitual dilemma that faces all historians, the popular history-writing that comes from the margins of contemporary cultures involves crossing "enemy lines" in more than a general, metahistorical sense. In their attempts to envision the complicated, hybridized dimensions of ethnicity in a postmodern context, writers such as Amy Tan, Trey Ellis, George Wolf, Louise Alvarez, Maxine Hong Kingston and Frank Chin, and visual artists like Spike Lee, Julie Dash, Wayne Wang and Lorna Simpson all construct elaborate ethnic/racial histories that attempt to explain the evolution of those identities. Their explanatory power depends on the crossing of a number of enemy lines—mainstream history-writing in all

its various guises, from textbooks to Hollywood films (all of which mar-
ginalize or eliminate other histories), as well as earlier racial histories
whose essentialism is often deemed equally pernicious.

The attempt to recover lost histories that will legitimate, emancipate
or just disambiguate the present is not restricted to subcultural writers,
rappers and filmmakers, nor is hybridity necessarily the dominant trope
for historical recovery.[21] Within contemporary British fiction-writing and
architecture, there have been a number of concentrated efforts to recon-
struct a lost *national* ethos, an ethos allegedly lost in the current rewritings
of history that privilege gender, race and class difference. Peter Ackroyd's
novel, *English Music* ,[22] is a paradigmatic example of this desire to ground
contemporary identity in reference to a lost tradition that must be
regained, now that Englishness seems hopelessly lost in the multicultur-
al array of contemporary Britain. The stakes of his recovery project are
in some ways remarkably similar to those of the "multiculturalists" (that
is, making critical selections of past texts the basis for a tradition that pro-
vides a sense of location in the present) but the "use value" that Ackroyd
attributes to history reflects a radically different ideological agenda for
mapping the present through the past.

The main characters of *English Music* are a father and son, Clement and
Timothy Harcombe. The former is a "medium and healer," and the lat-
ter likewise has special powers, specifically the ability to travel across time
into the worlds of famous British novels, poems and paintings. These
visions are inspired by his father's attempts to give him a sense of his cul-
tural heritage, accomplished primarily by reading to him each night from
his favorite books and discussing:

> what he used to call "English music," by which he meant not only
> music itself, but also English history, English literature, and
> English painting. With him one subject always led to another, and
> he would break off from a discussion of William Byrd or Henry
> Purcell in order to tell me about Tennyson and Browning; he
> would turn from the work of Samuel Johnson to the painting of
> Thomas Gainsborough, from pavans and galliards to odes and

sonnets, from the London of Daniel Defoe to the London of Charles Dickens. (p. 21)

This education always involves learning key words, the first of which happens to be "palimpsest," (p. 12) and key images, the first of which is an illustration in their edition of *Pilgrim's Progress* that becomes for young Timothy "a true image of life." It features the pilgrim "with a book in his hand and a burden on his back. *That* is what I saw. Where others may have noticed only the wanderer himself, I recognized the book and the burden which he carried with him everywhere" (p. 18).

While the intertextual infrastructure of Ackroyd's novel is as elaborate as *The Name of the Rose*, the intertextuality of the latter constitutes a frontal attack on cultural hierarchies, whereas the intertexuality of *English Music* serves as the basis of an extended exercise in cultural restoration, resulting in a bizarre amalgamation of Umberto Eco and Allan Bloom. Ackroyd begins the novel with a quotation from Joshua Reynolds, which sounds decidedly protopostmodern. "Invention, strictly speaking, is little more than a new combination of those images which have been previously gathered and deposited in the memory: nothing can come of nothing." Yet the process of reworking memory in this case could hardly be more conservative, in the most literal sense of the term. Through his intertextual travels Timothy discovers a "secret inheritance" that one generation passes on to the next, but without any sort of Oedipal struggle. As he moves from the fictional universe of *Great Expectations*, to *Robinson Crusoe*, to the paintings of Gainsborough, to his personal encounters with Hogarth and Byrd, Timothy begins to discern the hidden English genius, the music of the English imagination. When he talks with the "man of the island" (a.k.a. Robinson Crusoe/Defoe), he is told:

> Never forget these books, and out of them you may build your own barricade against sorrow.... But think not where you are or where you may go, since, with these books, you are in England, everywhere and under any meridian.... The treasures of time be all around us here, and we need no map to discover them.' He

reached up and held out a broad leaf of deep green, although he
did not pluck it from its parent tree. 'It is always the same, and
yet it must always be renewed, it is the same, and not the same.
So this island is continually being recreated in other men's words
while its identity can never change.' (pp. 170–71)

Cultural identity becomes a matter of discovering this hidden music,
which Ackroyd describes in metaphors that repeatedly stress the "natur-
al" as well as mythic quality of that music. The music is always there and
can be envisioned as a totality, but only by the English geniuses: "Defoe
hit upon a shadowed and hieroglyphical lesson of the whole world."
Timothy need only learn to listen to what is always there, a point made
quite explicitly in the Blake chapter,

Blake heard the music of the generations interlinked,
The father reaching for the son, the son calling to the father,
Their sighs and tears intermingled so they seem as one:
To touch each other and recede, to cross and change and return
In the intricate image of the chance which is also music.
The son resting on the words of the father in eternity,
The father guided by the son throughout eternity.

And now this verse has come, rejoicing in English music,
For the poets have fashioned a melodic line to express
The forms of English imagination through the centuries.
All things begin and end on Albion's ancient Druid rocky shore.

Awake, awake Albion! O lovely emanation of music,
Awake and overspread the nation as in ancient time;
For lo! the night of death is past and the eternal day
Appears above our cities and fields. Awake Albion!
Timothy heard these songs and voices echoing around him;
And he understood their name: they are named England.
(pp. 358–59)

While Ackroyd's notion of cultural heritage could hardly be more conservative, *English Music* is as much an architecture of excess as *Neuromancer* or digital hip-hop. Ackroyd accesses the past and re-organizes it in an elaborate intertextual structure as a response to the excess of the later twentieth century, but also as a rejection of it in the pursuit of lost purity, a lost oneness and totality that may form a protective barrier as transcendent as that genius. Ackroyd's sophisticated intertextual play yields the hidden harmony behind all that cultural noise, a lost melody that, once recovered, will retune the stars, if only over England. In so doing, he appeals to a foundational myth in the truest sense of the term. While his position may not be that different from Matthew Arnold's or Allan Bloom's, his legitimation of a canonical body of texts as transcendent depends on an appeal to the mythic, a point that becomes most obvious when Timothy finally meets Merlin, who hands him a:

> book marvelously wrought. 'This is the very emblem of your her
> itage,' said he. 'Take this book and throw it into the water as far
> as you might.' He did as he was enjoined, and there came an arm
> and a hand above the water of Albion, and took it and clutched it,
> and then vanished with the book into the water. (p. 389)

The determination to recover a once and future archetypal purity that is handed down from father to son is predicated on the denial of any sort of cultural difference within the transcendent category of English genius. Tim's intertextual travels lead him throughout dozens of novels and paintings, but not once does he enter a diegetic universe created by a woman or person of color. Neither the Brontës, Austen, or Woolf, to cite a few obvious candidates, appear in this Great Tradition; they remain on the other side of the barricade, seemingly incapable of providing the hieroglyphic lesson of the *whole world*, none possessing the English genius which can envision Albion in all its totality.

Yet the foregrounding of the father-son relationship as the means of transmission of cultural heritage does not necessarily preclude the recognition of difference or contingency. Charles Johnson's *Middle Passage*[23] makes the meeting between father and son the pivotal scene in the nar-

rative, the moment when the son finally realizes the nature of his racial
identity. But that scene of recognition, while in some ways remarkably
similar to the mythic apotheosis of the last chapter of *English Music*, is also
a thoroughgoing rejection of the transcendent purity of Ackroyd's novel.
The narrator, Rutherford Calhoun, a freed slave who mistakenly stows
away on a slave ship, comes face to face with the captured "African god"
held in the ship's hold:

> It stood before me mute as a mountain, preferring not to speak, I
> suspected, because to say anything was to fall short of ever say-
> ing enough.... I came within a hair's-breadth of collapsing, for the
> god, or devil, had dressed itself in the flesh of my father. That is
> what I mostly saw, and for the life of me, I could no more sepa-
> rate the two, deserting father and divine monster, than I could sort
> wave from sea. Nor something more phantasmal that forever con-
> fused lineage as a marginalized American colored man. To wit,
> his gradual enfoldment before me, *a seriality of images* I could not
> stare at straight on, but only take in furtive glimpses, because the
> god, like a griot asked one item from tribal history, which he
> could only recite by reeling forth the entire story of his people,
> could not bring forth this one man's life without delivering as well
> the complete content of the antecedent universe to which my
> father, as a single thread, belonged. (pp. 168–169, italics mine)

The emphasis on seriality here epitomizes Johnson's notion of historical
tradition as a dynamic, evolutionary project which envisions subjectivi-
ty neither as transcendent essence, nor as random fragmentation, but as a
heterogeneous continuity. During his meeting with the god, Rutherford
remembers his "real" father, and describes him first as "an Eternal Object,
pure essence," in his memory, but then he hears in this creature's breath-
ing:

> a thousand soft undervoices that jumped my jangling sense from
> the last, weakly syllabled wind to a mosaic of voices within voic-
> es...this deity from the dim beginnings of the black past, folded

my father back into the broader shifting field—as waves vanish
into water—his breathing blurred in a dissolution of sounds and I
could only feel that identity was imagined; I had to listen to isolate
him from the We that swelled each particle and pore of him, as if
the (black) self was the greatest of all fictions. He seemed every-
where, his presence, and that of countless others, in me as well as
the chamber, which had subtly changed. Suddenly I knew the
god's name: Rutherford. (p. 171)

This confrontation could hardly be framed in more mythical terms,
and the kinship between father and son seems every bit as mystically
intense as that between Clement and Tim in *English Music*. One could also
argue that in both cases a national or racial "We" persists across the cen-
turies, but where each English genius is merely another leaf on the exact
same tree, Rutherford's mosaic of voices are an ever-shifting chorus. This
point is made particularly clear in Rutherford's changing impression of
the Almuseri tribespeople, whom the slavers have kidnapped. His initial
perspective is essentialist: "a clan distilled from the essence of everything
that came earlier. Put another way, they might be the Ur-tribe of human-
ity itself. I'd never seen anyone like them. Or felt such ambiguity in the
presence of others; a clan of Spaeriker" (p. 61). Later in the voyage he real-
izes his mistake:

Stupidly, I had seen their lives and culture as timeless product, as
a finished thing, pure essence or a Parmenidean meaning I envied
and wanted to embrace, when the truth was that they were
process and Heraclitean change, like any men, not fixed but
evolving…. Ngonyama and maybe all the Africans, I realized,
were not wholly Almuseri anymore. We had changed them…. No
longer Africans, yet not Americans either. Then what? And of
what were they now capable? (p. 124)

Rutherford himself realizes at the end of the novel that identity should
be conceived of as a process. "The voyage had irreversibly changed my
seeing, made of me a cultural mongrel, and transformed the world into a
fleeting shadow play I felt no need to possess or dominate, only appreciate

in the over-extended present" (187).

A sense of historical location within postmodern cultures depends on the complicated interplay of a *seriality* which can provide continuity with the past defined in terms of racial heritage, and a *mongrelization* that necessitates an ad hoc construction of identity in reference to a radically discontinuous present. The photographs of Lorna Simpson are paradigmatic examples of this highly productive tension between seriality and eclecticism. Simpson's photographs and installations envision the continuity of a shared history, but that heritage is not a transcendent essence always already there, thoroughly articulated, waiting only to be rediscovered, as in *English Music*. Simpson's work purposely frustrates any presumption of any archetypal African-American subjugated self through serial compositions which emphasize two complex points regarding historical tradition: 1) that any sense of historical continuity or tradition is something that is constructed in the present, rather than some sort of mystical DNA that is always there, waiting to appear; 2) that the construction of a meaningful sense of historical self-location must be done in the present in which aspects of the African-American physiognomy are mass-mediated, "floating" signifiers that defy the monolithic sense of racial heritage.

Simpson's own meditation on the Middle Passage, a site-specific installation entitled *Five Rooms* (1991), exemplifies the complicated interplay of seriality and eclecticism involved in the process of historical self-location. Commissioned by the Spoleto Festival in Charleston, South Carolina, in 1991, Simpson's installation was housed in a former slave quarters, built in 1822, and each room represents a period or aspect in the history of slavery—for instance, the Middle Passage, slave revolts, lynching, the rice market as justification for slave trade. In one room Simpson installed glass jugs filled with different varieties of rice, labeled with the names of slave ships, the African countries from which they departed, the African rivers that formed part of the Middle Passage route, and the number of Africans on those ships. Placed on the wall behind those jugs are four Polaroid prints, those on each end featuring the heads of black women (turned away from the camera, one wearing

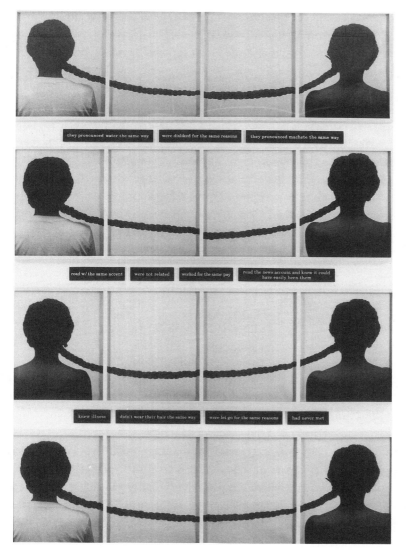

Figure 5: Simpson, *Same*

a T-shirt, the other nude), the middle panels containing only the long interwoven braid that connects them. These panels are quadrupled in *Same* (1991) and captions are added to a more elaborate series of images (see figure 5). The phrases between each panel emphasize the visual contradiction of the images themselves—the explicit attempt to visualize connection, but also distance, a sense of physical affiliation that apparently cross-cuts the frame lines of individual images, while simultaneously the frame lines frustrate or fragment that bond. The phrases come in three sequences: they pronounced water the same way—were disliked for the same reasons—they pronounced machete the same way; read with the same accent—were not related—worked for the same pay—read the news account and knew it could have easily been them; knew illness—didn't wear their hair the same way—were let go for the same reasons—had never met. This seriality that stresses connection and difference simultaneously envisions the commonality of heritage as a complicated process, not a submerged "given." As Saidiya Hartman says in her compelling analysis of Simpson's work:

> By engaging identity in terms of sameness—the favored theme of essentialist discourses of race and gender—it too runs the risk of homogenizing blackness. However, it also avoids this by engaging identity as constructed and lived experience…. Simpson incorporates difference in forging a narrative of identity. Sameness in these terms is fundamentally about one's social position, not one's skin.[24] (p. 66)

The constructed nature of a common heritage is precisely the opposite of the sentimentalized sense of "family tradition" which is prevalent now, even in advertising images. One brief example should suffice to throw into sharp relief the differences between the comlex ways in which Johnson and Simpson represent social continuity and the other less sophisticated ways that heritage is envisioned in reference to African-Americans. One could of course offer any number of choices here—several episodes of *The Cosby Show* featured the younger generation learning about the history of black culture from their grandparents and

weekly guest stars. But an advertisement for Nuveen Investments that appeared in *The Atlantic* (July 1993) is particularly useful, because the ad makes racial heritage the basis of its appeal to a black, middle-class consumer. The ad is a four-page spread, shot in gauzy black and white images that are obviously intended to seem like antique images from a family photo album (provided, of course, that one of the family was an African-American David Hamilton). The first two pages form one broad image, an African-American daughter and father beneath a spreading live oak covered with Spanish moss. Off to the right, the same couple walk hand in hand through the idyllic Old South. The copy reads, "The tree was like his family journal. His great-great-grandfather, or so the story went, planted it. His mother played in it. And now his daughter was about to get married under it. As a child he'd wondered if the tree held them together. But he knew now it was something far greater than that. The human bond." The third page is a still gauzier, even more picturesque portrait of daughter and father beneath the tree, with the fourth showing them embracing in medium close-up, with the following copy superimposed over all this family heritage. "At John Nuveen and Company, where our tax-free municipal bonds have helped people live their dreams for nearly one hundred years, we still believe our strongest bond is human." Here the commonality is unproblematic because it is "natural," as natural as generational bonding (like father-daughter) and in the tree of life on which each generation is merely, echoing Ackroyd's vision, another leaf, only this "human bond" is an explicitly registered trademark.

The point of this comparison is not just that Simpson's envisioning of racial bonding that crosscuts centuries and continents is far more complex than the "natural" generational connections imagined by the advertisement; as smarmy as the ad may be, it does reflect an all-pervasive desire to locate oneself historically, a need to self-situate through a temporal sense of location that spatial location alone may no longer provide. Most importantly, the ramifications of a remembered past in the Old South as the foundation of African-American cultural heritage are not restricted to investment firm imagery. The reification of a shared her-

itage that provides a sense of location which has become far too fixed and self-limiting serves as the primary target of Trey Ellis's novel, *Platitudes* [25] and George Wolfe's play, *The Colored Museum*.[26] Both are examples of what Ellis has called the "New Black Aesthetic,"[27] an aesthetic which emerged in the late eighties as a reaction to the ossification of African-American cultural heritage by a number of writers who seem unable to do what Simpson's photographs do, namely, consider the nature of continuity in reference to dissonant media-sophisticated cultures of the present.

According to Ellis, the New Black Aesthetic is a reaction against the stultifying effects of the traditions of African-American culture that have been formulated along highly essentialist lines. To return to James's metaphor of crossing enemy lines, the recovery of the African-American past now means crossing two different lines, one formed by white American historians (official and unofficial), the other formed by African-American scholars and artists who, in attempting to recover and consolidate black cultural traditions, have so privileged continuity that they are now unable to confront the complexity of the postmodern present. Ellis argues, "It is by and large a rapidly growing group of cultural mulattoes that fuels the New Black Aesthetic. We no longer need to deny or suppress any part of our culture or our complicated and sometimes contradictory cultural baggage to please either white people or black."(p. 235) In *Platitudes* he uses two narrators to construct a series of antagonistic, dialogic relationships between essentialist and anti-essentialist voices that throw into question the virtues and limitations of both continuity and eclecticism. The two narrators are DeWayne Wellington, a fading black experimental novelist, and Isshee Ayam, a best-selling feminist author of national prominence. They each tell their own version of the story of Earle and Dorothy, two black teenagers living in present-day New York City. DeWayne instigates this dual creation process by sending Isshee a sample of his novel, but she is appalled by his "defiling the temple of black literature." She attacks what she considers his vulgarity and, worse yet, his failure to sufficiently emphasize the characters' blackness. She responds by re-writing the story of Earle and Dorothy in her own style, shifting the action from contemporary Upper Manhattan to the rural

segregated South, where Earle and Dorothy no longer worry about word processors and college entrance exams. Isshee's version demonizes all black males as whoring, shiftless alcoholics, and canonizes the black earth mother in the following way:

> Yes, from out of those wide Baptist thighs, thighs that shook with centuries of injustice and degradation, thighs that twitched with the hope of generations yet unplanted, thighs that quivered with the friction of jubilant bed-thumping and funky-smelling lovemaking, emerged Earle. (p. 16)

Earle's father is written off as a "disgrace" who "slouched North to the land of gambling, drinking, and 'fine light women'," while Earle's mother is consistently portrayed as a "fierce lioness," "the Nubian Queen," whose voice is "as deep and as rich as the Mississippi silt into which, she firmly believed, God had once breathed," and whose bosom swells "like the sea of Galilee." DeWayne responds to this rewriting by saying, "I'm speechless, Ms. Ayam. How can I thank you for dragging my meager tale back to its roots in Afro-American glory tales?" (p.19).

George Wolfe parodies this same tendency toward the canonization of African-American glory tales in *The Colored Museum* (1987). Like Ellis, he introduces a dissonant mixture of voices to articulate alternative ways of reconceptualizing the history of African-American culture that creates a far more dynamic relationship to the problem of self-location in the present. *The Colored Museum* consists of a series of short scenes, called Exhibits, played in a museum set "where the myths and madness of black/Negro/colored Americans are stored." His most explicit attack on the "glory-tale" tradition is "The Last Mama on the Couch Play," which is presented in Masterpiece Theater style, complete with pompous intellectual host. The play parodies the canonization of plays like *Raisin in the Sun,* and Wolfe's host/narrator introduces a cast of black stereotypes.

> Lights up on a dreary, depressing, but middle-class-aspirations tenement slum. There is a couch with Mama on it. Both are well-

worn.... Enter Walter-Lee-Beau-Willie Jones. He is Mama's thirty-year-old son. His brow is heavy from three hundred years of oppression. His wife, The Lady in Plaid, enters saying, "She was a creature of regal beauty, who in ancient times graced the temples of the Nile with her womanliness. But here she was, stuck being colored and a woman in a world that valued neither.

After a few exchanges and (according to the stage directions) grotesque overacting, Walter is shot by "the Man," at which point Mama says, over the body of her son, "My son, he was a good boy. Confused. Angry. Just like his father. And his father's father. And his father's father's father." Here Wolfe parodies the continuity of the generational bond by stressing the static rather than serial nature of that heritage, so static that it precludes variation or evolution. At this point, the Exhibit shifts genres, when Mama continues, "If only he had been born into a world better than this. A world where there are no well-worn couches and well-worn Mamas and nobody over-emotes. If only he had been born into an all-black musical. Nobody ever dies in an all-black musical." Walter revives and a "foot-stomping, hand-clapping production takes off, which encompasses a myriad of black Broadway dancing styles" (p.31).

While Wolfe critiques the stereotypical dimensions of black history as it enters the "museum" of official culture, at no point does he advocate the abandonment of racial history, only the fetishization which renders it so static that it precludes even the possibility of a productive sense of historical self-location in the present. In another of the exhibits, "Symbiosis," two characters, the Black Man in corporate dress, and the Kid, dressed in late-sixties street style, debate the use of the past. The scene begins with the former throwing objects into a trash can from a Saks Fifth Avenue bag. "My first pair of Converse All-Stars. Gone. My first Afro comb. Gone. My first dashiki. Gone..." He continues this litany until the Kid stops him and tells him that "The Kid is here to stay." They grapple as the Man first struggles and then throws the Kid into the trash can, saying, "Man kills his own rage. Film at Eleven. I have no history. I have no past. I can't. It's too much.... Being black is too emotionally taxing; there-

fore I will be black on weekends and holidays." But the inability to discard history is driven home at the conclusion of the scene, when the Kid pops back out of the can "with a death grip" on the Man's arm. The intensely ambivalent, highly conflicted, generational tension is complicated here by the specific historical periods involved; father of the eighties tries to kill his "son," but that "son" is the former self, the Kid of the sixties, serving as the father to the Black Man of the eighties.

This generational tension, expressed in terms of a complicated historical reversal of the traditional Oedipal scenario, demonstrates the complexity of contemporary attempts to situate oneself in reference to historical coordinates, since temporal location is always contingent upon motivations which complicate the process of "fixing" that sense of location. While Ackroyd's father-son relationship may be considered anti-Oedipal in its determination to characterize that relationship in terms of glorious intergenerational bonding, the generational tensions at work in *The Colored Museum* suggest yet another dynamic, an ambivalent Oedipal struggle in which intergenerational relationships are alternately cemented or trashed. *The Colored Museum* ends in a "vocal and visual cacophony" in which characters from the various Exhibits all speak simultaneously, ending with Topsy:

TOPSY: THERE'S MADNESS IN ME AND THAT MADNESS SETS ME FREE. My power is in my—
EVERYBODY: Madness!
TOPSY: and my colored contradictions. (p.53)

Ellis and Simpson also emphasize cacophonous articulations of a common heritage that are presented as the "essence" of African-American culture in the late eighties and nineties. In *Platitudes*, Ellis rejects the glory-tale essentialism through a series of his own wildly eclectic set pieces that feature either Earle or DeWayne successfully manipulating information technologies, from a rapid-fire montage of television images generated by the magic wand of a remote control to his own modified version of the Preliminary Scholastic Aptitude Test.

Throughout the novel, Ellis foregrounds word processor technology, playing with fonts and page formats in order to expose the thoroughly codified, highly discursified nature of the messages that surround his characters. In the PSAT exam, the arbitrariness of the categorization and transmission of information is brilliantly exposed, as the information requested comes from outside the confines of a PSAT exam, but the format is sustained nonetheless.

In the Reading Comprehension section, one short story passage concerns a Georgia church deacon who decides to contest Jim Crow laws by organizing a boycott of local merchants, and who ends up not only changing the store's policies, but also winning a Cadillac in "the Chamber of Commerce's First Annual Negro Car Lottery!" This selection is followed by questions like these:

> 3. The most precise title for this passage is
> a. Glory! One Chapter in the Struggle
> b. The Deacon's New Car
> c. Shameless: The Buying of Deacon
> d. Free at Last: "I Won't Be Takin' No Bus No Mo'!"
>
> 4. In line 17 "integrated" means
> a. your daughter can now marry anyone
> b. improved
> c. Afro-Americans have no more excuses
> d. all of the above (p.71)

In another passage, DeWayne parodies Isshee's African-American glory tale style directly. The story here concerns the successful black novelist Little Eehssi Robinson's return to her Southern roots. She pulls up to her mother's home in her sports car,

> He-llo, Ma-ma," enunciated the jubilant writer. "I am absolutely fatigued after such a long journey...Oh, and, Mama,'fatigued' means tired."
> Mama, her nostrils flaring like a holy god's chariot-pulling

mare, her heavy, joyous bosom rising and falling with every pro-
found breath of that sweet Georgia wind, her legs as strong and
stout as the mighty Georgia pines, exuberantly hoisted that heavy
iron skillet over her kerchief-covered head, the skillet from which
she had fried the eggs and bacon and ham and apples and corn-
bread, and had cooked the grits and greens and black-eyed peas
and chit'lin's and okra for her thirty healthy children, and she
swung that skillet down with a quickness far beyond her seventy
years onto the hot-combed hair of her youngest daughter, Eehssi,
killing the child with a *clonk.*
 "Fatigued my ass."

11.How would you describe the style of this passage?
a. neo-classical
b. postmodern
c. Afro-Baroque
d. mock Afro-Baroque (p. 75)

The exam becomes a microcosm of the collisions between black and
white culture, as well as between different black cultures, as the discur-
sive enclosures of both the standardized test and the African-American
glory-tale are undermined by the introduction of inappropriate material.

Reality is *Not* Real Estate: Figurative Mapping and Speculative Subjectivity

In this final section I want to concentrate on works that reenvision phys-
ical and historical landscapes in reference to symbolic paradigms that
become the figurative coordinates of a meaningful sense of self-location.
The process of substituting alternative paradigms begins with the con-
tention that mappable geographies and calendrical time are merely
arbitrary reference points that have lost their efficacy, but that experience
can nevertheless be rendered legible by attempting to fix the forces that
shape its permutations. Rather than adopting a nihilistic position that
insists on the unmappable nature of a culture where traditional temporal
and spatial distinctions are no longer applicable, the texts that exemplify

this symbolic or figurative mapping of contemporary cultures are enormous in scope.

The basis of these figurative mappings appears relatively simple — the successful envisioning of any sort of spatial or temporal location is tied directly to a complete reconceptualization of subjectivity. In his perceptive discussion of urban theory, entitled "Oublier La Città,"[28] Donald Preziosi recognizes the crucial link between physical form and subjectivity:

> Questions of the city (or of the built environment as such) are irresolvable apart from considerations of the constitution of the subject.... For if it is the case that the power of the city consists in the fact that it is made up out of the same materials as our subjecthood, the latter being fabricated out of the materials of the former, then the only cogent answer would be an appeal to an as yet not fully articulated commonality of historiographic and psychoanalytic attention. (p. 264)

This dual consideration would open a "space of interpretive activity and critique," a space that would be a "projective topology of coimplicative relations of the Real, the Symbolic, and the Imaginary" (p. 265).

In order to elaborate on this important point, I want to discuss three representative texts: the buildings of Shin Takamatsu (1985–1992), Jeanette Winterson's *Sexing the Cherry*[29] and Steve Erickson's *Arc d'X*[30]—all of which try to reconceptualize the process of self-location by re-enfiguring the relationships between history, geography and subjectivity. Clearly, the idea that space and time can be properly understood only as they are "psychologized" is hardly a new concept since any number of High Modernist texts, particularly *nouveaux romans* like Michel Butor's *L'emploi du temps*[31] or Robbe Grillet's *Les gommes*[32] made the descriptions of landscapes and the handling of time inseparable from character consciousness. But in Takamatsu, Winterson and Erickson, the refiguration of subjectivity vis-à-vis history and geography involves more than the subjectivization of time and space or the projection of individual psychology on landscape. Butor's narrator in *L'emploi du temps* keeps a diary in order to make use of

time and, in the process, make sense of the foreign city in which he finds himself, but the project remains intensely individual, of little or no use in reference to anyone else's psychic agenda. The distinguishing feature of the more recent texts is their determination to move beyond the self-consciously limited scope of the Modernist pathetic fallacy and to situate the mutual refiguration of subjectivity, space and time within the more expansive categories of national and sexual identity.

The work of Takamatsu, Winterson and Erickson does not form a school or "ism," but they do share certain stylistic and thematic interests that indicate a significant development in the envisioning of contemporary cultures. All three insist upon the primacy of psychic structures whose discovery is contingent upon the rejection of traditional categories of time and space. More specifically, in each case, penetrating insight depends upon the purposeful undermining of distinctions between the historical and the futuristic—if there is any continuity, it exists only in reference to overtly symbolic trajectories.

In his introduction to Takamatsu's work, Ruchi Miyake argues that for this architect:

> the structure of a city is not a matter of physical form or social organization; the structure has to do with the visions that are assembled there, with matters of density or intensity. He sees the city intuitively, though his intuitions resemble those of a psychiatrist more than those of an architect.... His interest is drawn not to the clear and easily described structure with which the city is endowed, but to the city's "thickly viscous" aura.... It is a bit difficult to say exactly what that aura consists of, but he is undoubtedly looking for something like the sediment of human desire that has been disgorged and that has accumulated over time in the city.[33]

Making sense of that sediment, but also cutting through it, means developing what Takamatsu refers to as a "dual mentality." Discovering the hidden paradigms that animate physical structures is neither a matter of reconnecting with the continuity of a lost tradition, nor inventing bold

new forms to imagine a high-tech future, but both simultaneously. David Stewart contends that Takamatsu's method of composition is best understood in reference to *renga*, the dominant form of poetic composition in medieval Japan, in which the principal mode of organization was connection by motif of adjacent stanzas without any sort of narrative progression. But Stewart also sees the influence of Italian Futurism (especially F. T. Marinetti's manifestos) at work in the mechanical imagery of one of Takamatsu's best known buildings, *Ark* (1981; see figure 6)which he describes as "the Great Futurist Railroad brought to life."[34] Arguing along similar lines, Botond Bognar claims buildings such as *Ark*:

> apparently repudiate traditionalism, yet grow out of the remnants of the culture of Kyoto that is more than a thousand years old. They are non-sentimental or nostalgic, yet search for a forever lost and unattainable "kingdom," one with ordered signs and symbols and meanings that may make sense. This much is evident from Takamatsu's own words: "I am an old style architect, who is always dreaming of architecture as a monument, or as something with a symbolic presence."[35]

But what kind of symbolic presence do they evoke? Stewart sees futuristic locomotives, and Miyake interprets them as desiring celibate machines inspired by Takamatsu's admiration for Deleuze and Guattari's *Anti-Oedipe*.[35] While both readings are convincing, I would like to pursue another reading of the symbolism of Takamatsu's structures. In buildings like *Ark* (1981), *Origins III* (1985–1986), *Solaris* (1988–1990) and *Syntax* (1988–1990) (see figures 6–9), Takamatsu's bizarre combinations of traditional Japanese and a wide range of antique and avant-garde styles such as Italian futurism and Art Deco, as well as elements of High-Tech, symbolize more complicated messages, namely, that in the "city which has overflowed with information," those juxtapositions symbolize the breadth of this architecture of *access*, the transitional, transhistorical nature of the ruthlessly contemporary. Takamatsu is "convinced that the most important function demanded of this art is for a building to possess

the ability to reveal a duality of meaning, respecting the wealth of history, while at the same time being a part of the future."[37] The nature of the duality takes on an even more complicated form when structures like *Ark, Origins III, Solaris* and *Syntax,* through their incorporation of Futuristic and Art Deco features, envision imaginary futures that never came to pass, except in the highly imaginative designs of the twenties and thirties, which are now considered antique.

In a building like *Solaris*, alternate future coalesces with alternate history in a hybrid form, perhaps best described as Martian Art Deco. Takamatsu's designs are the architectural equivalent of "the Gernsbach continuum" described by William Gibson in the story of the same name.[38] In this story, the hero is a photographer working on an illustrated history of the streamlined Moderne style popular in the thirties, entitled "*The Airstream Futuropolis: The Tomorrow that Never Was.*" While shooting the photographs for the book, he begins to have hallucinations of this imaginary future that exists in a phantasmatic parallel realm. He's finally able to exorcise these semiotic ghosts, but Takamatsu's buildings give concrete forms to those ghosts, symbolizing the complicated nature of semiotic environments where antique futuropolises can now be realized and become part of the urban landscape of the nineties, where the tomorrow that never was, *is*. As such, they symbolize the thickness of sedimented envisionings of classical and futuristic, a conceptual space so always already mapped that any new maps must rechart the relationships between historical, spatial and psychic investment.

In *Syntax* (1988–1990), Takamatsu utilizes stylistic features associated with Art Deco, but this appropriation takes a very particular form that simultaneously appropriates and defies the stabilizing forces that historical quotations usually provide. Takamatsu invokes the streamlined moderne ocean liner, but instead of anchoring the structure in a specific context, the metaphoric quotation sets the building sailing through a complex semiotic environment of sedimented imaginaries. As Takamatsu describes it, "The building is a sea, a sea with no charts to navigate by" (*G A Architect*, p. 143). On this sea the different structural components are a "flotilla of variously elaborated elements drifting independently...a ver-

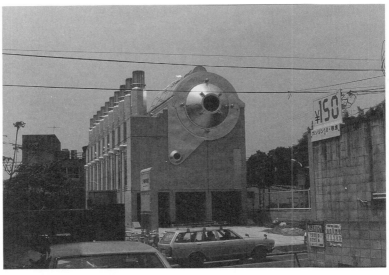

Figure 6: Takamatsu, *Ark*

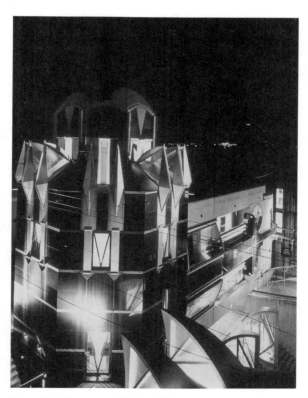

Figure 7: Takamatsu, *Origins III*

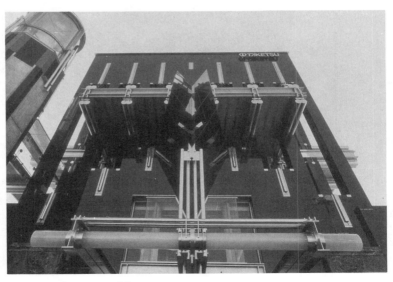

Figure 8: Takamatsu, *Solaris*

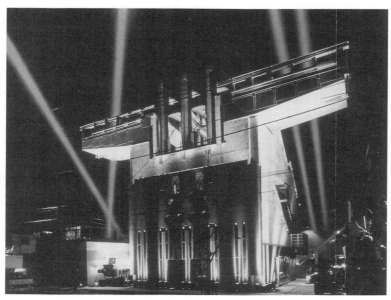

Figure 9: Takamatsu, *Syntax*

itable sea of quarks." This imaginary steamship composed of quarks (charged particles that are fundamental units of matter) is in many ways a *classical* design, given its symmetry, its ordered, proportional system of parts resulting in a "syntax" that suggests order but also perpetual fluctuation, as historical forms are subject to constant reinvestment with psychic desire.

Winterson's *Sexing the Cherry* "takes place" ostensibly in two different time periods specified by the text, 1640 and 1990. In each period we follow the adventures of Dog Woman and Jordan, the former a woman of Rabelaisian size and appetites, the latter a young boy she finds in the slime of the Thames. In the seventeenth century, Dog Woman breeds a pack of dogs when not otherwise terrorizing Roundheads, and Jordan becomes an apprentice to John Tradescant, "Gardener to the King." When the action moves to the end of the twentieth century, Dog Woman has become a radical environmental activist, and Jordan a sailor in the Royal Navy. These times and identities are tied together by an ongoing series of reflections on the interconnected nature of time, place, love and sexual identity. Jordan has the ability to "sail" through time and space, but unlike Ackroyd's intertextual traveler Tim, Jordan enters realms that have remained largely silenced rather than canonized. When he sails into the world of the "Twelve Dancing Princesses" fairy tale, he hears the story of each princess, their accounts giving voice to the unspoken aspects of fairy tales, namely the subjugation and brutalization of women in the name of all-conquering heterosexism. One princess narrates the story of Rapunzel from the perspective of the witch. According to her account, Rapunzel went to live with an older woman and they became lovers, but "her family were so incensed by her refusal to marry the prince next door that they vilified the couple, calling one a witch and the other a little girl. Not content with names, they ceaselessly tried to break into the tower, so much so that the happy pair had to seal up any entrance to the tower that was not on a level with the sky" (p. 52). One day the prince comes to the rescue:

He carried Rapunzel down the rope he had brought with him and

forced her to watch while he blinded her broken lover in a field of thorns. After that, they lived happily ever after, of course. As for me, my body healed though my eyes never did and I eventually was found by my sisters, who had come in their various ways to live on this estate." (p. 52)

Winterson does not use Jordan's travels to form a countercanon; the effective critique of the mythologies that have secured gender subordination and the repression of desire appears not to be the construction of ad hoc traditions *à la* Lorna Simpson in a work like *Same*, but a complete rejection of historical demarcation in the traditional sense. "Time has no meaning, space and place have no meaning on this journey. All times can be inhabited, all places visited.... The journey is not linear, it is always back and forth, denying the calendar, the wrinkles and lines of the body. The self is not contained in any moment or any place...." (p. 87) The only way to escape the terror of containment is to embrace the multiplicity of the self. "Escape from what? The present? Yes, from the foreground that blinds me to whatever may be happening in the distance. If I have a spirit, a soul, any name will do, then it won't be single, it will be multiple. Its dimensions will not be one of confinement, but one of space" (p. 144). This division, however, cannot be accounted for with existing maps or calendars; only symbolic figuration will allow it to become legible.

> Fold up the maps and put away the globe. If someone else had charted it, let them. Start another drawing with whales at the bottom and cormorants at the top, and in between identify, if you can, the places you have not found yet on those other maps, the connections only obvious to you. Round or flat, only a very little has been discovered. (p. 88)

The map and the calendar are considered arbitrary, but like the distinctions that legitimize or demonize different forms of desire, they have a pernicious effect, because they partition experience in ways that prohibit the emancipation of the self. The need to introduce another imaginary in order to envision subjectivity in reference to other more figural coordinates of history and geography is summed up by the Dog Woman of

1990: "I don't know if other worlds exist in space and time. Perhaps that is the only one, and the rest is rich imaginings. Either way it doesn't matter. We have to protect both possibilities. They seem to be interdependent" (p. 146).

The necessary interdependence of a known history and an imaginary other that runs alongside it, which operates according to other ideological dynamics is the basic structuring tension of Steve Erickson's *Arc d'X*. Here, as in *Sexing the Cherry*, spatial and temporal demarcation are intimately connected up to the partitioning of desire and the development of other ways of envisioning subjectivity, ways that might effectively critique existing forms and at the same time stake out alternatives, made possible only through the introduction of different figural paradigms. The opening section of the novel takes place in Paris at the end of the eighteenth century, and the main characters are Thomas, "the inventor of the American dream," and his slave Sally, who comes to Paris as his daughter's attendant. Thomas soon becomes overcome with desire for Sally and rapes her violently. Within a few weeks the family has to return to America and the central dilemma of the novel is introduced: will Thomas follow his conscience and allow Sally to remain in France where she is technically a free woman, or will he obey his desire and take her back to Virginia where he can control her as his property? After Sally agrees to return as his mistress the narrative slides into a futuristic world founded on an alternate history, and the action moves back and forth between the historical past we seemingly already know, a futuristic theocracy called Primacy, and an alternate history that speculates what might have occurred had Jefferson followed the dictates of his conscience. This world features, among other things, Sally as the mistress of French revolutionaries and Thomas as general/chief slave of a black army he leads across Virginia en route to Washington. The re-writing of history is undertaken by Etcher, a functionary at Church Central, who discovers a set of books locked away from the public, books which contain "another history...the history of our secrets," entitled "Unexpurgated Volumes of Unconscious History." The idea of parallel histories, one official and one

figurative, is reiterated by another character, Seuroq, as he attempts to calculate history:

> One calculation based itself on history's denial of the human heart
> and the other on history's secret pursuit of the heart's expression;
> if one's heart story was the pursuit and denial of love and if histo-
> ry was the pursuit and denial of freedom, what lay at the heart's
> intersection except the missing moments consumed by memory....
> If it was the lesson of the early days of the Twentieth Century that
> the truth could be dislocated from time, the lesson of the waning
> days of the second millennium was the dislocation of time from
> memory, by which the truth is surmised. (p. 209)

Seuroq continues to grapple with his calculations, trying to determine the future date when "all history would collapse" (p. 210), but he fails to realize "that beyond such a day time would measure itself not by the numbers of the clock but of the psyche, which was to say that history would measure itself not by years but by memory, where the heart is a country" (p. 211). Erickson temporalizes and spatializes the figural, while at the same time enfiguring both time and space. Late in the novel, Sally's daughter Polly searches for Etcher, who has hidden himself away in order to rewrite the volumes of Unconscious History. When she finds him she notices a map on the wall above the volumes that have been ripped apart.

> Only after she'd studied it some time did Polly understand it was a
> diagram of the city.... Some zones were clearly designated—
> Sorrow and Ambivalence and Humiliation—and others not, the
> most confused being the name Redemption, which the map's
> author had replaced with Desire, only to cross that out and rewrite
> Redemption, only to obliterate the first again for the second until
> all that was left was a crazed blotch of confirmation and denial.
> (p. 270)

The psychic dimensions of the mapping of the city become explicit at this point, but the variability in the designation of places does not result in a dissolve into a nihilistic mutability or endless play of signs. Earlier in the

novel, the narrator (who appears to be Erickson speaking directly to the reader) says:

> even as the fact of it becomes more overwhelming, more unbear-
> able, some things are irrevocable, if not circumstantially, then in
> the heart and memory, the heart and memory being the only two
> things that can puncture the flow of time through which hisses the
> history of the future…. Everything that's truly irrevocable finally
> has to do with love or freedom, but whether you act in the name
> of the first or the second, one of them ultimately bows to the other,
> and that's the most irrevocable thing of all. (p. 195)

Within *Arc d'X*, all temporal and spatial demarcations are mutable except when animated by one ultimate value or the other, resulting in the collision of foundational narratives that forms the central tension of the novel, a choice of narratives that is presented as a matter not of individual psychology but of national identities. Near the end of the text, one of the characters from the Berlin of the future travels across the United States, where he finally encounters, while wandering through the bowels of an excavated city, an ancient Thomas, who asks him, "What finally loses a man's soul, the betrayal of his conscience or the betrayal of his heart? Both you're thinking, aren't you? You're thinking both. But what if you have to choose? What if your life chooses for you or she does…." (p. 260) The scope of this dilemma is not restricted to an individual psyche; when Georgie asks the grotesque old man his name, he tells him simply "America."

This rewriting of American history and the perpetual remapping of the city in terms of psychic figures shaped by conflicting foundational narratives crystalizes the central argument of this chapter—that self-invention and self-location are interdependent, but developing a coherent sense of how either one can be achieved is possible only by recognizing the mutability of both the cultural geography and cultural memory, the endlessly reconfigurable landscapes and histories which are made to serve, nonetheless, as immutable points of reference within specific maps, envisionings and narratives. The various strategies that are employed in the

process—the appeal to intrinsic structural essences in the form of atem-poral archetypes, the construction of cultural traditions through seriality and cacophony, the introduction of figural paradigms that form the psy-chotectures of the present—all envision *another* cultural terrain, one which exists above, beyond or within the known landscape and the official history. The critical tropes that have been used to make sense of this diverse activity have in large part oversimplified its complexity by failing to recognize that, while we may exist in physical landscapes, we also "live in the city of dreams." Accounting for the interdependent nature of those realms necessitates the development of new theories of the imaginary and of subjectivity that can elucidate the nature of self-location in "image cultures" without falling into the easy demonization of nostalgia, televi-sion, theme parks and shopping malls. Panoptic cultural theory has demonstrated only its inability to understand the stakes involved in the "dramas of choice" that are played out within that excess. Developing theories of subjectivity that might account for the effects of the Information Age on identity formation depends on coming to terms with the complexity those dramas, most especially the values that animate them and the strategies used to resolve them.

Appropriating Like Crazy
From Pop Art to Meta-Pop

My primary goal in the previous chapters was to throw into question many of the supposed "givens" concerning life in information cultures and to present alternative ways of theorizing the effects of this excess, specifically in regard to the ways in which that array of information is being domesticated, and how satisfying notions of identity and self-location are constructed in the process. The next two chapters will focus on the specific effects that this semiotic excess have had on the two most significant ways of envisioning contemporary cultural life—picture-making and story-telling—and, in the process, trace those effects within two very particular cultural arenas—the Art World and "Mall Movies."

One of the great truisms regarding cultural production since the advent of postmodernism is that all forms of art and entertainment have become merely one form of appropriation or another, whether it be called pastiche, parody, revivalism or just plain *retro*. The problem with this "common knowledge" is that it finally doesn't tell us much at all about the particularity of different forms of re-articulation. There have been remarkably few attempts to chart either the evolution of appropriationism or its permutations in regard to circuit of exchange, institutional arena or animating motivation. The intensity and diversity of appropriationism is epitomized by the September 19, 1993 edition of the *New York Times*. The cover story in the Arts and Leisure section, entitled "Still Subversive After All These Years" is devoted to the major retrospective exhibition of Roy Lichtenstein's work at the Guggenheim Museum, the cover of the Book Review features a Barbara Kruger photogragh, "Don't Force It" used to illustrate a review of two books devoted to date rape, and the ads for several high-profile bookstores showcase Anne Rice's new novel, *Lasher*, a continuation of the adventures of her hyper-self-conscious witches and spiritual beings. At this point, when the Old Master, the Radical Feminist and the Best-Selling Author are all defined by their sophisticated re-articulations of antecedent texts and traditions, and those re-articulations are circulated so prominently in terms of museum culture, debates about third-wave feminism, and popular entertainment, there is clearly a need to develop more nuanced ways of understanding the complexity of appropriationism.

It has by now become commonplace to argue that appropriationism signals a fundamental shift in the conception of artistic production in which creativity is no longer conceived of in terms of pure invention but rather as re-articulation of pre-existing codes. While the ramifications of this point could hardly be overestimated, I'd like to pursue a related yet often neglected aspect of this shift from invention to re-articulation. Appropriation is not simply an anti-Romantic stance opposed to the mythology of personal genius; this shift also involves profound changes in regard the mutability of both information and the forms of cultural authority which govern (or used to govern) its circulation. To appropri-

ate is to take control over that which originated elsewhere for other semi-otic/ideological purposes. One could describe this activity in terms of Michel de Certeau's notion of cultural "poaching"[1] but the different forms of appropriation that I will be discussing in this chapter aren't real-ly poaching in his sense of the term, since they aren't semi-clandestine "networks of antidiscipline," that is, small acts of defiance which, for the most part, go unnoticed. The appropriationism of individuals as different as Lichtenstein, Kruger and Rice could hardly be more explicit in their seizure of signs, images and iconography found *elsewhere*, or more overt in their defiance of taste hierarchies which would determine the limits of their usage. Appropriation depends on two interdependent contentions: 1) acknowledging the limits of specific discursive/institutional enclosures that previously restricted the significance and circulation of a particular image or iconography; 2) defying the legitimacy of those limits by taking possession of those images. This determination to take possession, then, does not signify the denial of cultural authority but, rather, the refusal to grant cultural *sovereignty* to any institution, as it counters one sort of authority with another.

The impact of this difference between authority and sovereignty will be discussed in greater detail in regard to debates about cultural value in Chapter Five, but here I want to delineate representative forms of appro-priation and the formal/ideological agendas that motivate them. Since an exhaustive survey of this activity is far beyond the scope of this book, I will focus on texts that address the entire formation of taste hierarchies by test-ing the borders between legitimate and illegitimate culture. In order to provide a sense of historical evolution I will concentrate on the various ways that popular culture has been rearticulated over the past four decades, focusing on three pivotal developments: the Pop Art of the late fifties and early sixties, the "Image Scavenger" photography of the eighties, and the emergence of "Meta-Pop" in the later eighties and early nineties.

Mickey is Taken to the Museum; Cindy Goes to the Movies

The first significant, widespread reevaluation of popular culture, specifi-cally in regard to its binary relationship with "high art," occurred in

Britain and the United States from the late fifties to the mid-sixties. The term Pop Art was used to describe quite disparate techniques and perspectives on what was then considered "mass culture," that is, homogeneous, mass-produced objects designed for immediate gratification/enslavement of its consumers. But the very appropriation of pop imagery and mass production techniques by artists as different as Richard Hamilton, Andy Warhol, David Hockney, Claes Oldenburg and Roy Lichtenstein meant that the popular could no longer be banished from the canvas or the museum. The definition of the avant-garde as that-which-is-not-mass-culture (developed and institutionalized by Theodor Adorno, Clement Greenberg, and company) was at that point held up to greater scrutiny because of the growing dissatisfaction with Abstract Expressionism as the official, hegemonic style of museum art. The aridity of that style (its self-enclosure, its removal from the realm of everyday experience, its Romantic fetishization of the originality of the artist's personal vision) and its institutionalization (the fact that it was not only hegemonic, but immensely profitable) led to a revaluation of the dichotomies that hitherto safeguarded its "integrity." The need to challenge this institutionalization is typified by Oldenberg's insistence that "I am for an art that is political-erotical-mystical, that does something other than sit on its ass in a museum. I am for an art that grows up not knowing that it is art at all, an art given the chance of having a starting point of zero."[2] The recognition that "artwork" as a critical category had become, by the late fifties, a set of pernicious prohibitions and enclosures, antagonistic to the original, radical gestures of the avant-garde, led to the Pop attack on delimitation of that category. The mass production techniques adopted by Warhol and others were an affront to that most sanctified of categories—personal genius—that by the late fifties to the early sixties was a form of product differentiation, a "name brand" that guaranteed investment value. "That's probably one reason I'm using silk screen, so that no one would know whether my picture was mine or somebody else's."[3] Using image conventions and techniques developed within the realm of popular culture became a way of challenging the structures of that discursive formation which had "capitalized" on its prohibitions that

were so completely institutionalized in its modalities and circuits of exchange.

Whether Pop Artists were engaged in formulating a radical critique of the commercialization of Modernism or simply "capitalizing" themselves by violating those prohibitions has been debated since their first appearance. The initial criticism of Pop—that it wasn't "transformative" enough to be considered genuine art (that is, that Lichtenstein, Warhol and company simply appropriated images without demonstrating the requisite level of personal manipulation of those images) reveals the exigencies of that discursive formation which demanded that any image "outside the walls" of that discourse had to be "converted" before entering the Holy City of the museum. The fetishization of the act of personal transformation was founded on a Romantic notion of creativity that remained firmly in place. Two decades later, to be "transformative" remains artists' highest priority, only now the term of choice is "oppositional" or "contestatory," reflecting the move away from personal creativity as transcendent value to a more "politicized" notion of creation as critical intervention. Andreas Huyssen's discussion of the cultural politics of Pop rests squarely on this division between the transformative and nontransformative potential. His historical overview of Pop centers on his own first encounter with it at the Documentain Kassel in 1968, when he believed it might signal the beginning of a "democratization of art and art appreciation," but he then rejects it, arguing that "Pop artists took the trivial and banal imagery of daily life at face value, and the subjugation of art by the laws of a commodity-producing capitalistic society seemed complete."[4] The failure to be sufficiently transformative in this context means that capitalism necessarily subjugates art, but if truly transformative, then art subjugates capitalism. The absolute, either/or dichotomy leaves no room for ambivalence, for texts which might critique the mass, acknowledge the force of popular images, especially in reference to the aridity of Abstract Expressionism. Huyssen modifies the rigid either/or alternatives in his conclusion, but even there he maintains, "the goal should still be a fictional transformation (*Umfunktionierung*) of false needs in an attempt to change everyday life" (p. 73).

In his analysis of the origins of British Pop in the fifties, Dick Hebdige likewise acknowledges the inevitable absorption of Pop Art into the language of commercial art, but argues that it played a crucial role in redefining the term "culture," throwing into sharp relief the tensions between the Arnoldian concept of culture ("the best that has been thought and said") and the more anthropological sense of the term (the ritual, images and practices that form a "whole way of life"). Hebdige makes the crucial point that:

> the dismissive critical response [to Pop] merely reproduces unaltered the ideological distinctions between, on the one hand, the 'serious,' the 'artistic,' the 'political,' and on the other, the 'ephemeral,' the 'commercial,' the 'pleasurable'—a set of distinctions which Pop practice set out to erode.... Pop's significance resides in the ways in which it demonstrated, illuminated, lit up in neon, the 'loaded arbitrariness' of those parallel distinctions, lit up the hidden economy which serves to valorize certain objects, certain forms of expression, certain voices to the exclusion of other objects, other forms, other voices by bestowing upon them the mantle of Art.[5]

Lichtenstein's comic strip paintings of the early sixties destabilized the parallel distinctions Hebdige cites; as such they helped inaugurate a process of redefinition of both the confines of popular culture and the critical presuppositions used to evaluate cultural production. But in order to appreciate the significance of Lichtenstein's work in relation to the more recent assaults on those parallel distinctions, we need to examine more closely what was and wasn't appropriated from popular culture in those paintings. Lichtenstein became interested in the subject matter and Ben Day dot patterns of the comic book because of the graphic possibilities they offered. In response to the criticism that the characters featured in his "action" comics (for example, *Takka Takka* [1962], *Wham* [1962], *O.K. Hot Shot* [1963]) were militaristic, he argued that:

> The heroes depicted in comic books are fascist types, but I don't

take them seriously in these paintings—maybe there is a point in not taking them seriously, a political point. I use them for purely formal reasons.... What I do is form, whereas the comic strip is not formed in the sense I'm using the word; the comics have shapes, but there has been no intent to make them intensely unified. The purpose is different, one intends to depict and I intend to unify.[6]

Lichtenstein's appropriation of both the iconography and materiality of the comics represented an affront to both Modernism and the institution of the museum, but the emphasis on formal experimentation, in which Ben Day dots were yet another form of abstraction, made Lichtenstein's "radical" gesture easily recuperable by both. That the comics merely served as the raw material for a new minimalism becomes particularly conspicuous in Lichtenstein's subsequent homages to Cubism, Purism and Surrealism, which feature the same Ben Day dots, but also feature figures appropriated from Picasso, Leger and Dali. The comparability of the comic and Modernist "masterpiece" as sources for abstract experimentation/quotation emerges most clearly in his *Artist's Studio No. 1* (*Look Mickey*; 1973). Lichtenstein's own earlier painting of Donald Duck and Mickey Mouse is the dominant image on the wall, but the appropriation of Disney sits alongside quotations from Matisse's *The Pewter Jug* (1917), Leger's *The Baluster* (1925), fragments from his own *Entablatures* series (1972–1976), which featured a series of variations on neo-classical borders, and his *Mirror* paintings (1969–1972), which borrowed images of mirrors from advertising brochures produced by commercial glass manufacturers that were then transformed into some of his most "abstract" paintings. Recognizing this comparability of comics and Early Modernists as sources of appropriation in Lichtenstein's more recent work does not mean that his work does not destabilize the "parallel distinctions" to which Hebdige refers, but it does require a careful delineation of the object the attack, of just what, after all, was being destabilized. Lichtenstein's comic book paintings of the early sixties were in a sense already "Artist Studio" paintings, in that the arena of conflict is still the specific discursive formation constituted by the gallery, the legacy of art history, the extended New

York art scene, and so on. Lawrence Alloway, in his perceptive study of Lichtenstein, argues that in paintings like *Reclining Nude* (1977), which quotes Henry Moore, Salvador Dali, and his own *Brushwork* series from 1966, Lichtenstein constructs the twentieth-century equivalent of the "gallery picture," comparable to Jan Brueghel's *The Sense of Sight* or David Tenier's *Gallery of the Archduke Leopold William*, all of which "take culture itself as subject."[7] Alloway's analogy is convincing, but just how culture is constituted here is not fully explored. For the comic book paintings of the early sixties, "culture" might include the popular image, but it remains circumscribed by the institutional framework that produced those parallel distinctions. Two paintings in particular, *Masterpiece* (1962), and *M-Maybe* (1965), epitomize that sense of enclosure, of a calculated gesture made in reference to a very particular framework. In the former, the woman says, "Why Brad Darling, This Painting is a Masterpiece! My, Soon You'll Have All of New York Clamoring For Your Work," while in the latter, a lone woman says of an unspecified he, "M-Maybe He Became Ill and Couldn't Leave the Studio!" Arguably, the last phase defines the scope of the attack—these paintings, these appropriations have force only so long as they remain, in a sense, within the studio, within the wholly artistic space defined by a particular circuit of production and evaluation. The use of the comic book creates a scandal only within that discursive space, and, as such, the iconoclastic dimension of the appropriation exists only within the world of museum art. Lichtenstein's pop appropriation may tell us a great deal about the limitation of that institutional framework, but they evidence little or no interest in the resonance of popular texts outside that realm, how they might capture the imagination of widespread publics, how they might affect us at a visceral level, forming the "stuff that dreams are made of."

The eclectic but precisely delimited nature of Lichtenstein's appropriationism is foregrounded in his most recent series of paintings entitled, quite aptly, *Interiors* (1991–1993) where he focuses on the specificity of another enclosure for serious art—the living room as contemporary gallery. Like his earlier *Artist's Studio* paintings, they "frame the frame," envisioning quite explicitly how contextualization gives the paintings

their significance, only here the juxtaposition involves not modernist masterpiece and popular icon, but museum art and domestic interior design, ensembles in which his own earlier works have become "sofa art," over-the-couch wall decorations chosen to match the decor of the room. His paintings have most definitely left the studio (and, by extension, the world of the gallery/museum) but they still remain anchored within domestic interiors that have become vulgarized galleries of contemporary art. Lichtenstein's eclectic appropriationism, then, finds sources for inspiration in the realms of both popular culture and the official art world, but his primary concern remains the fate of the artistic as it transforms popular iconography into visual patterns and then circulates as art through the popular, defined as the foreign terrain of the domestic interior.

That Lichtenstein's appropriations were conceived in reference to the world of the gallery/museum becomes especially apparent in the ways they themselves have been apppropriated, particularly in Tony Hendra's *Brad 61, Portrait of the Artist as a Young Man*.[8] Billed as "An Original Romance Inspired by the Pop Paintings of Roy Lichtenstein," Hendra's work constructs a semicontinuous narrative by adding connecting phrases to the Pop paintings, whose written texts are then made to seem like successive installments in the continuing saga of Brad the aspiring artist. Hendra's attempts to narrativize images that were once conceived in isolation as crystallizations of the Romance are amusing, but his narrative also reveals the limited scope of the narrative possibilities in those borrowed panels— *Brad 61* could only be an art world romance because Lichtenstein's appropriations so thoroughly foreclose the range of that narrative potential. Not surprisingly, *"M-Maybe He Became Ill And Couldn't Leave The Studio"* and *"Why Brad Darling, This Painting is a Masterpiece! My, Soon You'll Have All of New York Clamoring For Your Work!"* both figure prominently in Hendra's narrative. After Brad makes an abortive attempt to take his work to New York to show it to Leo Castelli (Lichtenstein's gallery) he finally realizes that "HIS LIFE IS A COMIC! HIS LOVE IS A COMIC! HIS ART IS A COMIC!" (p. 91). But Hendra's narrative, consciously or unconsciously, proves only the opposite—that LICHTENSTEINS'S COMICS ARE ART! HIS COMICS ARE ALL ABOUT THE

ART WORLD! HIS COMICS ARE ALL ABOUT HOW THE ART WORLD SEES ITSELF, USING
POPULAR CULTURE AS IT SEES FIT!

The appropriationism or "image scavenging" that developed in pho-
tography and conceptual art of the late seventies to the early eighties,
specifically the work of Sherrie Levine, John Baldassari, Louise Lawler,
Judith Barry, Richard Hamilton, Cindy Sherman and Barbara Kruger, also
made appropriation a weapon in a similar series of attacks on the institu-
tionalized notion of Fine Art. This work also reveals a fascination with the
circulation of the popular that goes well beyond the confines of the muse-
um and gallery. A great deal of important critical work has already
detailed the permutations of photographic appropriation and its rela-
tionship to concurrent developments in poststructuralist theory,[9] so here
I will discuss this work in relation to the Pop Art that preceded it and the
Meta-Pop that emerged alongside it. The critique of the institutionaliza-
tion of Fine Art that figures so prominently in the work of Sherrie Levine
and Louise Lawler extends many of the issues raised by Pop Art, but it also
introduces other concerns as it envisions the Art World of the eighties.
Levine's photographs of what are considered "masterpiece" photographs
by Walker Evans and Edward Weston, for example, were clearly a contin-
uation of the tradition inaugurated by Warhol and Lichtenstein,
critiquing the sanctified values of personal vision and the aura of the indi-
vidual work in a medium capable of infinite reproducibility. The more
recent work of Louise Lawler explicitly visualizes the tradition of Warhol's
critique, yet at the same time confronts the fact that Warhol has himself
become an Old Master.

This extended critique which reformulates the "parallel distinctions"
Hebdige refers to in light of the institutionalization of Pop Art, is most
explicit in Lawler's paired pieces Does *Marilyn Monroe Make You Cry?* and *Does
Andy Warhol Make You Cry?* (see figures 10 and 11). Through the juxtaposi-
tion of the Monroe icon and the Warhol-Monroe icon Lawler encourages
the viewer to reflect on the endless play of both appropriation and its
institutionalization, the pop image becoming art as it is redoubled, print-
ed as classical art, hung in a museum and appropriately captioned.
Lawler's appropriations reflect on the primacy of hanging and caption-

Figure 10: Lawler, *Does Marilyn Monroe Make You Cry?*

Figure 11: Lawler, *Does Andy Warhol Make You Cry?*

ing, foregrounding repeatedly the roles they play in re-articulation and reevaluation. Lawler's brilliant juxtaposition of captions and materials in this pair throws into question the state of the parallel distinctions between Fine and Popular Art in the contemporary period. The movie image is printed not on the cheap china "collector's plate," but on the terra-cotta dish normally associated with classical antiquities—this is, after all, a classic photograph of Monroe that has now entered the museum, first via Warhol's multiplication, then through Lawler's appropriation of the appropriation, which itself multiples the signifiers of "classic." Lawler's questions address respective resonances of each captioned image—does Monroe's image evoke an emotional response because she is the tragic victim of popular culture, a figure whose own iconicity got out of control and destroyed her, and if so, does Warhol's Marilyn have the same power to produce emotional response, or does it become another experience altogether when it serves as the basis for a stylistic exercise by Warhol trying to terrorize the world of Fine Art and, in the process, make a name for himself? Does Monroe as movie star icon move us because it evokes the tragedy of celebrity, but when re-articulated as "Pop Art Monroe"-as-presented-by-a-twentieth-century-Old Master, does it lose its emotional aura as it gains an artistic one as a meditation on celebrity? Is the former a souvenir (in the most literal sense) of the glamor and tragedy of the end of Hollywood's Golden Age, and the latter a souvenir of Pop Art's Golden Age, when a new generation of iconoclasts tried to import the visceral intensity of popular imagery into the museum for the first time in the early sixties? Does Monroe as Monroe generate a less mediated response in the viewer, or is each image, movie icon and Pop Art icon, so heavily mediated that each now carries its own aura that explains its "lasting" appeal in the museum of the popular imagination? Just what does mediation mean at this point vis-à-vis emotional or intellectual response? How do the captions determine value in the sense of both financial investment and psychic investment?

Lawler's captioning addresses the "power" that both Fine Art and popular images have within specific discursive contexts, their resonance determined by their circulation. Cindy Sherman's photographs have also

investigated the power of the iconography of both movie classics and Old Masters, the former in the much-discussed, widely imitated *Untitled Film Stills* series (1980), the latter in the *History Portraits* series (1990), but Lawler's work appears more concerned with the power of the frame on that iconography. In *CS 204* Lawler executes another appropriation squared, borrowing image 204 from Cindy Sherman's *History Portraits* series (see figures 12 and 13). In this photograph, Lawler constructs series of frames within frames—the camera, the photograph, the mirror, the window. By juxtaposing these frames, all of which have served as metaphors for envisioning "the world," she makes the frames the primary subject of the work. Lawler's use of Sherman's photograph at the center of this accordian structure of frames emphasizes the variable status of the photograph. Sherman's photograph is presented by Sherman as a photographic portrait done in the style of classical portraiture; Lawler's placement of that portrait behind a canvas in the gilded frame intensifies the painterly aspects of the photograph—it appears at first to be one more "canvas" stacked against the wall. But the double reflection within this portrait stresses first the depth of the painterly space through the use of the mirror hung on the wall behind the sitter's head; then the reflection of what appear to be windows across the street from the studio in the glass in front of the photograph, which intensifies the back-and-forth movement through the frames (what appears at first to be far behind the figure is actually on the surface in front of it), and the back-and-forth movement between painting and photograph. The sheet of plastic to the right intensifies the discordant juxtaposition—one side of the image layered with signifiers of refined visual artistry, the other side resembling a plastic tarp thrown up to cover walls during a "paint job," framing the Sherman photograph from the right in a manner virtually antithetical to the canvas that frames it from the left front. Just which image, or which frame, or even which plane is supposed to be the central reference point is impossible to determine, as Lawler mutiplies the frames and reflecting surfaces.

The foregrounding and backgrounding of the frame as determinant of the power and resonance a particular image achieves is also a constitutive element in the photographs of Barbara Kruger, whose work represents

Figure 12: Sherman, *History Portrait* #204

Figure 13: Lawler, *CS 204*

the evolution of appropriationist photography from the early eighties into the early nineties. The openly discursive (in the Benvenistean sense of the term as well as the Foucauldian) nature of that confrontation in works such as *We Won't Play Nature to Your Culture*, *You Destroy What You Think is Difference*, and *You Divide and Conquer* (all 1981–1983) signaled a crucial shift in the motivation and strategies of appropriation. The exigencies of appropriation were no longer a matter of personal expression as formal experimentation, but a matter of hijacking an image, forcing it to say that which it wanted to keep secret, namely the visual exploitation/subjugation of women. The appropriation of the fashion image, coupled with the confrontational address to other women ("We") and men ("You") foregrounds the connection between the construction of images and the construction of gender difference in both the "original" photos and in their re-articulations. Here Kruger broadens the scope of the appropriationist gesture, expanding the number of interested parties involved by that activity, and in so doing redefines the "stakes" by making the reception of popular imagery a vital critical issue. As such, Kruger's work marks a significant advance over the Pop Art appropriationists because of its sensitivity to impact. This is not to suggest that Pop Art was oblivious to or unconcerned with reception, or that it didn't involve a different relationship between artist and spectator. Carole Ann Mahsun argues, following Alloway, that in Pop:

> spectators are confronted with a self-contained entity removed from its familiar surroundings and challenged to do their "own work of looking".... Thus the pop artist avoids interpretation, "message," emotion, or personal style—avoids anything alien entering into the viewer's experience—and instead turns the viewer back upon his (*sic*) own sensory experience by thwarting conventional interpretive practice.[10]

While Mahsun's characterization of that relationship may be accurate, the activity of the viewer is predicated on the relative silence of the artist, whose very disinterested neutrality on the subject of eventual impact allows that viewer to fill in the gap, as it were. Kruger's work could hard-

ly be called silent, nor does she avoid interpretation. Her second-person address emphasizes quite explicitly that the text is constructed in reference to that "you" who has already "interpreted" in regularized ways, so the appropriationist gesture is by ideological and semiotic necessity a discursive exchange.

The increased emphasis on the resonance of images outside the realm of museum art also distinguished the early work of Cindy Sherman who, through her particular strategy of appropriation, conflated the concerns of personal expression and the cultural impact of popular media images. In her series of *Untitled Film Stills* (1977–1980) and *Untitled* (1981–1985) photographs, Sherman posed herself as the heroine of a number of different genre films, enacting or "impersonating" the visual stereotypes those films produced and /or reiterated. By making herself into a series of icons, Sherman immersed herself in popular imagery and explored the connections between that imagery and personal gender identity. Where a Pop text like Richard Hamilton's *She* (1958) may have presented a series of advertising images featuring women in the home (forming what he describes as "a sieved reflection of the ad man's paraphrase of the consumer's dream,"[11] Sherman's impersonations situated her as a performing artist within that world, thereby constructing the strange duality which is the foundation of her work. She is both critical outsider, the director of an imaginary film and the character within the film, whose identity is enmeshed in and inseparable from that iconography. In her introduction to Sherman's photographs, Judith Williamson stresses the implication of the viewer in that work, arguing that Sherman's presentation of the multiple images of women:

> is such a superb way of flashing the images of "Woman" back where they belong, in the recognition of the beholder.... Within each image, far from deconstructing the elision of image and identity, she very smartly leads the viewer to *construct* it; by presenting a whole lexicon of feminine identities, all of them played by "her," she undermines your little constructions as fast as you can build them up.[12]

Following Williamson's argument, one could say that Sherman is able to effect such a critique because she is the director, character and beholder simultaneously, "Woman" looked at, but also a woman looking ambivalently at her self-image as cultural image. In this context, the act of appropriation is inseparable from the act of self-definition.

While the early work of Kruger and Sherman invested the art of appropriation with broader significance by emphasizing the impact of popular images, as well as their modes of production, popular culture remained a category framed by the institution of Fine Art. Like Pop Art, appropriationist photography was initially considered an affront to all that was sacred about that context but just as Pop was absorbed into the museum, the postmodernist photography of the early eighties has already been institutionalized. Abigail Solomon Godeau details this most recent absorption, pointing to the inclusion of these photographs in shows at galleries that specialized in showcasing Modernist and Official Art photography. "The appearance of Postmodernist photography within the institutional precincts of art photography signaled that whatever difference, much less critique, had been attributed to the work of Levine, et al., it had now been fully and seamlessly recuperated under the sign of art photography, an operation that might be called deconstruction in reverse."[13] In their most recent work, Kruger and Sherman have both adopted extreme, virtually antithetical strategies for responding to this institutionalization which places not just their work, but their critique of dominant "ways of seeing" within the museum as *art* photography. Sherman has moved in a centripetal fashion, gravitating ever more deeply, and ever more parodically, into the world of Fine Art through her *History Portraits*, which appropriate styles of portraiture from the Renaissance though the nineteenth century and through her special edition "Madame de Pompadour" porcelain table service, which features one such portrait printed in the middle of fabulously expensive plates and tea cups.

Kruger has moved in an increasingly centrifugal direction, clearly attempting to escape the confines of the museum by moving into the realm of public art. Her billboards, cover photos for popular, mass-market

magazines like *Newsweek* and *Esquire*, as well as her poster for the Abortion Rights March on Washington in April, 1989 all suggest a concerted attempt to appropriate not just the iconography and modes of image reproduction of popular culture, but also the sites of its transmission and circulation. This taking possession of the sites of transmission in the hope of escaping the safe confines of gallery/museum and its already converted audience is especially striking in her contributions to fashion magazines. In the October 1991 issue of *Glamour*, Kruger does the graphic art for an article entitled "the Politics of Birth of Control" in which she uses her most widely circulated image, *Your Body is a Battleground.* The appearance of this image, otherwise seen as a poster for abortion rights and on the cover of Susan Rubin Suleiman's book, *Subversive Intents: Gender, Politics, and the Avant-Garde* (Harvard, 1992) may seem surprising at first, since *Glamour* is usually thought of as part of a "beauty system" that needs to be subverted rather than another site of political contestation, that is, it's one thing for radical art to take to the streets or to the covers of news magazines, but quite another to appear on the pages of a tool of the oppressor.

The juxtapositions that the reader encounters on the table of contents page of this issue make the discrepancy quite explicit (see figure 14). Kruger's *Battleground* image appears at the bottom of the page, beneath two other photos featuring fashion models, one illustrating a photo spread entitled "Fall Colors: Intoxicating." But another juxtaposition on this page suggests the comparability of Kruger's images and the look of the fashion magazine. The layout of the page itself reveals the source for Kruger's signature red bars and block letters. This table of contents page is a fascinating text unto itself because it depicts the successive waves of appropriation; first, the hijacking of the graphic style of the popular fashion magazine (the style Kruger learned while working as a graphic artist for Condé Nast) to make feminist art opposed to that whole "way of seeing" which would appear *elsewhere* in the politically appropriate sites; and a second, more recently adopted strategy which integrates feminist art into the actual sites of popular culture. Where the former could be considered roughly comparable to Lichtenstein's use of Ben Day dots but with a very precise ideological agenda, the latter suggests a very different perspective

Figure 14: Kruger, *Glamour*

regarding the relationship between art and popular culture, one that comes closer to the position outlined by Robert Venturi and Denise Scott Brown—that there is much about the language of commercial persuasion that can be put to civic use.[14] Kruger's use of both this language and its sites clearly has, echoing Suleiman's title, a subversive intent, but the key point here is that subversion is *not* tied to the avant-garde venue. The need to occupy the spaces of the popular, if only as a force of contradiction, depends on a categorical refusal to maintain the traditional *cordon sanitaire* between art and mass culture which would guarantee the integrity of the former, even if its impact would be sharply delimited. The fashion magazine is a battleground for women's bodies in a way that the New York gallery scene can no longer be, since it encompasses such disparate envisionings of femininity, all addressed to an audience still in the process of negotiating those contradictory positions.

Kruger has obviously not been the only artist to attempt to move outside the realm of the gallery by appropriating the sites of popular culture. An increasing number of artists—Jenny Holzer, Judith Barry, the Guerilla Girls, Group Material—have been experimenting with new forms of public art since the mid-eighties. Despite the determination to challenge the traditional demarcations between Fine Art and Activist Art, one bar, however, apparently cannot be crossed. A semantic *cordon sanitaire* has been maintained in the discourse devoted to this work; it is described as *public* art but seldom, if ever, *popular* art, even when it appears on T-shirts, shopping bags, or stadium scoreboards. The very term "popular" remains demonized, as if the appropriation of the popular can be considered legitimate only when it is sufficiently transformative, now defined more in political than aesthetic terms. In other words, the iconography, techniques of image reproduction, modes of transmission and actual sites of the popular may be appropriated, but not the term itself. This is not to suggest that there shouldn't be a distinction between public and popular art —only that the continuing uneasiness that the latter causes, reflects the persistence of taste hierarchies that will still only allow certain types of iconoclastic experimentation to be recognized as artistic. That the critical component of that discursive formation continues to insist on a

demonstrable distantiation, a discernable, oppositional "transformation," of the popular is apparent in Solomon Godeau's condemnation of what she labels the "second generation" of postmodernist photographers (Frank Majore, Alan Belcher, Stephen Frailey) "whose relation to the sources and significance of their appropriative strategies (primarily advertising) seemed to be predominantly a function of fascination."[15]

To be fascinated appears to be the greatest sin of all, because it suggests a lack of respect for an institutional framework that may be challenged, but not jilted, especially by artists who have been seduced by mere popular culture. Making fascination antithetical to "critique" has been a stock-in-trade feature of avant-gardist self-promotion since its inception; fascination has been made to mean uncritical acceptance, promiscuity, lack of rigor, and so on. Patrice Petro, in her compelling study of Weimar cinema, makes the crucial point that distinctions between the popular and the avant-garde have been consistently linked to gender difference. "Mass culture was itself commonly personified as 'feminine', having the capacity to induce passivity, vulnerability, even corruption. And as mass culture's opposite, modernism was often construed as masculine, as providing an active and productive alternative to the pleasure of mass cultural entertainment."[16] The disqualification of fascination as an acceptable response to popular culture reveals a series of interconnected problems, particularly the inability to account for pleasure except in terms of negative category, that which the truly oppositional text will not allow, except in the form of a self-congratulatory detachment that is suitably distanced.

We Won't Play Other to Your Culture

The viability of fascination as a critical perspective distinguishes a number of recent appropriationist texts, such as Max Apple's *The Propheteers* and Jay Cantor's *Krazy Kat*, and it is precisely the status of fascination which differentiates Meta-Pop from earlier strategies of appropriation. Here the hyperconscious reflection on the nature of popular culture is not conducted from within a discursive framework that defines popular culture as its "Other," but in relation to the conventions, mythologies and insti-

tutions that constitute popular culture as another sort of discursive formation, or more precisely, a series of discursive formations. While these works are still aggressively appropriative in orientation, they are meditations on popular culture and how it resonates outside the walls of museum art. They are "transformative" in regard to the history of popular culture and its possible functions, challenging accepted opinions concerning its homogeneity, what it is capable of expressing, what factors shape its most recognizable forms, and how it circulates as a commodity.

In *The Propheteers*,[17] Apple appropriates not just images or iconographies of popular culture, but the entire personas of some of its major figures. Where Lichtenstein's artist's studio may have included Donald Duck, Apple's novel makes Walt Disney one of its major characters in this story of the development of Disney World, in which Disney's major foils are his evil brother Will, his rival Howard Johnson, and his sworn enemy, Marjorie Post Merriweather (and by extension her father C. W. Post, and her lover Clarence Birdseye). Unlike E. L. Doctorow's *Ragtime* (1975), which features cameo appearances by historical figures, such as Emma Goldman and Henry Ford, Apple makes these figures his central characters, and instead of characterizing them in ways consistent with their historical images, he invents elaborate personal histories that he admits in his prefatory comments are "drawn entirely from my imagination. My only connection to the real names used in this novel is the frequent appearance of a number of them at my breakfast table." The reference to the breakfast table as the source or genesis of his inspiration is significant insofar as it functions as an image comparable to Lichtenstein's *Artist's Studio* paintings, yet the disparity between the two sites suggests profound differences in their respective positions vis-à-vis popular culture. Where Lichtenstein's appropriations introduce a "foreign" element into his discursive space, Apple's appropriation comes from within a world where Disney, Johnson and Post form the stuff of everyday life.

Apple's imaginary history undermines a number of the most commonly held assumptions about mass culture, especially the binary, negative definition—that its mass-produced, corporation-based nature means that it can be neither folk culture (which was indigenous, sponta-

neous, of the people), nor genuine art (which is unique, of the individual artist). Folk culture and High Art are united in this negative definition by their alleged authenticity and organicity, founded on the direct connection between produced and artistic producer. Apple's characters are among the most significant inventors of mass-cultural existence, but their respective products, and the visions of America they entail, are represented within this novel as fundamentally authentic and almost maniacally organic. The novel opens with Howard Johnson endlessly roaming the highways with his assistant Milly, searching out locations for new motor inns. Johnson roams until he begins to know the territory:

> Howard knew the land, Mildred thought, the way the Indians must have known it.... Howard had a sixth sense that would sometimes lead them from the main roads to, say, a dark green field in Iowa or Kansas.... And before the emergency brake had settled into its final prong, Howard Johnson was into the field and after the scent...he felt some secret vibration from the place. Turning his back on Milly he would mark the spot with his urine or break some of the clayey earth in his strong pink hands, sifting it like flour for a delicate recipe. She had actually seen him chew the grass, getting down on all fours like an animal.... (p. 6)

If Apple describes the determination of the right place for his "houses" in terms of an organic folk ritual, the inspiration for the orange roofs is characterized in terms of poetic inspiration comparable to genuine Art. In the course of their early travels, Milly and Howard visit Robert Frost, Howard's old poetry teacher. The two great men meet amicably, and then, after leaving Frost, Howard and Milly stop for lunch, from which point Milly remembers:

> We stayed on that hilltop while the sun began to set in New Hampshire. I felt so full of poetry and of love, Howard, only an hour's drive from Robert Frost's farmhouse.... I think the sun set differently that night, filtering through the clouds like a big paintbrush making the top of the town all orange. And suddenly I

thought what if the tops of our houses were that kind of orange,
what a world it would be.... The feeling we had about that orange,
Howard, that was ours and that's what I've tried to bring to every
house, the way we felt that night. Oh, it makes me sick to think of
Colonel Sanders, and Big Boy, and Holiday Inn and Best
Western.... (pp. 16–17)

The connections that Apple makes between Johnson and the Indians
(the natives who know nature most intimately) and Johnson and Frost
(one of America's foremost nature poets) obviously suggest a high degree
of both authenticity and organicity in his "oranging" of America. The
conclusion of Milly's reverie is just as significant, because it restricts those
qualities to Johnson and depicts his rivals as their antithesis. Here "mass"
culture is represented not as one homogeneous system of relations, but
as a deeply conflicted, internally inconsistent collection of divergent envi-
sionings of America. This conflict between authentic and inauthentic,
organic and inorganic within popular culture recurs throughout the
novel. Howard Johnson and Walt Disney come to represent (at least in
the former's mind) polar opposites along exactly these lines. Their oppo-
sition becoming most explicit when Johnson stops in San Antonio and
daydreams while contemplating the Alamo.

Without too much effort he imagined himself, Milly, and Otis
entrapped in that small clean fort while Walt Disney surrounded
them with the engines of war. The Disney wolves and dogs
growled at the walls, mice skirted the parapets.... Outside the fort
were the Disneys, like bus tourists lined up before a gas station
urinal. O smug one come out, they yelled from their pissoir,
O eater of ice cream, longer for calm sleep, make way for us who
are future.
 We have a thousand musicians synchronized to our movements
and ten million carefully framed actions. All possibilities are pre-
drawn. Already, five minutes from now our banner in 35-mm.
color overhangs your roof. Your Alamo Lounge will become a wax
museum, your 28 flavors a single gray Tastee Freeze.... As he
tried to enjoy a quiet meal, the Disney creatures bombarded the

walls with their popcorn machines and stormed the motel on lad-
ders of pink and white peppermint sticks. Fess Parker led them
singing the Davy Crockett anthem.... (pp. 112–113)

While the conflict between Johnson and Disney, each representing dif-
ferent ways of capturing the hearts and minds of their public, culminates
in the mid-sixties, and as such this novel could be considered a "retro"
text, the choice of this period is not motivated by a nostalgia (even a par-
odic one) for a bygone era. The choice of this period emphasizes its pivotal
status in the history of popular culture, due to the advent of television,
the theme park, the superhighway, rising levels of disposable income, and
so on, all of which made for an ever more mobile America where con-
sumers begin to circulate as endlessly as the popular artifacts that
surround them. At this point, American culture is "in transit" in a phys-
ical sense, but also in reference to what this new public considered to be
pleasure or entertainment. Johnson sees his mission as providing com-
fort, a "house" (not a hotel) away from home, where "you were redeemed
from the road" (p. 15), whereas Disney and company build an empire on
the exhilaration of the road, the very foreignness, the fact that enjoyment
comes from displacement. As Milly tells Howard, "The Disneys have
made a happy little nightmare. Making nightmares, Howard, even good
ones, is the opposite of what we've always tried to do" (p. 39). The oppo-
sition between Johnson's travelers and Disney's vacationers represents the
shifting geographic and psychological terrain. For the former, being in
transit, the loss of connection with a sense of place, is a trial to be endured,
but for the latter that loss is the key to maximum entertainment.

As a self-conscious meditation on popular culture, *The Propheteers* culti-
vates rather than avoids the category of "fascination." Through its appro-
priations, the novel adopts a perspective that is neither uniformly
condemnatory, nor uniformly celebratory, opting instead for a *critical*
ambivalence. I use the term "critical" here because that ambivalence is
not a matter of deadpan apathy, but alternation, its lack of consistency
due to the very inconsistency of popular culture, which is made to appear
both captivating and contemptible. This alternation is most explicit in the

relation between Walt and Will Disney, which Apple constructs in terms of popular culture *doppelgänger*, with Walt playing the role of the artist-visionary, and Will the shameless huckster. Each envisions the nature (and eventual functions) of comic figures according to his own set of values.

> An initial philosophical premise separated the brothers on cartoons throughout their lives.... To Walt Disney a mouse was always a mouse. Mouseness, not humanity, was the heart of his creation. The business Disney saw it otherwise. The mouse was only a cute disguise for the man who lurked within. If you put tits on girl mice, then Mickey could walk up and squeeze one and everyone would get a kick out of that. (pp. 147–148).

Where Walt is lost in the joy of drawing, obsessed with refining the act of movement, Will merchandises. One of his abortive projects is to sell Biblical cartoons to the Sunday School market.

> I'd say one good seven minute cartoon that we could put out for less than eighty thousand would revolutionize the Sunday Schools.... We talked to Stravinsky about the music and Vincent Price about the voice, but the Bishop said, "No dice." And this guy George Beverly Shea who does all the Billy Graham arrangements said it was too cute. Imagine a guy like him calling Walt Disney and Stravinsky too cute. Did anyone say De Mille's *Ten Commandments* was too cute? (p. 160)

What happens to Walt's vision is the same thing that happens to Howard Johnson. "HJ felt the motions and the needs of travelers, and he translated his feeling into buildings and watering places. Now, his vision had become a large public corporation" (p. 23). The opposition between individuals and corporations becomes the basis for the novel's ambivalence. Traditional notions of "mass" culture are rendered inapplicable, because the visions of its creators are represented as entirely organic and personal, but the novel resists any kind of naive celebration of popular culture, because the popularization of those visions inevitably leads to their perversion when those visionaries shift from prophets to profiteers. Apple's

own vision may be considered nostalgic, then, but only insofar as it privileges the precorporate moment of development when popular invention remains authentic, a manifestation of a kind of postindustrial "folk" culture that responds to the uniqueness of a newly mobile American culture without a nostalgia for the pretechnological past.

That the original inspiration for and eventual uses of popular invention are most often disconnected, or even contradictory, is most evident in the relationship between C. W. Post and Salvador Dali. Post conceives of his creation (breakfast cereal) not as a commodity, but as a distillation of his vision—in this case a world where cattle will not have to be slaughtered, because everyone will turn to a life of spiritual vegetarianism now that they have a nutritious alternative. C. W. Post's vision becomes most maniacal (and Apple's narration most parodic) when he tries to have meat dishes painted out of Western art, first attempting to acquire some of the greatest masterpieces of European art, most especially *The Last Supper*, and then hiring Dali to replace the offending roasts with tasteful (and even more nutritious) fruit substitutes. This plan inspires an assassination plot directed at Post by his art dealer, and its completion remains a mystery. Not until Marjorie meets Dali years after her father's death does he make his rather startling confession. Initially expressing only contempt for the project, Dali later admits:

> I was 20 years old. If you mentioned Rubens or Leonardo to me at
> that time tears still came to my eyes.... Great art, the glories of
> the past, the mysteries of every brush stroke—you know the whole
> story. It intimidates the young. There are your great-great-grand-
> parents growing more powerful over the centuries, strengthened
> by death, accumulating a whole army of commentators and own-
> ers, each masterpiece becomes like a state over time, with its own
> citizens, its own language, it has rights and privileges. Then along
> comes your father, C. W. Post of Battle Creek, who recognizes
> none of this, is not affected by any worship of the past, considers
> it all idolatry.... Your father's commission cured me of forms of
> forms, of worship of the past. He didn't save the world from idola-
> try, but saved me from it. (pp. 261–262)

This reformulation of the relationship between the realms of popular culture and the avant-garde/High Art is also central to Jay Cantor's *Krazy Kat: A Novel in Five Panels*.[18] Like *The Propheteers*, this text is "retro," appropriationist (abducting figures from the history of both popular and High Art), and extrapolative (inventing entire new existences for popular icons, in this case the characters in George Herriman's legendary comic strip). As in Apple's novel, popular culture furnishes the primary subject matter of the fiction, only here the hyperconsciousness is intensified further by the proliferation of discursive frameworks and the introduction of characters who are not just popular icons, but icons who are self-conscious about their own iconicity, obsessed with their own reception as they circulate through those frameworks.

The novel opens with Krazy Kat and Ignatz now in retirement from their strip career, but contemplating a return. Krazy sits reading trade papers, checking grosses, while Ignatz reads critical essays about them, and ransacks novels looking for plots for their comeback. Krazy muses over the tyranny of the box office and the technological changes that have occurred in storytelling, "from vaudeville to motion pictures, to radio, to television…and next? Computers? Video games? How would the next generation tell its stories?" (p. 5) She also reflects on the current state of the comic pages, particularly the representation of cats. "They were Cute Cats, not Krazy Kats, sentimental Hallmark cards of cats tasting of cardboard sentiments cooked up on assembly lines by anonymous hands…. And with all the sentimentality, she thought, came its ghost, its ugly shadow-—*a book of things to do with a dead cat*…. It was a sick jaded audience that wanted—as these moderns did—to either drown in sugar or…poison mixed with amyl nitrate" (p. 9). Krazy Kat's reveries crystalize Cantor's vision of popular culture—as the intersection of aesthetic, economic, critical and technological factors which are in a constant state of reconfiguration.

That the resonance of popular icons depends entirely on their circulation is emphasized repeatedly through the novel's aggressive eclecticism, in which different discursive formations, each giving different identities to Krazy and Ignatz, roll by like stills in a cultural View-Master. In the

first panel, the Los Alamos project invades the desert world of their comic landscape, at which point the novel begins to mix "shoptalk" about a comeback with Krazy Kat's frustrated desire for Ignatz (and Robert Oppenheimer), along with scenes of nuclear holocaust. The second panel, "The Talking Cure," parodies Freud's correspondence, as Ignatz decides that their new career should be as analyst and analysand. In the third panel, "The Talking Pictures," the characters from the strip meet up with The Producer, with whom they discuss a cinematic comeback, the Producer throwing out one concept after another featuring the pair in a Western, a Musical, a Bio-Pic, and so on. The Producer is remarkably similar to Apple's Will Disney, demonstrating the same obsession with marketing, particularly tie-ins. "That's where the money is nowadays. You people are a potential K Mart full of franchised plastic" (p. 119). In the fourth panel, "The Possessed," Krazy Kat and Ignatz meet the COMISALADS—the Comic Strip Artists Liberation Army, Division One, who call for the death of "Fascist Copyright Holders Who Suck the Brains of Avant-Garde Artists!" (p. 129). This group, obviously a knockoff of the Symbionese Liberation Army (a link made even more explicit by the fact that Krazy Kat and Ignatz belong to "Mr. Hearst"), represents the inevitable conflation of radical politics and television culture, the former obsessed with media exposure, the latter driven by an insatiable appetite for the really new. "Media access sped like a drug through Mouse's blood. Getting on TV Ignatz said *was* the new avant-garde mass art form!" (p. 150). In the last panel, "Venus in Furs," the couple imagine themselves as human beings, inventing their "own" fantasy scenario, at which point the novel changes discourse again, now resembling, alternately, the psychoanalytic case study and hard-core pornography, in which the two try to come to terms with the inherent sadomasochism of Ignatz's brick—throwing, and finally emerge from their ordeal as a wildly successful cabaret act, "Kat and Ignatz."

This eclecticism is not mere "pastiche" because the shifts from panel to panel involve changes in discursive formation, not simply stylistic variations;that is, we see how each formation redefines their image as popular icons, as well as the love relationship between them, in terms of

its own discursive economy, now so wholly institutionalized. Where Lichtenstein's appropriations of popular culture were defined in terms of the institutional framework that was/is museum art, Cantor adopts a different strategy which does not, like the COMISALADS, seek to "liberate" the couple, but instead shows that they are in the "public domain," and as such they are subject to multiple articulations which anchor them in very specific ways. While they circulate from discourse to discourse as mobile signifiers, within the confines of each formation, both their identity and their desire become fixed values. In its juxtapositions of such different discourses, *Krazy Kat* resembles Manuel Puig's *Kiss of the Spider Woman*,[19] but in Puig's novel, pulp romance and psychoanalytic theory, while quite literally adjacent and theoretically complementary, remain distinct, in two different regimes. In *Krazy Kat*, the couples cross the bar, as it were, and invade the theoretical discourse which has already appropriated and categorized their desire. Their very presence as operators of that discourse throws into question its sovereignty. Here appropriation ceases to be an entirely satisfying description of this circulation, in that the earlier forms of appropriation were predicated on the abduction of x while firmly situated within y. In *Krazy Kat*, the circulation of the characters, their ability to inhabit, even impersonate, different discursive identities destabilizes the fixity of any such coordinates.

The traditional distinctions between popular culture and the world of the avant-garde/High Art begin to unravel in *Krazy Kat*, as the coordinates previously used to measure their differences are rendered historically and institutionally contingent. Krazy and Ignatz argue repeatedly through the novel about the need to be more than "just a comic strip," which time and again leads to a discussion of flatness and roundness. For Krazy, "Her art had been what she was—-how could it have been otherwise?" (p. 8), but Ignatz longs:

> to create the new rounder soul that we need for artistic greatness, that Americans need to be rounded, godlike individuals. Like in really good books.... Why not strut uptown to the mansion of high art, of roundness and say that our gift to America could rank with

Eugene O'Neill's or Henry James's? America *needs* a truly democratic high art. America needs a rounded comic strip! (p. 61)

Later, when they are living among the COMISALADS, Ignatz changes his model for artistic excellence to the avant-garde. When Krazy asks him "But Ignatz, didn't people like us the way we were?" he responds, "That was false consciousness on their part. We have to shock and abuse them. They won't like it any more than they like twelve tone music. But our new work will awake them.... We're going to make the future. The future is our audience!" (p. 140). In the last panel, Krazy, in the form of Kate, a graduate student in Art History, turns the tables on Ignatz when she shows him pictures of Pop Art, specifically Jasper John's *American Flag*. Ignatz responds, "'So high art wants to be flat?' Why did he suddenly feel so bewildered?" (p. 213). Kate launches into her own tirade:

The flag is what it is. So it has real presence. Fantasy = Reality. Art = Life. Just like in popular art where Hammett = Spade = Bogart. He's an icon like comic strip characters. Mickey Mouse, say, or Krazy Kat. Mickey isn't a drawing of Mickey. The drawing *is* Mickey.... The popular workers provided pleasure scenarios, liberated zones; the high arts stylized them and gave them back, as if they were a scandal. Trademark soup cans, flatness, same-same repetitions. But who were they shocking? Their own tuxedo dignity! Shock was spicy strychnine on the palette. The popular workers hadn't meant to shock, just to master a sorrow, improvise a pleasure.

Kate's response to Ignatz stresses the variability of all evaluative criteria, that the binary distinction between roundness and flatness can no longer serve as transcendent distinctions of equality when all values are functions of specific institutions. The rejection of Pop Art appropriation of comic book figures like Warhol's, Lichtenstein's, or Fahlstrom's own "Krazy Kat" series (1963–1965) is part of a wider indictment of the discursive formation of museum art, including its critical apparatus. While they read reviews of their cabaret act, Ignatz reacts in disgust:

"This guy is like all the high brow critics you love so much. He's showing how smart he is by writing about us. See, he says, I *can* make something out of junk." Ignatz didn't like these new magazines…their academic discourse peppered with jive talk…. This was not avant-garde popular art, but avant-people being ironic about a little uptown thrill. (p. 240).

This dismissal, considered along with Kat's and Ignatz's "finding themselves" as a cabaret act (in which they make Cole Porter and Larry Hart songs *their own* by singing those songs which seem to illustrate perfectly the rather unusual nature of their desire), suggests that popular culture can continue to be vitally and personally meaningful for both its producers and its audiences if it achieves a kind of hybrid status that is neither an uncritical revivalism nor an avant-garde "wannabe." Cantor's parody of the avant-gardist appropriation, and his advocacy of an eclectic but highly selective appropriation of antecedent forms of popular culture as a way of making affecting statements about the nature of desire in contemporary culture—instead of simply "holding a mirror up to a mirror"—leads to the simple, but inevitable question: is a book like *Krazy Kat* still popular culture?

Before that question can be answered, another has to be posed: by what criteria can that question be answered satisfactorily? The most far-reaching ramification of the MetaPop hyperconsciousness of novels like *The Propheteers* and *Krazy Kat* is their purposeful complication of that question. Neither subject matter nor attitude toward popular culture can be the distinguishing criterion since, in *Krazy Kat*, cartoon animals are the main characters, and the novel concludes with a ringing endorsement of the possibilities of popular culture. Nor can the means of production and distribution serve as a litmus test in this case, since the book was published by a major trade press and sold in mall bookstores as well as university bookstores. If that very hyperconsciousness disqualifies it as popular culture, then certainly Ann Rice's best-selling vampire novels (in which vampires write their best-selling memoirs on word processors, discuss the future of myth, watch movies obsessively, become rock stars, and so on) and the

Batman phenomenon in its various incarnations (which self-consciously foregrounds the re-articulation of superhero narrative) must be excluded as well. Perhaps more appropriate questions are: How we can *not* consider *Krazy Kat* popular culture? And what value there is in making exclusionary distinctions about whether any text is popular culture?

Delimiting popular culture continues to be a viable activity, but only for those who frame it as Other, as that which must be resisted, appropriated (only to be condemned or "transformed"), or dismissed as that which might tarnish the canon or collection. Hebdige's contention that Pop Art erodes the "parallel distinctions" that cast popular culture in a negative light now seems accurate, but premature, more applicable to the Meta-Pop of the eighties than the Pop Art of the sixties. But in a sense, these more recent texts go even further; where Pop Art challenges the "parallel distinctions," it still respects those binary oppositions in order to ensure itself the requisite parameters to be read as a challenge or a violation of those prohibitions, perpetuating them as it contests them. The Meta-Pop text of the eighties dismisses even the viability of such distinctions, except to expose them as obsolete—except, of course, for those institutions (like museum art or the academy) that have such vested interests in maintaining them.

This ongoing redefinition of popular culture *by popular culture* involves different strategies of appropriation because the stakes of its reconfiguration of cultural hierarchies differ so profoundly from earlier forms of appropriationist art. The permutations of these stakes and strategies within the world of the massest of mass culture, namely "Mall Movies" are the subject of the next chapter.

3

When The Legend Becomes
Hyperconscious, Print the...

In a review of *Demolition Man* in the *New York Times*, Caryn James attributes the film's "recycled" nature to Hollywood's fear of innovation, yet she concedes that the film "knowingly takes recycling to a head-spinning, enjoyable extreme." She describes the Sylvester Stallone-Wesley Snipes hit as a "futuristic-action-comedy-cop-movie, though that doesn't begin to exhaust all the elements salvaged from the pop-culture junk heap."[1]

James's critique of the film exemplifies the prevalent critical response toward these popular film narratives which seem to become ever more eclectic and citational—point to the phenomenon, enumerate a few chosen intertexts, and then end with a blanket condemnation of Hollywood's

lack of originality and the all-purpose junk heap of popular culture. Most reviewers, as well as most theoreticians, have been content with issuing pronouncements that appropriationism is now rampant and something ought to be done about it. In the previous chapter I traced the evolution of appropriationism from the Pop-Art of the sixties through the Meta-Pop of the nineties in order to develop an historical framework for understanding the various strategies of re-articulation that have emerged over the past four decades and what stylistic/ideological concerns have animated those developments. This chapter will examine the permutations of hyperconscious textuality in popular film, specifically in regard to "mall movies." How has the art of popular story-telling changed in cultures defined by their semiotic excess?

The foregrounding of a highly eclectic range of intertexts in so many recent popular films needs to be investigated in greater detail, because the significance of these quotations cannot be adequately explained in terms of overheated intertextual relations or the diminished creativity of Hollywood screenwriters. The ubiquity of quotations reflects massive, widespread changes within some of the most fundamental categories of filmmaking and film criticism, namely genre, auteur and national cinema. The eclecticism of contemporary genre films involves a hybridity of conventions that works at cross-purposes with the traditional notion of genre as a stable, integrated set of narrative and stylistic conventions. The primacy of quotation likewise troubles the category of auteur, since cinematic authorship now obviously needs to be reconceptualized in reference to directors whose "personal vision" is articulated in terms of their ability to reconfigure generic artifacts as eclectically, but also as individually, as possible. The stability of the category of national cinema inevitably weakens as well, given the aggressively transnational character of so much of this appropriationism. Ultimately, the ubiquity of this hyperconscious quotation and re-articulation suggests a profound change at the most basic level, that of the narrative contract established between text and audience—what films now promise to deliver in terms of "action" and what audiences now conceive of as entertainment has changed so thoroughly that the cul-

tural function of popular storytelling appears to be in the process of profound redefinition.

Genre Films/Genre Theories: Narrative "Action" in the Age of Total Recall

Perhaps the most useful way to begin discussion of "genre film" in the early 1990s is to look at representative scenes in two quite recent Westerns, each representing in its own way how "genericity" works in contemporary American culture. In *Back to the Future III* (1990), Marty and Doc ride through the desert in what is supposed to be 1885, charging across the landscape in their disabled DeLorean time machine, sitting side-by-side atop the car, drawn by a team of horses. This configuration of drivers, horses and desert is made to resemble not just any stagecoach in any old Western, but *the* stagecoach, namely John Ford's *Stagecoach* (1939)—a parallel made explicit by replicating one of the most famous shots of Ford's film almost exactly. The DeLorean "stagecoach" is pulled through Monument Valley, framed in a high-angle shot, moving diagonally through the frame, accompanied by sound track music that is remarkably similar to the "original." The second scene comes from *Dances with Wolves* (1990). After John Dunbar has taken part in a buffalo hunt and begun his initiation into the tribe, he contemplates the Sioux tribe moving across the horizon, silhouetted against a spectacular sunset, a picturesque vision of an unspoiled West. Dunbar says in a voice-over that he had never encountered a people so completely connected to their environment—"The only word that came to mind was harmony"—at which point we see not the Sioux, but Dunbar framed perfectly in the midst of a magnificent sunset, situated just as heroically and just as harmoniously within that landscape.

I choose these scenes because they represent two divergent types of genre film that circulate alongside one another in current popular culture. One is founded on dissonance, on eclectic juxtapositions of elements that very obviously don't belong together, while the other is obsessed with recovering some sort of missing harmony, where everything works in unison. Where the former involves an ironic hybridization of pure clas-

sical genres in which John Ford meets Jules Verne and H. G. Wells, the lat-
ter epitomizes a "new sincerity" that rejects any form of irony or
eclecticism in its sanctimonious pursuit of lost purity. Despite their appar-
ently antithetical perspectives, both types of genericity have emerged
within the past decade as reactions to the same cultural milieu—namely,
the media-saturated landscape of contemporary American cultures. I use
the term "genericity" here because I want to address not just specific
genre films, but genre as a category of film production and film viewing.
Traditionally, Hollywood studios subdivided their annual production into
specific genre films that, if nothing else, served as a useful way of striking
a balance between product standardization and differentiation.
Maintaining certain formulas that would stabilize audience expectations
and, by extension, stabilize those audiences, was obviously in Hollywood's
best interests. But how does the category of genre "work" today, when
popular entertainment is undergoing such a massive recategorization
brought on by the ever-increasing number of entertainment options and
the fragmentation of what was once thought to be a mass audience into a
cluster of "target" audiences?

Just as generic texts have been a staple of the culture industries, genre
theory has been all-pervasive within the criticism industries. Film scholars
and social historians have tried to explain the cultural significance of the
Western, the melodrama and other popular genres since the 1940s, and
they have employed a number of critical methodologies to explain the
popularity of genres and what that popularity suggests about "mass con-
sciousness." One of the most commonly used approaches, once film study
began to acquire a certain degree of rigor in the 1960s, was myth study,
that is, reading popular narratives as the secularized myths of modern
societies. This work depends on two interconnected assumptions: 1) films
function as explanatory narratives told by multiple storytellers in mul-
tiple versions; and 2) out of this storytelling certain patterns emerge that
reflect how the "mass consciousness" feels about any number of issues at
a given time. The genre-as-myth approach most often incorporated the
work of French anthropologist Claude Lévi-Strauss, whose analysis of
myth in primitive cultures provided a theoretical framework for investi-

gating just how popular stories could be interpreted as a symbolic work-ing-out of a given culture's core values and its most pressing social problems.[2] The most frequently borrowed principle of Lévi-Strauss's methodology was his notion of "structuring antinomies," the binary oppositions around which the conflicts of any number of films were structured. This approach was used by Rick Altman[3] and Jane Feuer[4] in reference to the musical and other genres, but it was most influential in the study of the Western. Jim Kitses, for example, in his introduction to *Horizons West*,[5] presents a table of antinomies that he believes are central to understanding the genre (Wilderness versus Civilization, Individual ver-sus Community, Nature versus Culture, and so on), and Will Wright[6] traces the evolution of the Western by charting the changing configura-tion of the antinomies from the 1940s through the 1960s.

By the 1970s, however, this view that classical genres owe their success to their mythical dimensions came under closer scrutiny. John Cawelti, for example, argued that by the late 1960s to early 1970s, genre films ceased to function as pure, unalloyed myth, and that four types of what he calls "generic transformation" appeared: the burlesque (in which the conventions of the classical genre are pushed to absurd lengths and played for laughs, for example, *Blazing Saddles*, 1974), the nostalgia film (in which the glorious myths of Hollywood's Golden Age are revisited sentimen-tally, for example, *True Grit*, 1978), demythologization (in which the lessons of these classical genre films are revealed to be destructive and deluding, for example, *Little Big Man*, 1970), and affirmation of the myth for its own sake (in which the original myth is seen as antiquated, but nev-ertheless significant in its own way, for example, *The Wild Bunch*, 1979).[7] The chief strength of Cawelti's overview is that it recognizes that Hollywood films could not be considered "pure myth" by the late 1960s, since all four forms of generic transformation frame the classical-genre-film-as-myth at one remove, from a self-conscious perspective in the present, clearly distanced from the imagined Golden Age. The chief lim-itation of Cawelti's argument is his explanation of why these transformations happened when they did. His contention was that "generic exhaustion" occurred largely because a new generation of film-

makers and film viewers (having grown up with television where older Hollywood films were ubiquitous) had acquired a degree of sophistication that made the old stories just that—old stories that failed to describe "the imaginative landscape of the latter half of the 20th century." Surely this increasing sophistication, the result of a fast-developing cinematic cultural literacy, was a major factor in shaping the changes in genre films by the late 1960s to early 1970s, but that explanation doesn't really address the interconnectedness of technological and demographic changes that accompanied those changes in cinematic literacy. The advent of television didn't just increase the average film viewer's stock of stored narrative memories, it actually changed which genres were given highest priority by Hollywood, initially by triggering the industry's move to CinemaScope, Technicolor and stereophonic sound, which resulted in the greater prominence of the Western and the historical epic. By the late 1960s, television's impact on genre films was felt in yet another way. The ubiquity of television in American homes by the 1960s caused a profound shift in the nature of the filmgoing public. Families tended to stay home and watch television, and would venture forth only rarely for special-event blockbusters. A new target audience emerged—namely, the youth audience, or more specifically a college-aged audience—who, by the late 1960s wanted a different form of entertainment, and to a certain extent received it in the form of "countercultural" films such as *The Graduate* (1967), *Medium Cool* (1970), *Zabriskie Point* (1970), *The Strawberry Statement* (1970), *Five Easy Pieces* (1970), which were marketed as a kind of genre unto themselves, alongside the generic transformation films such as *Bonnie and Clyde* (1967), *Little Big Man* (1970), etc. If genre-film-as-myth changed, it was due to the interconnectedness of social, technological and demographic changes that gave rise to target myths for target audiences, a development that has serious ramifications for any claim that popular films reflect some sort of unitary, *mass* consciousness in some abstract sense.

If we are to understand the cultural context of genericity in the late 1980s to early 1990s, we need to examine the current set of preconditions formed by that interplay of cultural, technological and demographic factors. Neither *Back to the Future III* nor *Dances with Wolves* fits any of Cawelti's

categories particularly well—hardly surprising, given the changes that have occurred in popular entertainment since the publication of his essay in 1978. The four types of generic transformation that were simultaneously at work in the 1960s and 1970s may have differed in regard to degree of respect shown a particular genre, but in each case the transformation is one that remains within the confines of a specific genre, whereas the eclectic, hybrid genre films of the eighties and nineties, like *Road Warrior* (1981), *Blade Runner* (1982), *Blue Velvet* (1986), *Near Dark* (1988), *Who Framed Roger Rabbit* (1988), *Batman* (1989), *Thelma and Louise* (1991), *Last Action Hero* (1993) and *Demolition Man* (1993) all engage in specific transformation *across* genres. Just as these eclectic films were a new development in genericity in the 1980s, so too is the "new sincerity" of films like *Field of Dreams* (1989), *Dances with Wolves* (1990), and *Hook* (1991), all of which depend not on hybridization, but on an "ethnographic" rewriting of the classic genre film that serves as their inspiration, all attempting, using one strategy or another, to recover a lost "purity," which apparently preexisted even the Golden Age of film genre.

Just as television changed the nature of popular entertainment in the 1950s and 1960s, a whole range of technological developments had a massive impact on the shape of genre films in the 1980s and 1990s, most especially the astounding increase in VCR ownership that developed in tandem with comparable developments in cable television, premium movie channels and further refinements in both television monitors (specifically, simultaneous display of multiple channels and remote control) and playback options with the introduction of videodiscs and CD video. These interdependent developments cannot be reduced to any one overall effect. Some of the most significant ramifications of this new media technology have been: the exponential increase in the sheer volume of images that were transmitted to or playable in the average household, a comparable increase in software (titles available on videotape, disc, and so on), and parallel developments that allow for both faster accessing and greater manipulability of that reservoir of images. The ever-expanding number of texts and technologies is both a reflection of and a significant contribution to the array—a situation in which diners at Taco

Bell can learn from their placemats that the number of "VCR house-holds" increased from 3.1 percent in 1981 to 73.3 percent in 1991 (facts provided by *Premiere* magazine). That increase is, of course, quite staggering but so is the dissemination of that very information, when bulletins concerning the progression of information cultures come with your burritos.

That a seemingly endless number of texts are subject to virtually immediate random access inevitably alters the relationship between classic and contemporary when both circulate alongside one another simultaneously. This simultaneity does not diminish the cultural "status" of the former, so much as it changes its possible functions, which has far-reaching implications for how genre, and by extension popular culture, function in contemporary culture. The evolution of genre is traditionally conceived as a three-stage pattern of development. There is an initial period of consolidation in which specific narratives and visual conventions begin to coalesce into a recognizable configuration of features corresponding to a stable set of audience expectations. This period is followed by a "Golden Age," in which the interplay of by now thoroughly stabilized sets of stylistic features and audience expectations is subject to elaborate variations and permutations. The final phase is generally described in terms of all-purpose decline, in which the played out conventions dissolve, either into self-parody or self-reflexivity (end-of-the-West Westerns, from *The Man Who Shot Liberty Valance* (1962) to *The Shootist* (1976).

This three-stage model, however, doesn't adequately explain the reemergence of the Western, primarily because that resurgence is in many ways unprecedented. Rather than conceiving of the return of the Western as some kind of "fourth stage," it is perhaps more profitable to see this "renaissance" phase in terms of technological and cultural changes that have produced a set of circumstances in which the central function of genericity is in the process of being redefined. The "recyclability" of texts from the past, the fact that once-forgotten popular texts can now be "accessed" almost at will, changes the cultural function of genre films, past *and* present. The omnipresence of what Umberto Eco has called the "already said,"[8] now represented and recirculated as the *still-*

being-said, is not just a matter of an ever-accumulating number of texts ready to be accessed, but also involves a transformation of the cultural terrain that contemporary genre films must somehow make sense of, or map. If genre films of the 1930s and 1940s functioned as the myths of Depression-era and wartime American culture, how do they function when they come back around as classics or just campy old movies? How does the cultural work of these genre films change, especially when these mythologies of earlier periods now coexist alongside the "new" genre films and the mythologies they activate, when *Unforgiven* is circulated as both a "classic Western" and as a "noir Western" at the same time?

If the genre texts of the 1960s are distinguished by their increasing self-reflexivity about their antecedents in the Golden Age of Hollywood, the genre texts of the late 1980s to early 1990s demonstrate an even more sophisticated hyperconsciousness concerning not just narrative formulae, but the conditions of their own circulation and reception in the present, which has a massive impact on what constitutes the nature of popular entertainment. The emergence of the "meets" film epitomizes the increasing hybridity and reflexivity of popular narratives. I'm refering here to the ubiquitous descriptions of hybrid genre films, in which "Film Noir Title" *meets* "Science Fiction Title", or "Western Title" *meets* "Blaxploitation Title" or "Gangster Title"…and so on. This generic triangulation, in which a given film is presented as a cross between at least two formerly distinct genres has become a commonplace category in and of itself. In the opening shot of *The Player* (which is itself an extended reference to Welles' *Touch of Evil*) the dialogue of Altman's movie people parodies exactly this hybridization, as writers pitch their story concepts, "It's *Out of Africa* meets *Pretty Woman*," "It's not unlike *Ghost* meets *Manchurian Candidate*…."

While these imaginary combinations are clearly intended to be farcical, the films of John Woo (specifically the two most widely distributed in the United States, *The Killer* and *Hard-Boiled*) have generated dozens of reviews that attempt to describe these films in remarkably similar ways. Yet the use of generic triangulation to account for the distinctiveness of Woo's films is inevitable, given the eclectic appropriations of his aggressively

transnational style. Stephen Holden described *The Killer* in a *New York Times* review as "An unlikely fusion of *The Wild Bunch* and *Dark Victory*,"[9] J. Hoberman characterized it in *Premiere* as "*Magnificent Obsession* remade by Peckinpah,"[10] and Maitland McDonagh, in a more extended appreciation of of Woo's films in *Film Comment*, says of Woo's *Bullet in the Head*, "Woo's favorite themes are all present in this hybrid of *The Deer Hunter* and *Casablanca*."[11] These characterizations seem, if anything, rather conservative regarding the range of Woo's quotations. In this same issue of *Film Comment*, Woo tells an interviewer that his gangster films represent an amalgamation of his own early kung fu films, Kurosawa's samurai epics, Jean Pierre Melville's Westernized, existentialized samurai gangsters in *Le Samourai* and *Bob le Flambeur*, poetic freeze-frames borrowed from Truffaut (especially *Jules et Jim*) and choreography from Hollywood musicals, such as *Singin' in the Rain, West Side Story* and those starring Fred Astaire.[12] The intertextual arena Woo articulates here is both transnational and *transhierarchical*, through his juxtapositions of conventions drawn from Asian, European and North American films, and his rejection of the traditional distinction within the international film market between art cinema and the action/exploitation film. Woo may have been the director of choice for the new Jean Claude Van Damme "action pic," *Hard Target* (1993) but he was also subject of a feature story in the *New Yorker* which, while maintaining a condescending tone throughout the profile, nevertheless acknowledged that Woo was the hot new *auteur* on the international film scene.

The final shoot-out in the church at the end of *The Killer* exemplifies the transnational and transhierarchical nature of Woo's appropriations. After an extended period of gunplay, featuring dozens of deaths shot in the style of a kung fu musical directed by Peckinpah, one of the mobsters shoots the statue of the Virgin Mary, which explodes in slow motion. This is immediately followed by an abrupt track-in to close-ups of both the killer and the good-bad-cop he's befriended, accompanied by a shift in the sound track in which ambient gun-fire is suddenly replaced by the opening of Handel's *Messiah*, played by a full orchestra. Marking the reactions to the explosion in this way momentarily suspends the action film

formulae in favor of European high-art signifiers that make the film comparable, at least at that moment, in its use of a classical music for emotional/intellectual impact, to the cinema of Truffaut, Visconti or any number of European auteurs. What is missing from all the various "meets" characterizations of *The Killer* is this purposeful confusion of the categories of art cinema and pulp adventure: the film may be described as *Magnificent Obsession* remade by Peckinpah but also, just as appropriately, as *Enter the Dragon* remade by Visconti. This sort of transnational/transhierarchical juxtaposition is clearly not restricted to Woo's films; Asian gangster iconography and codes of behavior have been widely appropriated in North American popular cultures, from the *yakuza*-style hit men and *zaibatsu* kingpins who figure so prominently in the novels of William Gibson to the overt incorporation of samurai mythology in comic books like Frank Miller's *Ronin* (DC 1983–1984). This particular type of eclecticism suggests that new forms of generic hybridity have indeed begun to reflect the" imaginative landscape of the latter decades of the 20th century," but it is a landscape thoroughly mediated by popular culture, a landscape whose contours are defined by patterns of circulation and exchange rather than being just sites of production.

What distinguishes Woo's films then, in a period when eclectic appropriation in and of itself is no longer individuating, is not the range of their intertextual quotations but, rather, their precise configuration. The traditional relationship between genre and auteur—in which the former was synonymous with the formulaic and the mythic, and the latter synonymous with the intensely personal—no longer holds in quite the same way when directorial signature has become increasingly a matter of a distinctive style of generic reconfiguration, as evidenced by the instantly recognizable, but wildly disparate styles of appropriationist auteurs like John Woo, David Lynch, Aki Kaurismaki, Tim Burton, Robert Zemeckis, Ridley Scott, Sam Raimi, Penelope Sphreris, Joe Dante and Juzo Itami. In each case, quotation is inseparable from narration, the former determining both the *range* of intertexts used to advance the "action," and their *register*, that is, the degree of ironic distance or empathetic involvement that the viewer is expected to mobilize from scene to scene. The differ-

ences between Woo, Lynch and Zemeckis's brands of appropriation, for example, are thrown into sharp relief if compared according to range and register, the specific intertextual arenas they construct, and the degree of tonal variability that results. In Woo's films the range of intertexts may be especially transnational and transhierarchical in scope (Sirkian melodrama, martial arts, European art cinema and so on) but relatively limited in regard to breadth of register, alternating between the intense visceral engagement called for by the action scenes and an empathetic identification demanded by the more sentimentalized male-bonding, a-samurai's-gotta-do-what-a-samurai's-gotta-do scenes that punctuate the action footage. In each case a knowing cinematic literacy comes along for the ride, but it seldom undermines the dominant register of the scene, as in *Hard-Boiled*, when the police detective, played by Chow Yun Fat, narrates the action to the baby he holds in his arms during the shoot-out, commenting in rap-lullaby style on the "X-rated violence" that surrounds them. Woo's films are both cine-literate and visceral, wearing their appropriations proudly on their blood-drenched sleeve.

The work of David Lynch, especially *Blue Velvet, Wild at Heart,* and the TV series *Twin Peaks*, also depends on a broad range of intertexts, but it is the variation in register that distinguishes Lynch's eclecticism. Woo's quotations contribute to the formation of a transnational operatic style in which seemingly everything is taken to excess with utmost intensity; Lynch's quotations, while wide-ranging only within one national culture, are particularly excessive in regard to their variability of register within one and the same scene. Since I have discussed the "suspensive" nature of Lynch's narration at length elsewhere,[13] I'll concentrate here on one representative scene in *Blue Velvet*, the one in which Frank does his rendition of "In Dreams." Frank menaces Jeffrey in one of the most suspenseful scenes in the film, and the exchange of tight close-ups on their faces intensifies the viewer's discomfort, as we are positioned between them, with the maniacal Frank "in our face" as much as he is in Jeffrey's. Lynch cuts away from these alternating close-ups to show us the reaction shots of two diegetic spectators—Dorothy, inside the car, frantic with anticipation, and another women standing on the roof of the car directly above

her, go-go dancing to the music. The former encourages the viewer to empathize and draws us further into the drama through her screams, while the latter pulls us out of it, dancing to what, for her, is formulaic spectacle, but with a great beat. By giving both the pop song and the crime genre antithetical registers within the same scene, Lynch creates two levels of narrative action—one which revolves around character adventure and another which concerns the film's own adventures as it delves into the array, into the accumulated layers of popular culture stored within the screen memories of individual viewers.

The range and register of the different types of cinematic eclecticism ultimately depend on what sort of fictional universe is constructed by a given text, whether that diegesis is be perceived as a real world (for at least the duration of the film), or if it is to meant to be taken as a purely cinematic universe in which the only reality is the the historicity of previous forms of popular entertainment. The eclecticism of Robert Zemeckis's films (*Who Framed Roger Rabbit?* and the *Back to the Future* trilogy) exemplifies the latter sort of fictional universe which determines both the range and the register of his appropriations. Two scenes from *Back to the Future III* are useful examples in this regard. In this film we follow the adventures of Marty and Doc on the Western frontier of the 1880s, but we are also encouraged to take simultaneous delight in the intertextual adventures that *Back to the Future III* engages in as it negotiates the array of the postmodern frontier. When the characters travel back in time to the Old West, their trip is actually a voyage into the Old Western, a point made most explicitly in the scene where Marty attempts to drive back to the 1880s to rescue Doc from certain death. His avenue to the past is the film screen, a metaphor literalized by his driving the time machine through a drive-in movie screen in order to reach the past. The screen, then, serves as a portal to a nineteenth century that can exist only in the form of images, in the form of cinematic reconstructions, and their very materiality is overtly foregrounded by the text, a point made especially explicit by the fact that the drive-in happens to be located within Monument Valley. Once back in the Old Western, where the painted image of Indians gives way to the real Indians (!) who chase the DeLorean across the desert, Marty looks

into his rearview mirror to check their location. This point-of-view shot, perhaps the most representative shot in the film, synthesizes in a single image the relationship between past and present and between genre and postmodern culture. This image, a close-up of the mirror from Marty's perspective, frames the approaching Indians perfectly—the viewer sees "history," but only as an image from the rearview mirror of the present. The literalizing of yet another metaphor concerning the visibility of the past from the present foregrounds once again, in comedic terms, one of the main themes of postmodern historiography—that history exists in the present only in forms of representation, that the significance of the past depends on how it's framed in the present. This, of course, has led to charges of trivialization of history; that is, evil postmodern culture has "reduced" the world to images that it then cannibalizes, as if "History" were somehow accessible to us without the mediation of representation, and as such possesses some kind of "sanctity" that cannot be treated iron-ically through such juxtapositions. In this foregrounding of time travel as a process inseparable from the production of images, *Back to the Future III* resembles Julian Barnes's *History of the World in 10 ¹/₂ Chapters*, in which the narrator states:

> We cling to history as a series of salon pictures, conversation pieces whose participants we can easily reimagine back into life, when all the time it's more like a multi-media collage. ...The his-tory of the world? Just voices echoing in the dark; images that burn for a few centuries and then fade; stories, old stories that sometimes seem to overlap; strange links, impertinent connec-tions.[14] (p. 240)

Within the Old West of *Back to the Future III*, viewers enter a narrative uni-verse defined by impertinent connections, no longer containable by one set of generic conventions. They encounter, instead, different sets of generic conventions that intermingle, constituting a profoundly inter-textual diegesis, nowhere more apparent than in the shot of the DeLorean time machine being pulled through the desert by a team of horses, the very copresence of John Ford and H. G. Wells demonstrating the film's

ability to access both as simultaneous narrative options, each with a set of conventions that can be recombined at will. This simultaneity of options, each subject to a kind of random access, is epitomized by the scene in which Marty prepares for his final showdown with the villain. While practicing his draw in the mirror, dressed as Clint Eastwood in *A Fistful of Dollars* (1966), he calls up a few tough-guy lines, opting first for Eastwood's "Make my day" from his Dirty Harry/Hard-boiled incarnation (*Dirty Harry*, 1971), then Travis Bickle's "Are you talkin' to me?" routine from *Taxi Driver* (1976). The simultaneous accessibility of the Spaghetti Westerner, the Hard-boiled Cop, and the Urban Psychopath as potentially heroic poses functions as a more sophisticated version of the printouts that the Terminator sees before his eyes in Cameron's 1984 film, a menu of relevant lines that can be selected according to immediate need. The fact that the hero's choices are all cinematic quotations reflects not just the increasing sophistication of the cinematic literacy of *Back to the Future*'s audiences (and the profoundly intertextual nature of that literacy), but also the entertainment value that the ironic manipulation of that stored information now provides.

In contemporary popular culture, we see both the menu and its misuse; while the Terminator's options are all *appropriate* to a given situation, Marty's options are all *appropriated* from divergent contexts, all relevant insofar as they serve as macho poses, but inappropriate in that they purposely confuse time and genre. The Dirty Harry and Travis Bickle quotations are latter-day manifestations of the conventional gunfight, anachronisms in relation to the 1880s, but flashbacks in reference to the 1990s. Their copresence in this scene reflects not the alleged "collapse of history," but a simultaneity that functions as a techno-palimpsest, in which earlier traces can be immediately called up, back to the surface to be replayed, or more precisely, recirculated. The act of appropriation problematizes distinctions between appropriate and inappropriate, as well as the stability of the categories of shared information that we might call cultural literacy. The categories are inappropriate only in reference to the *topoi* of the Old Western, but entirely appropriate to a culture in which those *topoi* have become one of a series of push-button options. This fore-

grounded, hyperconscious intertextuality reflects not just a change in terms of audience competence or narrative technique, but a fundamental shift in what constitutes both entertainment and cultural literacy in the "Information Age."

Contemporary film criticism has been unable to come to terms with these very profound changes in the nature of entertainment because this hyperconscious eclecticism is measured against nineteenth-century notions of classical narrative and realist representation. The indictment drawn up by critics on the "left" and "right," who are horrified by this unmanageable textuality that refuses to play by the old rules, always takes the same form—hyperconscious eclecticism is a sign of (choose one): a) the end of "Narrative"; b) the end of "the Real," or "Real History"; c) the end of art and entertainment for anyone other than overstimulated promiscuous teenagers; d) a sign of moral and intellectual decay. All of this has been caused by: a) the all-purpose postmodern malaise that is hell-bent on recycling the detritus of Western Civilization instead of presenting us with the "really Real," "History" and so on; b) the overwhelming desire for perpetual stimulation that makes reading "Great Books" or watching "fine films" passé; c) shorter attention spans caused by television, advertising, rock music, and permissive child-raising; d) unbridled greed in people who have read neither (choose one) Aristotle nor Marx; e) technology in the hands of people described in d). What is also left out of these pronouncements is the possibility that the nature of entertainment, narrative, art, identification may be undergoing significant reformulation due to widespread changes in the nature of information distribution, access and manipulability. That this simply doesn't exist as an option reveals the tenacity with which social critics, from Allan Bloom to Jean-Louis Baudrillard still cling to notions of art, epistemology and signification that were developed, at the very latest, in the nineteenth century. The following quotations from Allan Bloom, Richard Schickel and Mark Crispin Miller suggest the common concerns as well as the hysterical tenor of these condemnations of this new, berserk *Zeitgeist*, in which all forms of art and entertainment have become pernicious:

Picture a thirteen-year-old sitting in the living room of his family home, doing his math assignment while wearing his headphones and watching MTV.... A pubescent child whose body throbs with orgasmic rhythms, whose feelings are made articulate in hymns to the joys of onanism or the killing of parents.... In short, life is made into a nonstop, commercially prepackaged masturbatory fantasy. [15]

Essentially a youthful crowd, this audience does not have very sophisticated tastes or expectations when it comes to narrative. Given that lack, they may never ask for strong, persuasive story-telling when they grow up. What we get...is not narrative as it has been traditionally defined, but a succession of undifferentiated sensations...there is in fact no *authentic* emotional build-up, con-sequently no catharsis at the movie's conclusion.... For in most movies today the traditional function has been inverted. Instead of the major dramatic incidents growing *naturally* out of the story, that is, out of the interaction of plausible characters with a recog-nizable moral and physical landscape, the opposite occurs.... [W]e are left without consoling coherences of old-fashioned movie narrative, left with anarchy, picking through the rubble it leaves in its wake, wondering what hit us.[16]

We rarely see the kind of panoramic composition that once allowed a generous impression of quasi-global simultaneity...and that also, more subtly enriches the frame in most great movies, whose makers have offered *pictures*, composed of pleasurable 'touches' and legible detail. These moving tableaux often, as André Bazin argued, gave their viewers more choice, and required some (often minimal) interpretive attention. Only now and then and in films that don't come out of Hollywood—Terry Gilliam's *Brazil*, Stanley Kubrick's *Full Metal Jacket*—do we per-ceive such exhilarating fullness. In contrast, today's American movies work without or against the potential depth and latitude of cinema, in favor of that systematic overemphasis deployed in advertising and all other propaganda.[17]

The all-purpose complaint about over-stimulation is framed by Richard Schickel in reference to its devastating impact on narrative, but what exactly is in crisis—narrative, or just traditional notions of that narrative that depend on coherence, plausibility, *authentic* emotional buildup, *natural* outgrowths and catharsis? This list of requirements grows out of conventions first developed in classical tragedy (and codified most obviously in Aristotle's *Poetics*) and then expanded in realist theater and literature of the nineteenth century. According to this definition, virtually all modernist and postmodernist stories would be deficient narratives. The only acceptable film narratives would appear to be those that are simply cinematic versions of nineteenth century models. Cultural changes that have occurred in the twentieth century apparently should have no impact on the well-made narrative. But even if we bracket this problem and ignore the obvious condescension in the dismissal of viewers less "sophisticated" than Schickel, the most serious problem with his narrative complaint has to do with yet another stipulation—the "recognizable moral and physical landscape" that characters must inhabit. This definition simply dismisses another possibility—that the popular narratives of the 1980s and 1990s present a moral and physical landscape in a state of previously unfathomable change and that these stories just might be attempts to make the chaotic, dissonant cultures of the later decades of the twentieth century somehow more manageable through their presentation of a new mediated landscape that can be successfully mapped out only by contemporary media, and not some antiquated notion of the well-made play. The alternatives that Schickel offers—classical narrative or anarchy—bear an uncanny resemblance to the binary, either/or, all-or-nothing opposition proposed by Matthew Arnold in *Culture and Anarchy*;[18] culture can only be "Culture" if it imitates the culture of any time *other than* the present.

Mark Crispin Miller's condemnation of contemporary film style is cast in the same nostalgic mode, but his presuppositions regarding what films supposedly "worked" in the good old days are even more problematic. Schickel's nostalgia is for old-fashioned storytelling that did indeed exist (and still does to a far greater extent than he is willing to allow), while

Crispin Miller pines for an imaginary filmviewing state that never existed, based as it is on André Bazin's now-discredited assumptions concerning the relationship among the camera, reality and the spectator.[19] Miller's argument concerning the negative impact that advertising has had on filmmaking is a rhetorically powerful argument, but his grand alternative—how film used to work—hinges on a thoroughly outdated understanding of filmic representation. By invoking Bazin's idealist theory of representation, in which true cinematic geniuses allow the photographic plate to capture the "real" in an unmediated way, thereby allowing truth to leap directly onto the celluloid strip, Miller posits an authentic or genuine form of representation against which all other types of film practice will be automatically judged deficient. The problem here, of course, is this notion of film as unmediated reality, a "fullness" that spectators were able to contemplate, free to formulate their own interpretations out of the essential ambiguity of the filmic image. One of the main themes of film theory since the late 1960s has been the rejection of this sort of idealism, and a number of theorists have delineated the various stylistic, institutional and ideological apparatuses that intervene between camera and "reality," and then between image and spectator, all of which demonstrate that these relationships are never as unmediated as Bazin imagined them to be.[20] Miller's sweeping rejection of Hollywood filmmaking rests on his appeal to a "classic" film style as imagined by an antiquated film theory developed in the 1950s to describe the masterpieces of the 1930s and 1940s. It should come as no surprise that such an approach would provide only a blindered view of recent filmmaking, unable to come to terms with the highly "mediated" nature of our contemporary cultural existences and the images needed to represent them. The "exhilarating fullness" of this world is due to the fact that the real now comes to us always already "imaged" in any number of ways, the "depth and latitude" of contemporary cinema depending on the negotiation of that thickness of representation, those sedimented layers of images that define the cultural significance of any subject matter.

In all such attacks on current popular film decrying its avoidance of traditional narrative and authentic representation, one finds the same

assumption—that the increasing sophistication of the media produces a sensory overload in which individual viewers are overstimulated into numbness, reachable only through blunt appeals to animal appetites. But these technophobic denunciations of media "overload" never even begin to address the distinguishing features of recent popular narratives, namely the attempts to directly encounter that "overload," that semiotic excess, and turn it into a new form of narrative entertainment that necessarily involves altering the structure and function of narrative. Tim Burton's *Batman* is a useful example here, because it exemplifies these attempts to incorporate the array that now forms the "imaginative landscape" of contemporary cultural life, and the criticism devoted to the film by Schickel and Miller epitomizes just as neatly the failure of the antiquated paradigms they use to evaluate the film. Miller dismisses *Batman* as part of the "cartooning" of Hollywood, and Schickel cites it as one more example of deficient narrative, of visual pyrotechnics instead of plot: "Its story—the conflict between its eponymous hero and the Joker for the soul of Gotham City—is all right, kind of fun. But that is not what the movie is primarily about. It is about—no kidding—urban design."[21] But Burton's film is about far more than urban design. It presents a decidedly "old-fashioned" plot, but it also situates the adventures of Batman and the Joker within the mediated culture of the present, and makes their manipulation of the images that surround them a crucial part of their battle. *Batman* is not just vaguely symptomatic of how popular narratives try to envision the array—its main characters actively engage in different strategies of image play. Throughout the film, the Joker appears in his headquarters, producing "cutups" from the photographs that surround him, and then in a later scene at the museum he defaces one painting after another, by either painting over the original or writing his name over the surface. His "hijacking" of signs becomes most explicit in his seizure of the television signal, when he interrupts scheduled programming with his own parodic advertisements. Batman's appropriation of images works according to a quite different dynamic. Like the Joker, Batman seems to spend a significant amount of time watching television, and also like his adversary, he is shown surrounded by images that he

manipulates for his own purposes. Just as the Joker appears practically engulfed by the photographs he cuts up, the first sequence in the Batcave presents Batman in front of a bank of monitors, surrounded by footage of his guests that his hidden cameras have recorded, images that he "calls up" (rather than "cuts up") in order to summon a reality that escaped his purview the first time around. While the Joker's manipulation of images is a process of consistent deformation, Batman engages in a process of retrieval, drawing on a reservoir of images that constitutes the past. The tension between abduction and retrieval epitomizes the conflicting but complementary processes at work in the film—a text that alternately *hijacks* and *accesses* the traditional Batman *topoi*, German Expressionism, Gaudi's *Sagrada Familia* Cathedral, Hitchcock films, and so on.

This self-referentiality, which has emerged as a response to the array, is directly comparable to parallel developments in other disciplines. Mark Poster's recent work on modes of information specifies very productively the impact of new technologies on the nature of information, yet it also reveals the necessity of dealing with the second half of the problem—the need to specify emerging forms of textuality used to manipulate the array. He argues:

> the complex linguistic worlds of the media, the computer and the database it can access, the surveillance capabilities of the state and the corporation, and finally the discourse of science are each realms in which the representational function of language has been placed in question by different communicational patterns, each of which shift to the forefront the self-referential aspect of language. In each case, the language in question is constituted as an intelligible field with a unique pattern of wrapping, whose power derives not so much from representing something else, but from its internal linguistic structure. While this feature of language is always present in its use—today, meaning is increasingly sustained through mechanisms of self-referentiality and the non-linguistic thing, the referent, fades into obscurity, playing less and less of a role in the delicate process of sustaining cultural memory.[22]

While Poster wisely acknowledges the plurality of discontinuous modes of information, each with its own historical peculiarities, he still maintains that this self-referentiality necessarily means the loss of the "really Real" referent, which has only devastating effects on communication and subjectivity:

> instead of envisioning language as a tool of a rational autonomous subject intent on controlling a world of objects for the purpose of enhanced freedom, the new language structures refer back upon themselves, severing referentiality and thereby acting upon the subject and constituting it in new and disorienting ways. (p.75)

But do these new structures sever referentiality or just redefine the nature of referentiality? The notion of the referent posited here presupposes that this self-referentiality necessarily replaces any other kind of referentiality, yet this argument offers no compelling reason to assume that self-referentiality, *ipso facto*, cancels out other types of referentiality. The self-referentiality that is symptomatic of communication in techno-sophisticated cultures recognizes the highly discursive, thoroughly institutionalized dimension of all signs. At this point these signs become doubly referential, referring to a "really real" world, *and* to the reality of the array that forms the fabric of day-to-day experience in those very cultures. The individual negotiations of the array form the delicate process of not just maintaining but constantly rearticulating cultural meanings.

This "double referentiality" that serves as the basis for the strategies of *re-articulation* has been discussed in the work of Ann Cvetkovich, Cathy Griggers, Sharon Willis and Ava Preacher Collins.[23] The individual voguers in *Paris is Burning* (1990), Callie Khouri's screenplay for *Thelma and Louise* (1991), and Jarmusch's use of Elvis in *Mystery Train* (1989), all recognize the inseparability of these two levels of referentiality in regard to notions of gender and racial difference, the nature of sexual preference and the determination of cultural value. All such distinctions are patterns of signs, conventionalized in such a way that they are now taken to

be "real" and therefore must be exposed as such through strategies of re-articulation which change that real by foregrounding mechanisms of referentiality. *Thelma and Louise* addresses the reality of the subjugation of women through its concerted reworking of the reality of the buddy film and the Western, repeatedly emphasizing the interconnectedness of gender difference and cinematic representation. Willis states this very succinctly:

> We women were raised on the same cinematic and televisual images that men were, and we were identifying, perhaps with more resistance or more intermittance, but identifying all the same, with the same male figures and masculine scenarios as our male contemporaries. This must be the framework in which images of women raiding those nearly worn out stories, trying on those clichéd postures might have the effect of "newness" and might challenge our readings of those postures themselves, as it might challenge our analyses of process and the effects of identification in our histories as consumers of popular culture.[24]

Rather than *dis*orientation, these strategies of re-articulation, which reflect a hyperconsciousness about the impact of images on social categorization, are a process of *re*-orientation conducted on and through that double referentiality.

The divergent, often conflicting ways in which recent narratives re-articulate conventional structures of popular genres have become a distinguishing feature of contemporary textuality, but there is no uniform politics of re-articulation, anymore than there is a single aesthetic of re-articulation. The ironic, hyperconscious reworking of the array varies, from the flat-out comedic parody of *Back to the Future III* to the more unsettling, ambivalent parody of *Blue Velvet*, to the explicit hijacking of signs in a film such as *Thelma and Louise*. While stakes and strategies may differ profoundly, they do have one thing in common—the recognition that the features of conventional genre films subjected to such intensive re-articulation are not the mere detritus of exhausted cultures past— those icons, scenarios, visual conventions continue to carry with them

some sort of cultural "charge" or resonance that must be reworked according to the exigencies of the present. The individual generic feature, then, is neither detritus nor reliquary, but an *artifact* of another cultural moment that now circulates in a different arena, retaining vestiges of past significance reinscribed in the present.

In their frustration of the homogeneity and predictability considered the prerequisite for "genericity," these hybrid popular narratives present a paradoxical situation in which we encounter texts composed entirely of generic artifacts that contradict, as an assemblage, the function of genre as coordinator of narrative conventions and audience expectations. I use the term "artifact" here because the individual icon or semantic feature acquires a kind of different status, not really the same element as before, since it now comes back with a set of quotation marks that hover above it like an ironic halo. But neither is really an exhausted piece of debris ready to be camped up. Finding an analogous sort of transformation is extremely difficult, because this transformation process is, to a great extent, unprecedented. One could point to the transformation/transportation that a tribal artifact undergoes when it is placed in the museum, when, for example, the ceremonial mask or door lock becomes revalued as minimalist sculpture once it is solidly ensconced not just behind the glass, but with the institutional frameworks that guarantee its new value. Rather than the figural becoming merely functional, the poetic degraded to common prosaic speech, here the functional acquires a figural status, becoming marked as a special kind of expression that can no longer be taken literally. Generic artifacts, like tribal artifacts, acquire new discursive registers unforeseen in their initial contexts, but they differ in regard to the stability of the rearticulation. Where the new value given to the mask is anchored by the discursive formation that is museum art, the generic artifact remains unanchored, subject to multiple transformations, multiple transportations, while still retaining vestiges of the original semantic and syntactic relationships that once gave it a precise generic value.

When the legend becomes hyperconscious, print the array.

And the Only Words That Came to Mind Were
"The New Sincerity"

Getting an adequate picture of contemporary genericity depends on our ability to recognize widespread changes in what constitutes narrative action and visual entertainment, but these ironic, eclectic texts are not the "whole story," or more appropriately, are not the *only* story. Another type of genre film has emerged since the late 1980s, that also responds explicitly to the same media-sophisticated landscape. Rather than trying to master the array through ironic manipulation, these films attempt to reject it altogether, purposely evading the media-saturated terrain of the present in pursuit of an almost forgotten authenticity, attainable only through a sincerity that avoids any sort of irony or eclecticism. Films such as *Dances with Wolves, Hook* and *Field of Dreams* all fix this recoverable purity in an impossible past—impossible because it exists not just before the advent of media corruption, but because this past is, by definition, a never-never land of pure wishfulfillment, in which the problems of the present are symbolically resolved in a past that not only did not, but could not exist.

In *Dances with Wolves*, that lost authenticity is situated in a West before the Western "got to it." In other words, the narrative of *Dances* focuses on the life of Native Americans before the arrival of the white man, a period traditionally ignored by the Western film. For most of the film, the only white man on the scene is John Dunbar, and he takes on the role of protoethnographer, rather than that of settler. His chief activity, observing and cataloguing the Sioux way of life, respects the purity of that tribe's existence. Dunbar's journal becomes all-important in this regard, since it serves as a guarantee of the authenticity of his position as ethnographer and as a symbol of his difference from other white men—a point made especially obvious when his journal is used as toilet paper by a pair of the most repulsive cavalrymen.

But *Dances with Wolves* makes this prehistory of the Western the site of another project—beyond an ostensible desire to depict the previously undepicted—in which the problems of white America of the 1990s are first diagnosed and then solved in the imaginary of that prehistory. The film repeatedly attempts to "demythologize" the classic Western, whether

by inverting conventions or by presenting what *really* happened. The manifest-destiny ideology that floated implicitly or explicitly throughout virtually all classic Westerns concerned with the settling of the West is rewritten as a ruthless imperialism. The traditional structuring antinomy, Civilization versus Savagery, comes into play, but the polarities are reversed, as the Sioux become the model civilization. This reversal reaches its culmination in the final scene, in which the heroic Indian warriors recapture Dunbar, now one of their own, and kill off a few soldiers (now defined as savages) in the process. But at the same time, this rewriting of the history of the Western expansion from the perspective of Native Americans is far from an end in itself. The other major project of the narrative, John Dunbar's self-actualization, is thoroughly intertwined with that rewriting; the virtues of the Sioux of the 1860s expressed in terms of another ideology generated by white America, specifically a "New Age" mentality that becomes increasingly prominent in the second half of the film, when Dunbar "finds himself." While the Sioux language may be respected here in an unprecedented manner through the use of subtitles, the content of their speech resembles what my students called the "California speak" of the present.

The complicated, conflicted agenda of the New Sincerity genre becomes apparent in the "harmony scene" mentioned in the introduction to this essay. After Dunbar takes part in the buffalo hunt and the celebration afterward, he watches the tribe move on the next day. The scene begins with a long pan across a breathtaking sunset—a tableau shot in the tradition of the classic Western, with the Sioux exquisitely silhouetted as dark figures on the crest of the horizon against the purple sky. This extremely painterly composition, when combined with Dunbar's voice over, accords the figures an almost divine status:

> "It seems everyday ends with a miracle here. And whatever God may be, I thank God for this day. To stay any longer would have been useless. We had all the meat we could possibly carry. We had hunted for three days, losing half-a-dozen ponies, and only three men injured. I'd never known a people so eager to laugh, so

devoted to family, so dedicated to each other, and the only word
that came to mind was harmony."

When we first see Dunbar, it is from the side, observing the tableau from
the distance in a completely different light zone. But as the scene pro-
gresses, his point-of-view shots of this awe-inspiring, harmonious
spectacle alternate with shots of Dunbar, now framed by exactly the same
majestic purple sunset. As he waves to his companions, he has been vir-
tually united with them, set in harmony with them through the lighting
and his Sioux chest-protector. Once this solidarity is established, he paus-
es, and the last shot of the Sioux is followed by a low-angle close-up of
Dunbar that monumentalizes him still further as he says, "Many times
I'd felt alone, but until this afternoon I'd never felt completely lonely."

The progression here epitomizes the interdependency of the rewriting
of history and the process of self-actualization in which the former
repeatedly gives way to the latter. The voice-over praises the Sioux, but
in the images they are framed as a decorative cluster of Noble Savages,
with only the sympathetic White Man receiving the big close-up.
Paradoxically, this scene, while it locates authenticity in the prehistory of
the Golden Age of the Western, uses the Native American in a way that
is remarkably similar to that employed by early nineteenth-century
European fiction, such as Chateaubriand's *Atala, or the Love of Two Savages in
the Desert*,[25] which virtually deified the Noble Savage. The ultimate
"authenticity" here depends upon another exigency—whether the plight
of the Noble Savage of the past can serve as a satisfactory site for the nar-
cissistic projections of alienated Europeans in the present. This dimension
of *Dances with Wolves* becomes particularly apparent later in the film, when
Dunbar reflects on the battle with the Pawnee, a battle without a "dark
political agenda." "I felt a pride I'd never felt before. I'd never really
known who John Dunbar was. Perhaps the name itself had no meaning,
but as I heard my Sioux name being called over and over, I knew for the
first time who I really was." In *Back to the Future III*, the rearview mirror
tableau of "Indians!" emphasized the artifice of any cinematic travels into
history, that all Westerns are finally nothing more than highly conven-

tionalized representations of an imaginary West. *Dances with Wolves* avoids any such ironic constructions in its attempt to locate the authentic vision of the past; nonetheless, the seemingly unmediated tableau becomes another kind of mirror, the idealized imaginary in which the troubled hero sees himself, a mirror in which he is magically healed, in harmony, although only in this unrecoverable past.

Dances with Wolves contains a number of distinguishing features of this New Sincerity genre film: the move back in time away from the corrupt sophistication of the media cultures toward a lost authenticity defined simultaneously as a yet-to-be-contaminated folk culture of elemental purity, and as the site of successful narcissistic projection, the hero's magic mirror; the foregrounding not only of the intertextual, but of the "Ur-textual," in which an originary genre text takes on a quasi-sacred function as the guarantee of authenticity; the fetishizing of "belief" rather than irony as the only way to resolve conflict; the introduction of a new generic imaginary that becomes the only site where unresolvable conflicts can be successfully resolved. While it is well beyond the scope of this essay to catalogue all the instances of this emergent configuration or to detail its various permutations, I hope a brief analysis of two representative films, *Hook* and *Field of Dreams*, will suggest how this configuration functions in other texts.

Spielberg's continuation of the Peter Pan story foregrounds all of these emergent conventions, and the differences between the Disney version and the Spielberg versions of J. M. Barrie's book[26] throw the changing stakes of the New Sincerity genre film into sharp relief. While the former establishes the opposition between childhood and adulthood, the latter adds a level of hyper-self-awareness regarding the role film plays in constructing that difference, only to provide an imaginary transgression that takes the form of an ideal synthesis of the two. The indictment of media-saturated culture is omnipresent—the portable phone and camcorder function only as major obstacles between Peter (now the lawyer as pirate) and his own children. The demonization of the camcorder involves one of the most interesting contradictions within the New Sincerity—that even though the search for lost purity and authenticity may depend on

dazzling special effects and the blockbuster budgets they entail, a free-floating technophobia remains all-pervasive. We know that Peter fails miserably as a father because he sends an assistant to videotape his son's baseball game, willfully foregoing the authentic, *unmediated* experience of watching his son's game *in person*. The opposition between an authentic "liveness," seen as superior to an artificial technology, is emphasized repeatedly in the opening scenes. The family goes to a school play to see one of the children perform as Wendy in a theatrical production of *Peter Pan*, which appears to charm everyone in the diegetic audience except Peter. When the family arrives at Wendy's London town house, she tells the children the story of Peter Pan, the tale-telling "primal scene" accentuated in much the same way as the reading of *Peter Pan* in a comparable scene in *E.T.* (1982). In the earlier Spielberg film, the transmission of the "Ur-story" is set up in a mise-en-abyme structure—while the mother reads the "clap your hands if you believe" passage to her daughter, the son and E.T. sit transfixed in the dark, listening unobserved in the closet, as the theater full of parents and children listen unobserved in the dark of the theater. The foregrounding of the Ur-text becomes most explicit when Wendy hands the adult Peter "the book"—apparently the first edition of Barrie's book, which, she tells Peter, was not fiction at all, but Barrie's transcription of the children's actual adventure, made possible by the fact that Barrie was their next-door neighbor. Once back in the world of children's fantasy, Peter regains his lost purity by recovering his childish delight in the elemental among the Wild Boys—a folk culture par excellence—leading to a resolution that can be effected only in *the* never-never land. Peter succeeds as a father only by recovering the lost child within him, thereby fusing two contradictory desires in one impossible composite: the desire to become the consummate father and the desire to return to the bliss of childhood outside any paternal control.

The determination to resolve the unresolvable in a never-never land that is available neither in the present nor the past, but in an imaginary prehistory or originary moment, takes an even more fanciful form in *Field of Dreams*. The film begins with a brief family history of the main character, Ray Kinsella, accomplished through family photos and voice-over

narration. The main point of this section is that Ray and his father, once close, especially in their love of baseball, broke irreconcilably during his teenage years. His father had "died" when his beloved White Sox threw the World Series in 1920, and later died an embittered shell of a man, old before his time. Once the film has established this troubled family history, the action in the present begins with Ray hearing voices in his cornfield. The field, like the Western landscape, is valorized two times over, as the yet-to-be-corrupted, preindustrial, agrarian paradise ("Is this heaven? No. It's Iowa."), and as the site of narcissistic projection, here taken to an even greater extreme as the land actually talks directly to Ray about his private psychodrama. The Ur-text in this film is likewise taken to more elaborate lengths; the lost text becomes the lost team, as the Black Sox magically reappear in the dream diamond in the midst of the cornfield, the purity of this "text" emphasized through explicit comparison to the corrupt present. Shoeless Joe waxes rhapsodic about the elemental joys of the game, the "thrill of the grass," the fact that he would have played just for meal money (unlike the soulless mercenaries of contemporary major league baseball, of course). Within this eulogizing of the game, baseball as it was played by Shoeless Joe and company becomes a folk-cultural activity—an organic, and at the same time, mystical ritual. Grafted onto this nostalgia for baseball the way it used to be is a parallel nostalgia for the 1960s, and Ray believes he must "ease the pain" of Terence Mann, the famous countercultural writer who becomes a kind of proxy father figure for Kinsella, first in the 1960s (after he reads Mann's *The Boat Rocker* he stops playing catch with his biological father), and then explicitly in the 1980s, when they travel together in search of their dreams. The connection between the America of the late teens and the late 1960s is articulated by Terence Mann during his "people will come" speech near the film's conclusion—both periods are collapsed into mere passing moments alongside the eternal game that represents an eternal childhood:

> Ray, people will come, Ray. They'll come to Iowa for reasons they
> can't even fathom. They'll turn in to your driveway not knowing
> for sure why they're doing it. They'll arrive at your door, as inno-

cent as children, longing for the past.... They'll find they have reserved seats somewhere along the baselines where they sat when they were children and cheered their heroes, and they'll watch the game and it'll be as if they dipped themselves in magic waters. The memories will be so thick they'll have to brush them away from their faces. People will come, Ray. The one constant through all the years, Ray, has been baseball. America has rolled by like an army of steamrollers. It's been erased like a blackboard, rebuilt and erased again. But baseball has marked the time. This field, this game, it's part of our past, Ray. It reminds us of all that once was good and could be again. Oh, people will come, Ray, people will definitely come.

Mann's oration perfectly describes the appeal of the New Sincerity. Like this mythical game, these films offer the recovery of lost purity, the attempt to recapture the elemental simplicity of childhood delight in a magical state that yields its perfect resolutions of the otherwise impossible conflict. Once Kinsella's proxy father departs with the players to document their stories and what is "out there," Ray finally reunites with his real father—but his father as a young man, a young baseball player years before he becomes a father. Generational tensions dissolve in this imaginary realm where boys can once again play catch with their fathers before their fathers became fathers, an impossible temporality that allows boys to reconcile with their lost fathers only when they've yet to become their fathers.

The two types of genre film that I have discussed here represent contradictory perspectives on "media culture," an ironic eclecticism that attempts to master the array through techno-sophistication, and a new sincerity that seeks to escape it through a fantasy technophobia. That both should appear as responses to media saturation is not surprising, nor is the simultaneity of these responses; the popular narratives of the late 1980s and early 1990s articulate a profound ambivalence that reflects the lack of any sort of unitary mass consciousness. Both types of these genre films involve a metamythological dimension, in which the cultural terrain that must be mapped is a world already sedimented with layers of

popular mythologies, some old, some recent, but all copresent, and subject to re-articulation according to different ideological agendas. If, following Marshal Berman, we might say that Modernism was a period in which all that was solid melted in to air,[27] the current period is defined by a different dynamic, in which *all that is aired eventually turns solid*, the transitory coming back around as the monumental with a decidedly different cultural status and resonance. Contemporary popular narratives mark the beginning of the next phase, when new forms of textuality emerge to absorb the impact of these changes, and in the process turn them into new forms of entertainment.

Retro-Modernism
Taste Cartographies in the Nineties

In the previous chapters I have concentrated on the ways in which the alleged information overload has been mastered for very particular purposes, that out of this semiotic excess new forms of textuality have emerged which have been shaped by the need to develop different notions of self-identity/self-location in reference to that array of information. In the final sections of this book I want to focus on the impact of that excess on forms of cultural evaluation, specifically how contemporary notions of taste are themselves architectures of excess. How have new technologies of circulation, storage and retrieval affected both standards of evaluation and the position of taste-makers? What have become the criteria used to determine *good taste* when styles from Greco-Roman

to High Modernist are recirculated as "classic," all reproducible at approximately the same cost, all promoted as the most appropriate choice for contemporary contexts?

In order to delineate the ways in which the determination of cultural value has been undergoing significant reformulation within the past decade, I'll begin with a discussion of *Retro-Modernism*. I use this term to describe the Modernist revival that is well under way in museum shows, interior design magazines, academic journals and architectural debates. A style that was once defined by the outright defiance of tradition is now being *recollected* as it is *re-collected*. This recollection, in both senses of the word, involves a profound shift in terms of aesthetic evaluation, since the Modernist designs in question were originally produced within discursive frameworks that conceived of artistic excellence in terms of temporal limitations—not as a disposable value as much as a transitory one, in which art, if it was worthy of the name, hoped it died before it got old. But now, as Modernism is being relentlessly historicized, that which was formerly transitory with a vengeance is being reevaluated according to a new gold standard that valorizes the *next-new-thing* and *timeless classics* simultaneously. Temporality has become perhaps the most significant priority in the determination of "style" value in the nineties. This is not to suggest that other categories which have previously served as the basis of discrimination—artistry, functionality, authenticity, rarity—are no longer operative in the constitution of cultural value, but, rather, that all of such categories are now defined in reference to new temporal paradigms that are a response to the accessibility and reproducibility of the past, a past that now includes Modernism. Nor am I suggesting that temporality hasn't been massively important in taste formation in earlier periods; the Modernist obsession with innovation, the very *avant* quality of the avant-garde, clearly depends on temporal distinctions that are of primary importance. Within a Modernist context, however, the temporal was conceived of in a linear sense, as one wave succeeded another in the style wars that raged throughout the century. Retro-Modernism, as a postmodern cultural phenomenon, exemplifies the changing terrain in which those battles are now fought according to new temporal criteria

in which the relationships between innovation and tradition, and, by extension, historicity and contemporaneity, are in the process of being reconfigured and hybridized.

I'll be concentrating on two forms of this Modernist revival—buildings and furniture. The previous chapters were concerned with the domestication of excess in the form of images and narratives: my primary interest here is the manipulation of that excess within domestic exteriors and interiors that become the stage for complicated forms of *cultural mise-en-scène*, that is, the ways in which the array of information is actually being "staged" as living environments by architectures at their most theoretically sophisticated and popular interior design magazines at their trendiest. Considering these arenas in tandem will allow for comparisons between the divergent reincarnations of Modernism across another taste hierarchy, one in which serious architecture has traditionally enjoyed far greater legitimacy than mere interior *decoration*.

Retro-Modernism, then, is an especially useful case study for understanding taste-making in the nineties, because it allows us to "see the sites" of evaluation. Developing new paradigms for understanding taste within a postmodern context obviously involves a host of interconnected issues, and any number of new first principles rush to the front of the line—that the ongoing reformulation of distinctions between high and low culture in the present should force us to reconsider the historicity of such distinctions in the past, thereby expanding the category of the aesthetic by throwing new light on formerly disreputable forms of mere entertainment that hid in the shadows of official histories; or that we must begin by acknowledging the fact that the aesthetics of the past are inseparable from the frame of the present and therefore any such histories now serve quite specific masters in regard to the highly politicized debates about canons and cultural literacy; or that, since history is no longer "History," but a series of heterogeneous, fragmentary accounts of discontinuous cultural activity, we have to reconsider both the scope and the eventual payoff of any historical claims. These are all crucially important issues, but in this chapter I'd like to investigate another set of questions that also need to become first principles in new theories of aesthetics—

namely, what, and where, are the *sites* of taste formation? Rather than simply expanding the category of critical objects to include the popular, it is crucially important to explore those sites inside and outside the academy that are engaged in evaluation of a particular aesthetic like Modernism, from universities and museums, to contemporary cutting-edge architecture, to popular design magazines and yuppie department stores. The coexistence of different ways of accessing and historicizing Modernism, then, reflects profound changes in both the grounding of cultural authority and how it is disseminated.

To introduce my analysis of the Retro-Modernist phenomenon, I'd like to offer a brief autobiographical interlude which I think is useful in explaining how and where one encounters it in its various incarnations. Two years ago I was invited to give a talk at the Los Angeles County Museum in conjunction with the travelling exhibition, "What Modern Was." When I first began to prepare for that lecture, I thought of that exhibition as part of the renewed fascination with Modernist aesthetics that had emerged in response to the overexposure of postmodernism, as well as the official acceptance of the latter within architectural circles by too many of the wrong sort of people—people like Disney's Michael Eisner, whose support spelled death for any cutting-edge aesthetic. Michael Graves's design for the Disney headquarters in Burbank (see figure 15) and his Swan Hotel at Disneyland led to charges that postmodern architecture had simply become too "user-friendly" and had passed from the realm of neo-vernacular to that of neo-kitsch. Given the popularity of postmodern design, coupled, not coincidentally, with a widening gap between the highly ironic uses of classical elements in what is now being refered to as "Pop" architecture and the sanctification of those same formal elements in the "New Classicism," it was hardly surprising that a new asceticism should appear that would try to revive the avant-garde purity of High Modernism. So in preparing my talk for the "What Modern Was" show, I had planned to concentrate on the relationship between the works in that exhibition and Neomodernist architecture. I had thought in terms of comparing Eisenman's fascination with grids to Eames's storage units and the all-pervasive fascination with geometric shapes that

Figure 15: Graves, *Disney Headquarters*

characterized High Modernism. This argument seemed eminently rea-
sonable to me, since after all, the debate between a staid postmodernism
and a resurgent radical aesthetic called Neomodernism was being hotly
debated in the worlds of high theory and high architecture. But as I
worked on this project, a series of chance encounters made me realize
that this sort of study was wildly insufficient for understanding the com-
plexity of the Modernist revival, because that revival wasn't restricted to
the discursive enclosures of the academy and the museum. The first
chance encounter was with a colleague's grandmother's silverware. While
I was in the initial research phase of this talk, one of my colleagues told
me about her grandmother's silverware, which she had rescued from
being sold at a garage sale. It was being shipped to her, and she suggested
that I take a look at it when it arrived because it was unique. I didn't pay
much attention at the time, because I was immersed in Eisenman and
deconstructive aesthetics, which were, after all, the very essence of
Modernism in the early nineties. So imagine my surprise when, a few
weeks later, I received a phone call from a very excited colleague, who
told me that "my grandmother's silverware is in the "What Modern Was"
catalogue." It turned out to be Gio Ponti's flatware (see figure 16). At this
point, I began to reconsider the lecture I was preparing. When grand-
mother's silver turned out to be High Modernist Italian flatware, I
was faced with another dimension to the contemporary state of
Modernism—namely heirloom or antique Modernism, which circulates
outside the realm of architecture and museums, and is therefore subject
to different standards of evaluation.

The second chance encounter was with my own espresso cups. I had
recently purchased them at Crate and Barrel, a yuppie department store
in Chicago, and I thought they were rather handsome in an old-fash-
ioned, "retro" sort of way. While flipping through copies of *Metropolitan
Home* in order to see how popular interior design magazines were covering
the Modernist Revival, I came across a full-page advertisement for my
espresso cups . It turned out that they were indeed retro, but retro with a
difference. "In 1936 the cups didn't come in raspberry. They didn't have
to. In 1936, the simple, unadorned shapes of Dr. Herman Gretch's new

Figure 16: Ponti, *Italian Flatware*

dinnerware were radical enough. But after 50 years, it was time to stir things up again. Forma dinnerware. A 1930's classic now ready for 1990's tables." At this point, I had to rethink my talk once again— the Modernist Revival involved not just museum shows, hot architecture and family heirlooms, but also a new, improved, "colorized" Modernism, in which "the shock of the new" had become the "shock of the newly raspberry."

The simultaneity of these various forms of recirculation complicates the process of evaluation in our culture, because it produces a hybrid evaluative criteria in which cutting edges must still be fetishized, but some cutting edges can now be brought back as classics, somehow still intact. Within the past decade, the retro phenomenon has been all-pervasive, especially as the ability to access the past has been enhanced by technological developments such as the computer, the VCR and digital recording, and commercial developments that allow for the successful merchandising of nostalgia. I'm referring specifically to nostalgia designers like Laura Ashley, Inc. who allow us to pretend we're Victorian gentlefolk living in picture perfect worlds, or Ralph Lauren, who will help us become English gentlefolk, New England aristocrats or Old Buckaroos if we've a mind to. The obsession with tradition as a value in and of itself could hardly be more explicit in Lauren's home decorating ads, which grace the pages of the *New York Times Sunday Magazine* and other magazines that appeal to a quality readership. Entire pages are often devoted to the definition of tradition and the explanation of the significance of what the reader is about to see on the following pages:

HOW A TRADITION BEGINS
Ralph Lauren introduces his first collection furnishings for the home, and a new tradition begins. As with everything he has done in the past, this collection of home furnishings is an expression of enduring quality and superb taste. There are four distinct collections. Each has been inspired by the richness and diversity of our American heritage, by our rustic pioneer roots, by the classic charm of our colonial past, and by the eloquent influences of

Europe. All offer timeless pieces you will want to live with and cherish forever.

But what do log cabins and the fetishizing of tradition, actual or newly invented, have to do with Retro-Modernism? What Modern *was*, at least the first time around, was antithetical to this sort of cozy ersatz design, but with Retro-Modernism another new tradition begins as seen in the ad for Palazzetti, (see figure 17) a trendy furniture store in Manhattan: "Modern Classics Are…the 50's reintroduced, and the 30's never before produced. Modern classics are…what we do best." This appeal to a *legacy* of the authentically radically new is exemplified by a review of a new housing project by *New York Times* architecture critic, Herbert Muschamp. In an article entitled "The New Public Housing, French Vintage 1922" he begins:

> Young Architects are supposed to make a splash. It's a letdown when their first building doesn't herald a new voice. But Jean Dubus, 41, and Jean Pierre Lott, 31, have done something truly original. Their first work, an apartment building in Paris, reverberates with the shock of the old. They've dusted off an unbuilt 1922 design for public housing by Le Corbusier, one of the most influential voices in 20th-century architecture, and brought it startlingly to life. What makes their debut even more stunning is that, after 70 years, the design still looks fresh. Not a dim echo, it's the bold refrain of an idea whose time has come again.[1]

This rather peculiar sense of timelessness, in which Modernist design alternately forms part of the legacy of the avant-garde or stands for the ultimate in contemporaneity, is all-pervasive within the discourse on Retro-Modernism. In the glossy coffee-table book, *The New Moderns*,[2] advertised in glossy magazines like *Architectural Digest*, *Vogue*, and *Vanity Fair*, "the Look of the Nineties" is characterized as the antithesis of the traditional. While Modernism is referred to repeatedly as the inspiration for these homes, it seems somehow to have escaped the fate of other past styles that have become merely old-fashioned. In the Forward to this vol-

Figure 17: Palazetti, *Modern Classics*

ume, architect Charles Gwathmey sets the tone for what is come. Modernism still retains its freshness and radical edge because it challenges:

> the prevailing aesthetic and socio-cultural order, thus provoking reevaluation, overturning conceptions and offering new perspectives and values. Picasso and Braque are an example of two artists who, in their relentless and competitive investigation of perceptual alternatives, forever changed our way of seeing. (p.8)

At this point, the contradictions within the "liberating international design" that is the New Modern begin to proliferate. For Gwathmey, Modernism is apparently of the past yet thoroughly timeless—our way of seeing has been *forever* changed, once and for all, and it's going to continue "destabilizing the status quo" as long as people of taste have the courage to keep the faith alive. But just who are these enemies of the status quo? The answer comes on the very next page:

> Today, people throughout the developed world can choose to build and furnish their homes in any style, historic or modern. Europe and America are littered with pseudo-historic and Post-Modern buildings. However, it is intriguing to see that some wealthy people are tiring of the visual clutter and sheer bulk of too many worldly possessions and discarding them in favor of more austere homes. (p. 10)

Here the New Modernism would appear to accomplish the seemingly impossible, since it challenges the status quo but still remains the style of choice for the tasteful wealthy "who are pioneers in the true sense because they have the vision and strength to jump clear over the hurdle of fake historic styles and look to a contemporary way of living that makes sense in today's noisy, intense, consumerist world" (p. 10). Within this world the historical is the unfashionable "other"; history as such is never rejected—just "fake" or "unquestioned historicism," but since that which is "historical" never appears in this book, except in these counterfeit forms, it remains all that the New Moderns fight against. That

Modernism is now a style which is as much of the past as the Victorian or Georgian periods appears too unthinkable within this discourse unless it comes with an officially certified avant-garde pedigree: "But what the New Modern house offers above all is an escape from bogus history.... This freedom is demanding because it requires the exercise of personal taste, rather than the mimicking of given style." That this New Modern style may offer only a bogus contemporaneity, since it depends so completely on an aesthetic codified in the past is not entertained by the authors who maintain that the New Modern house makes "no concessions to history" (p. 179).

Modern Classicism may indeed seem oxymoronic, but as a phenomenon, it is completely understandable as the perfect combination of two hitherto contradictory evaluative criteria, the fascination with the shock of the new and the richness of the past, a situation in which "quality" is synonymous with radical innovation but also with tradition, and even better is both at the same time. If High Modernism can be defined as that period when Modern and Classic were thought to be mutually exclusive, Retro-Modernism represents their amalgamation, the point at which designs that once depended on timeliness as markers of their validity now are recirculated as timeless. David Hallett, in a recent issue of *Design World,* praises the architecture of Richard Rogers because it represents "the Modern ethos...while the clothing may change, the spirit is timeless and of immutable relevance in the 20th century."[3]

This refashioning of Modernist aesthetics that fuses tradition and innovation in a synthesis called transcendence was inevitable in a culture where these two priorities coexist within one and the same institution, whether it be interior design magazines, rock culture or the academy. It is, of course, tempting to explain this coexistence in terms of temporal discontinuities, that is, that in certain First-World nations the evaluative ideologies of pre-Modernist, Modernist, and Postmodernist periods now circulate at the same time, each with their own infrastructural support systems to promote them. This assessment is only partially accurate, however, since what is distinctive about the current state of taste ideologies is not just their coexistence, but their recombination in

unprecedented ways. Mukarovsky, for example, argued in 1936 that a "large number of aesthetic canons exist simultaneously in any collective.... But the coexistence of several different canons within the same collective is not without tension. Each of them strives for sole validity and attempts to supplant the others."[4] While the struggle between evaluative ideologies may be a useful way to characterize the ongoing battles between tradition and radical innovation that are all-pervasive across the cultural landscape, the recent attempts to fuse the two in a new ideology of classical transcendence represents a significant development in the evolution of aesthetic evaluation. If the emergence of the avant-garde in the twentieth century was, as Paolo Portoghesi says,[5] an unprecedented aberration in the history of art, in its ruthless forgetting of the past in favor of an open-ended perpetual present, the postmodern period has seen a number of developments that are likewise unprecedented: the historicizing of the relentlessly current, the shock of the new becoming quite literally *antique,* a development embodied very neatly in the form of Modernist antique stores that have recently sprung up in the tonier sections of major American cities—stores like Modern Age in New York, Modern Times and Modernica in Los Angeles (see figure 18) and Modernology, Modern Furniture Classics (see figure 19) and Vintage Modern (see figure 20) in San Francisco.

Just as Modernism is now presented as classic, Neo-neo Classicism is circulated as ultra-contemporary. In the premier issue of *Classic Home* of Fall, 1993 (which I encountered first in a display case in the Architecture Library at Notre Dame and then, half-an-hour later, in the magazine rack in the checkout line at my local supermarket) the editors make their declaration of principles in a splashy fold-out cover page with the following text superimposed over a photo of a magnificent antique settee complete with gold leaf ornamentation:

WE INTRODUCE THIS FIRST ISSUE WITH APPROPRIATE PRIDE
IN ITS UNIQUE INTERPRETATION OF THE ENDURING BEAUTY
AND TREASURED TRADITION THAT IS THE HALLMARK OF
CLASSICISM. WE VALUE THE CHARM OF ECLECTICISM, THE

Figure 18: Modernica

Figure 19: Modern Furniture Classics

Figure 20: Vintage Modern

CHALLENGE OF STYLE, AND THE ART OF SIMPLICITY. THE
AUTHENTIC AND THE ORIGINAL HIGHLIGHT ALL THAT WE
PRESENT: DESIGN, HISTORY, ARCHITECTURE, TRAVEL, THE
CHERISHED OLD AND THE NEWLY DISCOVERED. *CLASSIC
HOME* CHOOSES FOR ITS CENTER THE MANY PLEASURES OF
AMERICA AND FLAVORS ITS PAGES WITH INTERNATIONAL
SIGHTINGS TO ADD A UNIVERSAL TASTE AND TEXTURE.

Metropolitan Home is disdainful of this sort of classicism, and has enshrined what I've called Retro-Modernism as the very cutting edge of contemporary style, yet their design priorities are remarkably similar to the definition of tradition found in the Lauren Home Furnishings ad and the *Classic Home* declaration of purpose. In an issue devoted to today's hottest designers[6] they begin with the following declaration, in which the emphasis is on tradition above all else, only here the values and quality of the past are coupled with "the new avant-garde":

elements
of
style
TRADITION
the new avant-garde

Every chair a concept: That's been the diminishing half-life of
modern design for 70 years. But the idea doesn't sit well with us
today. Our sense of value is keener. We're putting tradition back.
Here's the difference. We don't mean revival. Now tradition's a
take-off point. Instead of re-inventing the wheel, the best design
transforms classic shapes and pumps them up with fresh style,
luxury and comfort. It's a new grammar of ornament—never
severe even at its most sophisticated. Look at Philippe Stark's
lobby for the Royalton Hotel —it's a space opera, but its also pure
French salon. Toasts Stark, 'I have created a new kind of cocktail.'
We'll drink to his urbane notion for design's avant-garde today. (p.
121)

This new avant-garde that comes after postmodernism sounds rather suspiciously like postmodernism, since this new cutting edge aesthetic sounds aggressively eclectic, ready and eager to make use of the "already said," whether it be high art or the neovernacular, and not at all shy about being into comfort or luxury. The examples of this approach include the work of Los Angeles architects Craig Hodgetts and Ming Fung whose design is:

> Suffused with color, these shapes seem at once primitive and strangely familiar. Tied to a pace, they refuse to be tethered to a style...the machine for living has become a messy and vital collage for living where the pieces fit you, not vice versa. This house's lineage is equally L.A. and Russian constructivist, Hodgett reckons. The message: Take your influences where you find them and patch them together not according to the dictates of a school, but of your own needs and sensibility.[7]

Another example of this new aesthetic advocated by *Metropolitan Home* is a Manhattan condominium, featured in an article entitled, "What's Modern Now: Lofts Go Soft." The owners proclaim their goal was "warm minimalism," which is described by the article in the following way: "This humane non-militant minimalism illustrates how less can indeed be more—more colorful, more sensuous, more fun" (p. 162). The text attached to another photo in the spread reads "Ralph Lauren here in a neo-modernist room? That's his carpet, and its paisley pattern harmonizes nicely with the curves of the late 40's dining room table and chairs." Yet the incredulity seems misplaced here, since the entire room is designed to be cozy modernism. We even have a touch of the log cabin here. The coffee table is described in the following way: "Its birch legs and maple branch struts support a copper top with acid-dressed inserts—the Adirondacks meet Corbu."

When I discussed this warm minimalism in my lecture at the Los Angeles County Museum, I suggested, facetiously, that a Ralph Lauren Modernist collection must be on the way—a themed ensemble of home furnishings featuring those eloquent European influences of circa 1950,

an imaginary New York apartment filled with Lauren's versions of Saarinen's modular cabinets, Aalto chairs, Noguchi tables and Russell Wright dinnerware, all somehow made more comfortable and cozy for todays New Modern Pioneers. After I'd finished the talk, one of members of the audience came up and asked me who I knew "on the inside" at Ralph Lauren because he had it on very good authority that such a collection was indeed in the works. Sure enough, in the following fall season, ads for Lauren's new Modernist series began to appear in the *New York Times* and interior design magazines, along with appreciative feature stories in *Elle Decor*, which informed the reader that:

> Ralph Lauren takes the lead as designers hail a return to the clarities of Modernism and De Stijl's bright-edged primaries. The clean-lined shapes and vibrant colors of Ralph Lauren's bold new modular furniture—the RL 2000 series—make up the designer's strongest statement so far into the 90s. Here, the lounge chair's Cubist frame and cushions are upholstered in Lauren's Motorcycle Leather....[8]

The advent of Ralph Lauren's classic modernist collection emblemizes sweeping changes in *taste cartography*. I use this term to describe the way in which relations between styles, values and individuals were set in reference to what were thought to be fixed nodal points, that is, categories like Modernism or Classicism which served as useful condensations, wrapping together aesthetic, ideological values, and personal tastes in absolute terms which then functioned like some sort of cultural magnetic poles possessed of their own ontological "pull." But within the past decade these nodal points have begun to unwrap, and the values, tastes and politics that were once considered homologous have started to realign in new configurations. In his analysis of the ongoing "style wars" in the architectural debates in Britain between Prince Charles and the Modernists, Charles Jencks describes this sort of realignment quite lucidly. He argues that Royals serve as:

> ombudsmen during the reign of professional elites, and the avant-

garde at a time of conservative re-trenchment. This last role is
really quite ironic, even humorous since it seems so at odds with
their traditional function and their many stated conservative
views. The avant-garde in culture has usually been associated
with radical politics, and even when it's conservative and right-
wing, it is considered the fundamental instrument of Cultural
Modernism. Can the Prince's anti-Modernism really be considered
part of the Modernist agenda? It seeks to overcome reigning
stereotypes, it appeals to youth, Post-Modernists and all those
who further minority interests against those of bureaucracy and
established professionals.... In the nineteenth century the avant-
garde usually tied its fortunes to the progressive potentials of
science and technology and, in early twentieth-century art and
architecture, supported the machine aesthetic. In post-industrial
society, however, where organised knowledge and information
flow have replaced machinery as the leading catalyst of change,
there is a new kind of progressivist logic at work, one taken up by
the Prince. Information, purveyed through the world media and
manipulated by electronics...allows every style to be individually
crafted, whether it is High Tech or Classicism. It decentralizes
decision-making, allows small production runs, facilitates the
manufacture of many shapes in all possible materials, including
traditional ones, and gives back stylistic decision-making to the
individual and the community.[9]

By stressing the impact of information technologies on what I've called
taste cartographies or, more specifically, on the taste homologies which
such cartographies are dependent on, Jencks identifies the key difference
between the effects of these technologies and earlier forms of techno-
determinism. While Modernists such as Richard Rogers have insisted on
the necessity of incorporating the newest technologies in order to devel-
op genuinely contemporary design (see Chapter One), the
preconceptions remain thoroughly "machine age," since they conceive
of change almost solely in terms of building technologies that will deter-
mine stylistic innovation, and see the benefits of information technologies
only in terms of computer-aided design. What they fail to recognize—

and this is what, ironically makes their professed determination to recon-
ceptualize design by incorporating cutting-edge technologies so
old-fashioned—is the impact of information circulation on the networks
of relations which determine taste, specifically what is and isn't *appropri-
ate*, what is and isn't *appropriated*, according to which form of cultural
authority. In other words, what they cannot conceive of is the effect of
information flow on those paradigms that determine cultural *fit*, that
they live in worlds where suitability of style is no longer predetermined
by building technology and the authority of a professional elite. It hardly
surprising, then, that when arch Retro-Modernist Peter Pran calls for
"the new authentic modern architecture" (which he opposes to the
"regressive post-modern (unhistoric) historicism") he looks for his own
radically new paradigms not in the information technologies of the pre-
sent or in contemporary theories of cultural production, but in the
"tremendous *heritage* of early modern architecture which is the *foundation*
for *all* substantive *contemporary* modern architecture"[10](italics mine).
Interestingly, when Japanese architect Fumihiko Maki praises Pran's work
in his introduction to a monograph devoted to the latter, he insists that
Pran "makes use of the legacy of De Stijl's compositional principles"(p. 7).
Here the worlds of popular interior design and Serious Architecture con-
verge as De Stijl becomes the basis for an imagined tradition for both
Lauren and Pran which is also supposed to resonate simultaneously as
design for the year 2000.

While the work of Lauren and Pran invokes the same Modernist her-
itage, I'm not suggesting that all forms of Retro-Modernism are so
thoroughly eclectic or so dedicated to being "homey." The deconstruc-
tive designs of Peter Eisenman, Rem Koolhaas, Zaha Hadid and Bernard
Tschumi are just as aggressively purist in their return to clear geometric
forms, and all attempt in various ways to restore a critical edge to their
designs. Eisenman insists that his work contests the very metaphysical
basis of structure, attempting to construct a dynamics of structuring
absences, which forces us to rethink, for example, the metaphysics of the
museum, by using primarily glass walls that frustrate the display of paint-
ings, by cutting holes in bedroom floors of his houses to preclude the use

of double beds, or placing so many pillars throughout a dining area that the room will not admit a table, thereby forcing inhabitants to rethink the metaphysics of dining. Eisenman's insistence on an architecture of dislocation and alienation represents the opposite of the Colorized Modernism advocated by *Metropolitan Home.* Both reflect, however, the two extremes of Retro-Modernism, each trying to reinvent High Modern aesthetics, one swinging modern design in the comfort zone of contemporary yuppie home life, and the other creating a style of building and decorating that alienates inhabitants from their own households. If one tries to make the well-appointed home the center of a design universe, the other valorizes a perpetual state of decentered anxiety. What constitutes aesthetic value in each case depends on the recreation of Modernist design in virtually antithetical terms, even though each celebrates the return to ostensibly the same style. The variability of aesthetic value here is attributable to neither the subjective taste of the perceiver nor inherent properties of the artistic object, but rather the discursive/institutional frameworks that coordinate the relationships between viewers and objects in specific sites of transmission according to divergent ideological agendas. While form may have followed function in Modernism, Retro-Modernism is a product of new taste cartographies in which *value follows location,* specifically the location of the evaluative criteria within the array of institutional frameworks that define beauty and utility in often contradictory terms for their respective audiences.

This variability of significance does not mean that the consideration of value has ceased to be a matter of intense debate. Bernard Tschumi, another deconstructivist architect, who has designed a series of "folies" at Parc de la Villette (see figure 21) argues that these structures are empty form, "an architecture that means nothing, an architecture of the signifier rather than the signified...its meaning is never fixed, but is always deferred, rendered irresolute by the multiplicity of meanings it inscribes."[11] What is at stake here is the nature, or more precisely the causes of that variability. Tschumi is correct in arguing that structures can produce a multiplicity of meanings, but wrong in believing that he can will this into or out of existence through his design technique. The vari-

Figure 21: Tschumi, *Folie*

ability of all design objects is due to not just stylistic features, but the variable modes of circulation, the diverse contexts in which one and the same object, or one and the same design discourse, is inflected differently according to the exigencies of that context, making a given text not just polysemic, but *polyvalued.* Tschumi's own deconstructive discourse is a perfect case in point. Within the world of *Architectural Design* magazine, deconstruction is a hot theory to be debated, but it takes on a different resonance in a fashion magazine like *Elle,* in its coverage of "Our Chicest Radicals: Alternative Fashion Routes." The reader is told:

> Don't look now, but fashion deconstructivists are ousting the academics. Design rules are ripped at the seams, good taste unraveled.... This is nothing less than the antifashion movement that's taking a tip from deconstructivist tendencies in literature and architecture. Radicals like Rei Kawakubo, Yohji Yamamoto, and Martin Margiela are questioning the very essence of clothing, breaking it down into raw materials and reassembling them in deliberately strange ways.

The text accompanying this photo tells us of Margiela: "the progressive Parisian makes no bones about stealing the front off a denim jacket, the sleeves off T-shirts or sweaters, a prairie dress from the late seventies. You figure it out."[12]

Deconstruction resonates yet another way within the context of the comic book, specifically in the *Justice League of Europe* (April 1992) comic produced by none other than DC Comics, in which The Flash, Batman and company fight the new European archvillain, Deconstructo. We first see Deconstructo as he runs through the street screaming about American cultural imperialism, particularly in the form of superheroes. He proclaims, "There is no meaning in Art, in Life, in history, in heroes. We can only know what our minds let us know. Language is a lie." In the bottom frame on this page, Bruce Wayne, a.k.a. Batman, asks his friend, Mr. Ruskin, what it's all about. He tells Wayne that the mad artist is "just a local deconstructionist artist." The next panel features the following exchange:

BRUCE WAYNE: I'm afraid I'm fuzzy on deconstructionism, Mr. Ruskin.
MR. RUSKIN: Quite the academic fad in France and America, it was.
Becoming passé now, I understand. It holds that all thought is dic-
tated by the structures of the mind...and language. Therefore no
human creation can reveal anything...except about itself. All
efforts to create meaning and values are pointless. This chap's
submission was a sieve with super-hero action figures half-melted
through it.
BRUCE WAYNE: Deconstruction isn't for me, I'm afraid.

The polysemic nature of the term deconstruction itself, then, is best
appreciated not in reference to Derrida's notion of *différance*, but in
Bakhtin's notion of heteroglossia, in which signs are multiaccentual
because they move in and out of discourses/institutions that stabilize their
significance according to the specific demands of each network, where lit-
tle or nothing is differed, because each one has its own "Mr. Ruskin" to
make the appropriate discriminations.

This variability of design objects and its impact on the process of evalu-
ation becomes especially obvious if we consider *where* we encounter many
of the lost treasures of Modernist design. Russell Wright's "American
Modern" dinnerware appears like this in the catalogue for "What Modern
Was,"(see figure 22), but it takes on an entirely different dimension when
it is encountered not as a museum piece but rather as a flea-market
antique. Inspired by a 1984 *Metropolitan Home* article on David Hanks, in
which he explained how he collected many of the pieces for *What Modern
Was*, I began my own field work at Picker's Paradise (see figure 23), an
antique mall on a strip expressway just north of South Bend, Indiana.
Searching for the discarded treasures that Hanks promised one might
find, I came upon the following sight (see figure 24). There lay the same
Russell Wright cups beneath juice glasses and more Russell Wright
Casual China next to Daffy Duck glasses and birthday candle holders.
Here the museum items were antiques, on their way up, subject to a dif-
ferent evaluative economy as newcomers on an antique scene that has
now begun to include High Modernist design, at least at a bargain base-

Figure 22: Wright American Modern

Figure 23: Picker's Paradise

ment level. This movement of American Modern between museum and flea market and back again became even more explicit as I left Picker's Paradise. I stopped by the information table at the door to check out fliers for upcoming auctions and estate sales. There on the table I found this assortment (see figure 25). There, next to the fliers for the antique fair at the Lawton Middle School Playground was the brochure for the "What Modern Was" Exhibition, now at the Toledo Museum of Art. The circuit at this point had come full circle—the museum show had led me to *Metropolitan Home,* which directed me to the flea market, which directed me back to the museum show. The same object took on different guises along the way, shifting from the object of aesthetic appreciation outside of market exchange, to a trendy design item to be acquired, quick, while it's hot, to a colorful piece of lost Americana, now resurfacing as a cheap collectible. It took on yet another dimension while I was looking at these same Russell Wright pieces in a glass case at the L. A. County Museum. Two elderly women walked up while I was standing in front of the case and one said to the other, "Oh, my Lord, I used to have that stuff," to which her friend replied, "I think we all did dear."

Understanding the intricacies of aesthetic evaluation and historicization within the array of postmodern culture depends upon our ability to see the interconnectedness of recirculation, re-articulation, and reevaluation. The issue of variability in regard to evaluation remains the crux of the matter here. In his extremely suggestive, but finally rather limiting study of the creation of cultural value[13] Michael Thompson describes the evolutions that individual objects undergo as they move through three categories or states of value—Transient, Rubbish and Durable. For example, old woven silk pictures from the 1880s, depicting sensational scenes of the day, that sold for a shilling now go for thousands of pounds. Thompson quite convincingly argues that these pictures, called Stevengraphs, were once Transient, became Rubbish, and now, having been rediscovered by the art market, are Durable. Thompson's case studies are fascinating, but according to his theory, value evolves along only one trajectory; the transfers between states are controlled by a cultural

Figure 24: Wright American Modern

Figure 25: What Modern Was

elite, and at each stage there is virtual unanimous agreement about the value and significance of a given object. Thompson chooses not to investigate the dissonance of cultural evaluation, the simultaneity of different institutional frameworks that will make one object, or an entire movement, resonate in conflicting ways according to which site, toward which end, and for which public aesthetic histories are now conceived in order to justify which tastes.

What are the cultural functions of tradition and innovation at this point? Eric Hobsbawm, in his analysis of the proliferation of invented traditions that appeared from the 1870s to the onset of World War I, argues that they were;

> responses to novel situations which take the form of reference to old situations, or which establish their own past by quasi-obligatory repetition. It is the contrast between the constant change and innovation of the modern world and the attempt to structure at least some parts of social life within it as unchanging and invariant that makes the "invention of tradition" so interesting for historians of the past two centuries.[14]

Some of the traditions invented in the postmodern world would seem to function in much the same manner—*Classic Home*, Laura Ashley, Quilan Terry and company do offer the old as a stable, "sane" alternative to what is reputed to be ever-accelerating innovation for its own sake that yields only empty technology and cultural "noise." Yet the "Modernist heritage" promoted by *The New Moderns, Metropolitan Home*, Modernist antique stores and architects like Peter Pran consists of exactly that "other," those innovations of the same modern world which by now have become a tradition complete with its own legacy, masterpieces and Ralph Lauren Interiors Collection, all of which are opposed to the noise and clutter of contemporary cultures. The need to establish invariant zones in the face of accelerating change is one of the strategies of absorption outlined in Chapter One for gaining a degree a mastery over a seemingly uncontrollable array of information, the sheer volume of which poses a threat to the values encircled within those zones. The taste for classicism has func-

tioned as this sort of invariant zone for the past two centuries, and taste homologies guaranteed the proper alignment of style, values, politics and class. But within the past decade another invariant zone has appeared in the form of Retro-Modernism, an *arriere avant-garde,* whose chief distinguishing feature is the desire to embrace the future, so long as it is envisioned in the style of the avant-gardes of the 1920s which are still thought to be a threat to the status quo. The emergence of this *tradition of invariant innovation,* with its heritage of contemporaneity, reflects the unravelling of taste homologies and the fixed polarities that once consolidated taste and cultural identity. The variability of value that I have referred to throughout this chapter is a result of the ongoing realignment of style choices and the concomitant reformulation of the notions of critical authority needed to legitimize those choices. This dispersal of authority, and the effects it has already had on notions of value, consensus and professionalism, still need to be explored in greater detail in the next chapter which will situate these issues in reference to the construction of alternative pedagogies.

Authority, Partiality, Pedagogy

In an article on the state of contemporary popular music that appeared in the *New York Times*, rock critic Simon Reynolds surveys the various forms of retro rock and concludes that:

> These days "alternative" can almost be defined as not contempo-
> rary, insofar as most alternative bands spurn the state-of-the-art
> techniques that underpin rap, new jack swing and techno, prefer-
> ing to renovate a period style from rock's past. This predilection
> doesn't mean their music is irrelevant, it just means such bands
> are distinguishable by the degree of sophistication with which
> they rework material from rock's archives.... One could call this

record collection rock, since a band is interesting in proportion to the esoteric scope of its musical learning.[1]

Reynolds' description of these trends in the rock music of the nineties is especially pertinent to the question of evaluation in cultures defined by semiotic excess. Here formal distinctions between genres of popular music are grounded on respective uses of technologies of access, and qualitative distinctions involving relative degrees of sophistication are now based on the refinement of that accessing. These forms of discrimination depend on the archivization of rock's past, a recovery process which gives a degree of permanence to what was once thought to be disposable, bestowing value simply by virtue of that recovery, consolidation and further quotation.

In the previous chapter I introduced the term *taste cartographies* in order to describe the ways in which critical distinctions are now being made in reference to different configurations of taste, values and class affiliations, particularly in regard to the shifting definitions of tradition and innovation. Insisting on the polysemic nature of texts has become commonplace within contemporary theory, but the multiaccentuality of signs in postmodern cultures is more than a matter of semiotic play, since the majority of texts are not just polysemic, but *polyvalued*. "Taste" may be considered an antiquated, counterproductive category for cultural analysis, yet it remains a vital component of day-to-day life in cultures where "taste-making" in various guises is the primary goal of both the education industry and the culture industries. Media scholars, in bracketing the issue of taste in the discussion of popular culture, fail to appreciate the inseparability of taste from the actual experience of popular texts, and in the process begin to make popular culture what it is not—a play of encoding and decoding strategies devoid of the evaluative energy that dynamizes both. In this chapter I want to pursue the issue of evaluation in reference to what constitutes cultural authority in the array of postmodern cultural production. What forms of authority are now in circulation simultaneously, and what serves as the basis for their respective claims for legitimacy?

Since one of these forms of authority is the academy, I believe it is imperative to consider the pedagogical dimensions of the issues raised by these questions. How does the investigation of cultural authority allow for the necessary reexamination of the professional legitimacy of the academic, particularly academic critics specializing in contemporary cultures? Teaching students about information cultures involves more than sensitizing them to the intricacies of emerging forms of textuality— it also means teaching them about how "all that stuff" is being evaluated and what comes into play in the justification of the various forms of evaluation. The pedagogy of evaluation that I will introduce in this chapter will focus on the proliferation of different forms of cultural capital, the agencies/institutions responsible for circulating them, and the interdependency of notions of consensus, professionalism and the manageability of semiotic excess.

Vissi d'arte, vissi de carpeting: Beyond Holistic Value Theory

As a way of introducing the discussion of the multiplication of different forms of cultural authority, I'd like to focus on how they collide within a taste cartography designed outside the academy in one of the most discredited realms of cultural expression—prime-time television. The ability to access both "high" and "low" and to recombine them at will, according to newly invented hierarchies, is epitomized by a recent episode of a network television series, *Northern Exposure*, in which the origins of the town that serves as a home base for the action are envisioned in an hour-long flashback, told to the current residents by one of the first settlers. The frame itself is noteworthy in two ways. First, it represents the desire to invent a history for a television series, a narrative form which has been, as John Ellis correctly argued,[2] based on collective amnesia on the part of all characters. The invention of not only a history, but a veritable "foundation myth" emblemizes the program's desire to frame itself differently from other television programs by giving itself a point of origin, a set of invented traditions that places *Northern Exposure* closer to a nineteenth century novel than the usual prime-time drama. Second, and especially significant, is the setting for the transmission of the tale—literally, a tale

told by a wise old man, with everyone grouped around a fire, invoking an even earlier tradition of oral storytelling. His story details the settling of Cecily, Alaska, when it was still part of the Western frontier. This transitional period is envisioned alternately, but simultaneously, as Western and Early Modernism. The town had been nothing but a mud hole overrun with varmints, until two ultracivilized women, Rosalind and Cecily, arrive and begin to transform the city into an artist's colony. Before long, the saloon becomes a *salon*, featuring public readings of the work of Stein, Yeats and Rilke, dance performances by Cecily conceived in the style of Isadora Duncan, and the occasional *tableau vivant*. The synthesis of Western and Early Modernism is actualized with the arrival of Franz Kafka, who suffers from "chronic writer's block," but as a "devotee of horse opera novels, he hoped the Alaskan frontier might inspire him." In the final confrontation between outlaws and Modernists, Cecily is killed, but the varmints are defeated, and the townsfolk adopt the pure aestheticism advocated by Rosalind and Cecily.

In this episode, a history is invented to serve as the antecedent of the town, but the nature of that history provides a kind of ad hoc legitimacy for *Northern Exposure*'s own eclecticism as an entity that is part popular narrative, part self-reflexive deconstruction of all the pre-requisites for "old-fashioned" storytelling, evidenced most obviously by the occasional ruptures in the diegetic world of the story, when actors suddenly walk out of character, or in the dream sequences of the town's resident filmmaker, Ed (for example, Steven Spielberg and George Lucas suddenly appear as themselves at an Academy Award ceremony when Ed is given a Lifetime Achievement Award), or in overt references to *Twin Peaks*, *St. Elsewhere* and other television series, which occur in virtually every episode. The use of Kafka exemplifies the refunctioning of authority, as the category of Early Modernist Artist, synonymous with rarefied sensibility and the agony of creativity, is itself re-articulated in terms of the Western frontier. This reworking of Kafka and the myth of the Modernist Artist denies the legitimacy of the Modernist artistic hierarchy, in which the avant-garde, so clearly superior to mere popular culture, must maintain a *cordon sanitaire* to ensure against contamination. The complete

interpenetration of these categories suggests a re-articulation that goes beyond Kafka and the Western to the very hierarchies that assigned them their specific positions based on the same gold standard of cultural value.

The proliferation of different standards of evaluation that both shape and legitimate divergent types of re-articulation leads not to the disappearance of critical distinctions, but rather to their intensification as they circulate within the same cultural arenas. In his seminal study on the creation of "high culture" in nineteenth century Boston, Paul DiMaggio argues that "Not until two distinct organizational forms—the private or semi-private, non-profit cultural institution and the commercial popular-culture industry—took shape, did the high/popular culture dichotomy emerge in its modern form." According to DiMaggio, before 1850, there were few efforts to make such distinctions, the Philharmonic Society giving classical concerts as well as backing popular singers of the day:

> One typical performance included a bit of Italian opera, a devotional song...a piece by Verdi, 'Bluebell of Scotland,' and 'The Origin of Common Nails,' recited by Mr. Bernard, a comedian.... The visual arts were also organized on a largely commercial basis in this era. Museums were modeled on Barnum's, fine art was interspersed among such curiosities as bearded women and mutant animals, and popular entertainments were offered for the price of admission to a clientele that included working people as well as the upper middle class.... By 1910, high and popular culture were encountered far less frequently in the same settings.[3]

What DiMaggio refers to as the "sacralization of art" was institutionalized through the differentiation of programs, sites and audiences, a process motivated by entrepreneurship, but also by "classification" and "framing," which he sees as concurrent projects undertaken by the Boston Brahmins. But in the 1990s, this sort of differentiation can no longer "hold" for entire societies, since "authority," in the sense of artistic creation *and* as a matter of critical distinction, are both so *dispersed*. The dispersal of authority and the concomitant shifts in classification and

framing have led once again to radical changes in program, location and audience that virtually reverse the distinctions that Boston's mandarin class labored so hard to enforce. Once could cite innumerable examples of the destabilization or rewriting of those distinctions, but an especially representative instance should suffice here as an illustration.

In the summer of 1992, I attended the San Francisco Opera Rossini Festival, drawn there by a performance of *Guillaume Tell*, the first complete performance in the original French since the nineteenth century. The event was given the requisite fanfare and publicity, as opera devotees and critics from around the world converged on the city for this once-in-a-lifetime event. The overture was conducted in dazzling fashion by Donald Runnicles, complete with flashing eyes and floating hair, and the audience leapt to their feet in a thunderous ovation. At this moment, the cultural distinctions that were classified and framed by the Boston Brahmins a century ago seemed firmly in place. Yet just the day before, in Symphony Hall, literally across the street from the Opera House, the San Francisco Symphony had also played the William Tell Overture, but in a somewhat different mode. The guest conductor was Bobby McFerrin, a well-known performance artist who has recorded with Laurie Anderson, and who is perhaps better known as a pop singer whose "Don't Worry, Be Happy" was a smash-hit record. McFerrin is now enjoying a career as a serious classical musician, and had just released another smash-hit album recorded with cellist Yo Yo Ma, entitled *Hush* (Sony, 1992), featuring his own compositions, a bit of Bach, some nursery songs, pieces by Rachmaninoff, Vivaldi, Rimsky-Korsakov and a comical interlude in which an imaginary stuffed-shirt announcer introduces a "Musette" by Bach, only to have McFerrin burst into Jimi Hendrix's "Purple Haze" *by mistake*. The program that night in San Francisco at Symphony Hall was similarly mixed, McFerrin conducting a Beethoven symphony "straight" to great applause, and then giving the Rossini overture the same treatment, at least until the final subject (the *Lone Ranger* theme) began, at which point the members of the orchestra leapt to their feet, put down their instruments, and played the rest of the overture on "mouth" in McFerrin's signature style—"brrump, brrump, brrump

bump bump, brrump, brrump, brrump bump bump," which was also met with a delirious ovation.

The key point here is that the virtual simultaneity of these two performances of the same Rossini masterpiece does not signal a wholesale return to the mid-nineteenth century, but rather the emergence of another phase in the history of art and entertainment that is just as distinctive as the two previous phases described so succinctly by DiMaggio. What distinguishes the current phase is the dispersal of cultural authority, in terms of creation and evaluation, as individual authors and standards of authority both circulate in ever wider orbits, but intersect in unpredictable ways, or at least ways not predicted by traditional media theory. McFerrin's ability to move in and out of the worlds of Top 40 Radio, the musical avant-garde and symphony orchestras depends on his ability to gain authority in each realm, which would be impossible if different standards of cultural capital weren't in circulation at the same time. McFerrin plays William Tell on mouth as a master entertainer, but as a consummate musician, he has been commissioned to write an opera for the San Francisco Opera. The either/or distinctions DiMaggio delineates in late ninteenth-century Boston are no longer uniformly operative in regard to program, location and audience because of the re-articulation, at the most fundamental level, of "authority" itself in each case.

The mixture of the popular and the classical in the postmodern period is not simply a return to critical standards of the pre/early modern period; the current relationship between the two takes the form that it does precisely because it comes *after* the modern period in which either/or distinctions were secured by an evaluative hierarchy founded on their separation. The popular entertainments that sat alongside classical masterpieces in the museums, music halls and theaters of the first half of the nineteenth century did not have to justify their presence there, but in the second half of the twentieth century, the popular must provide its own justification, its own built-in evaluative standards, because even if the unitary hierarchy of taste no longer holds dominion over all cultural production, it continues to exercise vestigial force, since it is so ingrained within specific institutions.

The proliferation of taste hierarchies is not allowed for by Pierre Bourdieu's notion of "cultural capital," which makes his concept useful for the analysis of contemporary notions of taste and evaluation, but only if sufficiently pluralized in reference to those factors that preclude the sovereignty of any one evaluative criteria. A number of sociologists of culture such as John R. Hall, Michele Lamont and Annette Lareau,[4] have critiqued Bourdieu's "holistic" conception of cultural capital. Hall argues that class affiliation is only one status group, and that all status groups cannot be reduced to market forces:

> Status groups may participate in, but they are not of, the market. To add to the complexity, in market societies, people typically participate in more than one status group, and each individual thus works with incommensurate kinds of cultural capital, entering into social relationships with others whose status situations, and concomitant forms of cultural capital, may be quite different.... Hard as Bourdieu works against its tendency, the holistic assumption gives rise to a class-reductionist analysis that objectifies and hypostatizes the flux of cultural distinctions and obscures the heterologous interplay of various kinds of cultural capital.[5]

While Bourdieu acknowledges "conflicts between symbolic powers that aim at imposing the vision of legitimate divisions," he maintains, nevertheless, that they are all subsumable to one master system of evaluation:

> Despite this potential plurality of possible structurings—what Weber called the *Vielseitigheit* of the given—it remains that the social world presents itself as a highly structured reality. This is because of a simple mechanism I want to sketch out briefly. Social space, as I described it above, presents itself in the form of agents endowed with different properties that are systematically linked among themselves.[6]

Bourdieu follows this assertion with a series of parallel distinctions between drinkers of champagne, red wine and whiskey, contending that the former have a greater chance than the latter two of having antiques,

playing golf at select clubs, riding horses, and so on. From there he goes on to insist that "differences function as distinctive signs, and once inscribed with language they express relations of symbolic power." But just because certain productive correlations can be made among such linkages, it does not follow that a single hierarchy of value secures the sovereignty or even the marginal superiority of one set of associated tastes over another. In other words, taste in alcohol, furniture and leisure-time entertainment may be linked, but individual chains of associated preferences do not cede cultural authority to other tastes, that is, for certain status groups, a La-Z-Boy Naugahyde easy chair will be judged better than a Georgian armchair, because comfort rather than design, age or provenance will be the basis for its superiority. Differences do function as signs, but those signs function, more often than not, polysemically, so that a given status object might signify excellence within one context, but stuffiness or pretentiousness in another, or even both within the same taste community, depending on whether an object is used in a straight or parodic manner.

The fate of Puccini's "O Mio Babbino Caro," as sung by Kiri Te Kanawa is a case in point. This aria appeared on Te Kanawa's best-selling recital disk of Verdi and Puccini arias, but then gained greater exposure when it was used on the sound track of Merchant and Ivory's *A Room With A View* (1985), where it signified all-purpose nineteenth-century Italian romantic class. Based on the success of the film, the Te Kanawa CD box began to sport little stickers that announced, "Contains 'O Mio Babbino Caro' as featured in *A Room With A View*." Subsequently, the same recording was used as a sound track for a "Tott's Champagne" ad, in which the aria, coupled with shots of Loire Valley chateaux and a designer-fashion-clad-super-sophisticated couple, is used to create a classy European image for cheap American sparkling wine. The success of this ad led to appearances of new stickers on Te Kanawa's CD—"As featured in the Tott's Champagne commercials." Subsequently, another ad appeared featuring Puccini and a Te Kanawa sound-alike, this one for DuPont Stainmaster carpeting. Here in a chateau setting, a remarkably similar sophisticated couple appears, the debonair man in evening wear walking toward the

camera, looking seductively at the woman. When he gets to the elaborate dining room table, he leans forward, trying to strike a suave pose, only to slip at the last moment, falling onto the table and spilling the contents onto the Stainmaster. Virtually the same signifiers—Puccini aria, soprano voice, chateau setting, designer fashions, elegant couple—are used by two different advertisers to appeal to the same middle class American audience, one using them "straight" in an attempt to give snob value to a supermarket wine, the other one using them for comic effect by stressing the pretentiousness of this vision of "class," at the same time emphasizing the down-to-earth quality of this brand of carpeting and the people who will buy it for their own dining rooms, which, according to other Stainmaster ads, are usually overrun by food-scattering children. The key point here is that the circulation of these signifiers, all of which signify "distinction," are being used to mark difference, according to different chains of associated tastes; in one, the supposedly "upper-class" tastes are being absorbed wholesale by middle-class taste; the other refigures those markers of distinction as signifiers of pretension, a counterfeit form of cultural capital to be laughed at. The circulation of these polysemic markers of distinction preclude the direct correlations between economic status and semiotic activity which Bourdieu makes the hinge point of his holistic approach to cultural value. For economic status to determine and hierarchize all semiotic activity depends on the ability of the former to establish not only cultural authority, but cultural sovereignty. The gap between authority and sovereignty is, semiotically speaking, enormous, and it is precisely this gap that has made cultural value a matter of insistence, contention, appropriation and reclamation.

As more and more institutions, rich in cultural capital of their own creation, insist on the authenticity of that capital, the tensions between authority and sovereignty become increasingly apparent. The conflicts between these standards is nowhere more obvious than in the evaluation of popular culture, because that evaluation is undertaken by so many different vested interests that utilize divergent, often contradictory criteria that define the nature, function and quality of popular culture in anything but a consistent manner. Conceptualizing taste in reference to the

popular is a highly contested arena primarily because three parties insist on the privileged position of their evaluative judgments: popular texts themselves, journalist critics, and the academy. Formerly, "intelligent" evaluations of the popular were believed to be done only by the latter; though popular critics may have passed judgment on movies, best-sellers and rock albums, their criteria were primarily understood to be watered-down versions of standards developed by academicians as far back as Matthew Arnold. Simon Frith, for example, has argued, quite rightly, that the criteria used to determine the quality factor of high art are often virtually the same as those employed in the evaluation of popular culture: "The fact that objects of judgment are different does not mean that processes of judgment are."[7] Frith contends that certain evaluative discourses (*art* discourse, *folk* discourse, pop discourse) "describe neither separate art worlds nor different class attitudes, but are, rather, all at play across all cultural practices. Value terms are therefore shared aesthetically; there is no immediate reason to treat popular culture any differently than high culture." (p. 107). While Frith argues correctly that taste is not specific to the bourgeoisie, his attempt to demonstrate the presence of taste distinctions within the popular, that is, the same criteria used to evaluate high art are also employed to evaluate popular texts, overestimates the sovereignty of those criteria and in the process oversimplifies the entire question of popular taste. He contends, for example, that "it is the academy that now provides the terms—the meaning—of high cultural experience; it is academic discourse that now shapes the newspaper review, the record-sleeve note, the exhibition catalogue" (p. 110). But just which academy does he have in mind? Here Frith, normally so insistent upon specificity, makes a thoroughly ahistorical argument by insisting on the hegemonic power of the academy to shape critical reviewing outside the academy. In the current situation, at least in the U.S., the opposite is more nearly the case, now that one of the common themes of popular criticism is that the academy has lost itself in some sort of poststructuralist haze, killing authors, rejecting evaluation, speaking impenetrable critical languages that only other addle-brained academics can understand. The popular critics who inveigh

most passionately against this lunatic fringe that has allegedly taken over the academy use critical discourses that did indeed originate within the academy, but a pre-Structuralist academy now allegedly dead, its values maintained only by the guardians of sanity and good taste who now exist only *outside* the academy in the world of journalism. Frith argues that, in the development of English literature as an academic discipline, "the academy became a stockade within which the better and the superior could be defended from the Philistines (and in particular from the Philistines literary representative, the journalist, the object of recurrent academic hostility") (p. 41). In the later eighties and early nineties, however, journalistic criticism has appropriated the stockade mentality, and the chief object of *its* collective scorn has become the "out-of-touch," "extremist" academic, who, though fascinated by popular culture, nevertheless fails to understand and, worse yet, fails to even care about evaluating it.

Two Autonomous Film Cultures: Authorizing Authorship

This conflict, between popular critics who care about critical distinctions (and express them in "comprehensible" discourses) and academic critics who made the term "journalistic" synonymous with superficiality, exemplifies the gap between cultural authority and cultural sovereignty. That gap is especially obvious in reference to the very issue of authority, or more specifically, authorship, particularly within the realm of film analysis, where auteurism has undergone significant redefinition. The category of the *auteur* has changed profoundly since its emergence in the French film criticism immediately after World War II. In a series of influential essays, Alexandre Astruc, François Truffaut, Jean-Luc Godard and others developed a criteria for distinguishing film artistry from mere anonymous entertainment, based on the ability of certain *auteur* directors to establish and maintain a consistent personal vision.[8] As such, auteurism grounded its own critical activity on borrowed criteria, developed by critics of the legitimate arts over a century before. The Romantic ideology of artistic creation as pure invention by the singular genius had, by the 1950s, already been institutionalized for decades in the worlds of literature, art

and music, and was used as a common coin of exchange by academics and auctioneers alike. The legitimation of "the cinema" depended on the appropriation of this ideology and, not so coincidentally, the institutionalization of film study within the academy was in large measure a very successful reclassification and "reframing" of the medium by auteurist professors. By the mid-sixties, auteurism had become the basis of a *critical* authority that was itself entirely dependent upon *creative* authority in the most unambiguous, Romantic sense of the term—genius as source and guarantee of value. As such, it served as a model for film criticism and filmmaking (the latter exemplified by the emergence of the "film school generation" of American directors and the institutionalization of the *autoren* film that became a rallying cry for the German New Wave) as well as the basis for the legitimation of film as an artistic medium and film study as a discipline.

In the 1980s, auteurism underwent significant reclassification as it began to circulate in different contexts. Pushed out of the center ring of film study within the academy by different forms of ideological and psychoanalytic analysis that decentered the auteur as the source of a film's meanings, it became a staple of popular film criticism, as it became a structural component of new systems of film financing. It is at this point, from the mid-seventies to the mid-eighties, that the split between academic film study and popular reviewing began to widen in regard to the shared evaluative criteria that Frith refers to, the point when popular critics may have still looked to the academy for its critical apparatus; but it was those same traditional, "new critical" elements of the academy which serious film study deemed antiquated and counterproductive. Romantic auteurism had finally become thoroughly institutionalized in popular reviewing at the same time as it was being just as thoroughly dismantled by poststructuralist contingents within the academy. Rather than a simple homology, the relationship between journalists and academic critics has instead been a constantly evolving, historically delimited relationship—in the fifties journalists at *Cahiers du Cinema* appropriated evaluative criteria institutionalized within the academy for the study of more "legitimate" arts, which were then circulated as a brand of popular auteurism

at a time when the academy refused to acknowledge the legitimacy of film or film study, and were then taken back into the academy in the sixties where they were further refined and given a degree of legitimacy through the standardized forms of academic respectability (inclusion in curricula, development of programs of study, scholarly journals, conferences, and so on). These criteria were then "delegitimated" by the discipline in the seventies and eighties through the adoption of new critical languages that were determined to expose the irrelevance of auteurism as a vestigial form of a liberal humanism that was best forgotten.

This shift in evaluative criteria was paralleled by concomitant changes in the nature of popular entertainment, as the traditional studio system gave way to a form of production that Scott Lash, Celia Lurey and others have refered to as "flexible specialization" which made auteurism an extremely useful form of "branding."[9] According to Lurey, one of the most significant ramifications of the move away from studio production founded on Fordist, vertically integrated, monopolist forms of production was that:

> Long term arrangements, in which once-and-for-all contracts were coupled to sustained role commitments, were largely replaced by hiring on a per project basis (Faulkner and Anderson 1987). One consequence of this for creative workers has been that a career now has to be built on a succession of temporary projects and a performance history or profile has to be created from an identifiable line of credits...a free-lancer is is forced to enter into a series of contracts to acquire a cumulative line of credits and build a record of accomplishment. (p.67)

Timothy Corrigan's analysis of the development of "designer-label" auteurism and its impact on film financing details the factors involved in this evolution quite succinctly:

> if in conjunction with this so-called international art cinema of the sixties and seventies, the *auteur* had been absorbed as a phantom presence within the text, he or she has rematerialized in the eight-

ies and nineties as a commercial performance of the business of being an *auteur*.... Here the *auteur* can be described according to the conditions of a cultural and commercial intersubjectivity, a social interaction distinct from an intentional causality or textual transcendence.[10]

For Corrigan, Coppola exemplifies this shift because he has exploited the myth of the Romantic artist so successfully that he now is just as well known as a "Romantic entrepreneur" (p. 108). The interconnectedness of these two personas that Corrigan attributes to Coppola is summed up in virtual epigrammatic form by Coppola himself in a recent interview in *Details*,[11] an American fashion magazine covering the *Dracula* phenomenon. When asked who his heroes were, he responded: "Heroes I divide into living and dead. Living: Ted Turner. Dead: Goethe." The juxtaposition here of Media Baron and Romantic Poet embodies Coppola's desire to stake his own authority on two forms of capital—financial and cultural, which, though formerly considered mutually exclusive, now intermingle in increasingly convoluted ways that complicate the determination of the value of any given text, since that value can no longer be fixed in reference to one shared standard.

Corrigan's analysis of the "commerce of *auteurs* and the *auteurs* of commerce" delineates how the material conditions of authority factor into film financing, but the persistence of a vestigial Romantic auteurism in the popular evaluation of film remains a crucial determining factor that often operates in contradistinction to that economy. The schizophrenic attitude of the American popular press toward the film industry is a case in point. Apparently, only two types of films are "newsworthy" beyond the confines of the columns of film reviewers—the megablockbuster and the "independent film" of the moment. While the release of most blockbusters is now treated, more often than not, as a media phenomenon, the fetishizing of the independent *auteur* has become a phenomenon unto itself. The Sunday edition of the *New York Times* has become a weekly testimonial to the copresence of two standards of cultural value. The "Arts and Leisure" section now features, on a regular basis, multiple full-page

ads for the opening of blockbusters, alongside major feature articles on new independent directors (possessing vision, but little financial backing) who, despite all odds, produce film art. In recent months the *New York Times* has profiled Stacy Cochran (*My New Gun*), Anthony Drazan (*Zebrahead*), Quentin Tarantino (*Reservoir Dogs*) and Hal Hartley (*Simple Men*). The title of the article devoted to Hartley sums up their criteria quite neatly: "This Director's Wish List Doesn't Include Hollywood,"[12] as does the primary featured quotation. "Hal Hartley, who made the droll *Simple Men*, is hardly Cecil B. DeMille. And he never wants to be." The opposition of the *New York Times* critics' criteria versus "The Industry's" is even more clear cut in an article on all the independents of the week.[13] Entitled "Is a Cinematic New Wave Cresting?" (paired on the front page of this section with an article on the current television season, entitled "Still Trapped in the Vast Wasteland") the story features a nearly-full-page box containing individual photos of "Who's Who Among the Hot New Filmmakers," with vital data alongside each photo. The text that accompanies each picture lists newest film, name, age, background and mentor—but also, tellingly, two more categories: "Why the major studio may have turned down his/her film," and "Why it deserves notice" (read: why it deserves *our* notice and, of course, yours, dear *Times* reader). The persistence of this vestigial Romantic auteurism that serves as a virtually axiomatic justification for a film's status is not restricted to the *Times* or other publications with claims to cultural prestige. Hal Hartley was also the subject of a major article in *GQ* (entitled "The Vision Thing: Hal Hartley's movies are like no one else's—and we mean that in the best possible way")[14] and the November 27, 1992 issue of *Entertainment Weekly* features a massive black X, with Spike Lee's face superimposed on its side, the title reading, "The Mind Behind X—How Spike Lee Willed *Malcolm X* to the Screen." Lee was also showcased on NBC's prime-time documentary *The New Hollywood*, the conclusion of which exemplifies the extent to Romantic auteurism has become ensconced in American film culture in the broadest sense of the term. After devoting the last section of the program to the return of vertical integration (in which the major studios are once again attempting to gain control over film exhibition by buying up the-

aters) and the impact of the conglomeration of Hollywood, anchorman Tom Brokaw, not normally considered a devotée of film art, brings the program to a close with this final thought:

> Movies and Big Business. They've always been two of the most prominent symbols of America, and they've always been able to live together compatibly. But now there's a danger that one will completely dominate the other, that the bottom line will suffocate the story line, that accountants, not artists will have the final cut. Of course, a lot of people will get rich in the process—studio executives and those stars, producers, and directors who can move people through the box offices as ever higher prices. But what about you? What about the audiences who buy the tickets? Well, if you don't like what you see, you can always go elsewhere, right? Not necessarily. If these big companies have complete control, there will be fewer opportunities for the unique vision, for the smaller film. In fact, someday these movie marquees could not only hold the title of the picture, but a subtitle: Take It or Leave It.

That Brokaw, speaking as a high-profile representative of another conglomerate structure (NBC, owned by General Electric) should express such auteurist sentiments in his obvious prejudice in favor of brave outsiders indicates how ensconced the Romantic ideology of artistic creation has become, how the authority of the unique vision remains an unquestioned value within the television exposé.

The opposition between artistry and box office represents the collision, however, of only two major economies of evaluation. The release of Coppola's *Bram Stoker's Dracula* has been met with the requisite auteurist reviews and feature stories about its financial success, of the film's record-breaking first weekend. Some, like a cover story in the *San Francisco Examiner*'s Sunday *Image* magazine, manage to situate Coppola and his film within both an artistic and a commercial context, alternating between the two virtually from paragraph to paragraph.[15] This Thanksgiving issue on "Holiday Cheer" focuses on the different ways Bay Area celebrities spend the holiday, with Coppola featured on the cover, toasting the sea-

son and the camera with a glass of his own proprietary red wine, Rubicon. The article comments at length on the luxuriousness of his Napa Valley estate and his recently acquired, meticulously restored Cord, "the dream car of the 30s." In the midst of this appreciation of Coppola's good life, auteurism rears its heroic head. While arguing with one of his guests, Fred Fuchs, from American Zoetrope, about what the studio might do to his film, we are told:

> He's afraid the unaltered film will be used and thus *Dracula* will not be exactly what he has labored two years to produce. At the picnic table, Coppola suddenly jumps to his feet, denouncing what he calls bureaucrats. He walks to a space between the tables and makes a brief, angry speech. He repeats his charges about bureaucrats, refers to his 30 years experience as a filmmaker. Amateurism is making inroads, he says. Firmly, he tells the assembled picnickers that nothing is to be sent out of the estate unless he personally—and no one else—signs off on it. (p. 14)

While Coppola insists on complete authority, the film has been evaluated in reference to other criteria that recontextualized it even as it was being released. The November issue of *Vogue* begins its coverage of the movie with a spread of glamour shots of Winona Ryder in various incarnations, including an homage to the Audrey Hepburn of *Breakfast at Tiffany's* vintage.[16] These photos are followed by black and white shots of Gary Oldham (who plays Dracula) and Ryder "in character," looking very Gothic, followed by a short essay by hot, new, outsider novelist Mary Gaitskill, in which she attempts to explain the timeless appeal of the vampire story. Here the status or value of the film is measured in reference to the star appeal of Ryder, who is given credit for initiating the project ("Winona Ryder not only stars in *Bram Stoker's Dracula*, she made it happen"), and in reference to the literary star appeal of Gaitskill, whose artistic credentials as a novelist give her authority to explain the significance of mere mass entertainment. The accumulation of these divergent reframings aren't just a matter of "encrustations," in Macherey's and Woollacott/Bennett's sense of the term, that mediate our relationship to

the film.[17] The various "activations" of James Bond that Bennett details so impressively are primarily a matter of diachronic evolution, not synchronic conflicts that frame the same text in divergent ways simultaneously. These articles that cover the *Dracula* phenomenon ask their readers to value the film as a star vehicle by Hollywood's newest vamp, as a narrative spectacle that somehow speaks directly to our unconscious desires, as the newest creation by a visionary *auteur*. If we add the film's intertextual quotations, *Dracula*'s own authority as a film work is grounded in historical significance as the inheritor of the great cinematic tradition of Lumière, Murnau and Griffith; and as the most "faithful" adaptation of Stoker's novel (a point Coppola insists upon), it also claims literary value through its respect for *the book*.

These reviews may seize on different aspects of *Bram Stoker's Dracula*, as entertainment machine or auteurist masterpiece, but none of them refer to either academic film scholars or popular culture theoreticians to lend weight or cultural authority to their repetitive arguments. One popular critic has addressed this absence explicitly. Jonathan Rosenbaum, the reviewer for the *Chicago Reader* (November 27, 1992) refers to the "two autonomous film cultures" in the United States that developed due to:

> the profound lack of communication between the film industry
> (including most movie reviewers) and academic film studies
> (including intellectuals in adjacent or related fields). You want
> examples? Look at the collected reviews of Pauline Kael since
> the early 70's when academic film study in the U.S. was just
> getting started, and you'll be hard put to find a shred of evidence
> in more than two decades of energetic writing that such studies
> existed at all. Look at the reviews of nearly all her journalistic
> colleagues during the same period and the absence is painfully
> apparent. (p. 10)

His review of *Dracula* elaborates on its "academic ripeness"; that is, academic critics will find the film fascinating in ways that popular critics fail even to mention:

> I could be wrong, but I'll bet academic critics will have a field day
> with Coppola's swarming, overpacked horror extravaganza once
> they have a chance to digest it.... For one thing, it's a movie that
> would benefit from excerpting and repeated viewings, two class-
> room standbys. For another, it seizes on all sorts of ideas that
> were kicking around certain film departments 10 or 15 years ago,
> such as the notion that movies and psychoanalysis got started
> around the same time, and concepts involving female desire, sex-
> ual hysteria and hypnosis that were related to some of Freud's
> early cases.

Rosenbaum's formulation is especially interesting in that he places pop-
ular reviewers within "the industry," which is "not on speaking terms"
with the academy, yet journalistic critics, from Camille Paglia to Tom
Brokaw, position themselves as guardians of the public sphere, opponents
of both excessive commercialization and unbridled intellectualism, both
of which reflect only the self-interestedness of the industry and the acad-
emy. Academic critics have, at the same time, claimed this same higher
ground of public interest, by positioning their critical discourses outside
the taint of superficial evaluation most often framed in terms of thumbs,
popcorn boxes, stars and hankies.

The coexistence of Rosenbaum's two autonomous film cultures
depends in large part on the ability of critics within each culture to
claim cultural sovereignty grounded in transcendent evaluative criteria
used in the service of common good, yet that very coexistence evidences
only a sovereignty operative solely within specific networks (each with
its own imagined public sphere) that are virtually valueless outside
them. The incommensurability of the public spheres imagined by jour-
nalists and academic critics arises from the reification of their evaluative
criteria, a reification secured by the axiomatic usage of critical principles
that by now have become institutionalized poses—the journalist critic
assuming the role of traditional humanist critic, (champion of the peo-
ple as voice of sanity and good taste), while the academic critic adopts
the role formerly inhabited by the avant-garde artist, (champion of the
people as critical outsider, speaking in "foreign" languages that escape

the banality of the commonplace).

Toward a Pedagogy of Partiality

The tensions between popular and academic critics involve a host of imbricated oppositions, but two are of paramount importance. The dichotomous relationship between amateur and professional rests on imagined relationships between consensus and fragmentation—each one's authority depending ultimately on who they speak *for*. In his provocative study of the professional status of intellectuals, *Secular Vocations* (1993),[18] Bruce Robbins surveys the complicated, shifting status of the professional academic by situating it within the other cultural categories which determine the value of professionalism in regard to culture "as a whole." Robbins meticulously delineates the various positions or poses that a number of high-profile intellectuals have adopted, but his analysis of two of Raymond Williams's later essays is particularly relevant here. He begins his discussion of the concept of critical *distance* by examining the presuppositions that are operative in Williams's critique of British television's coverage of the Falklands/Malvinas war. Williams was appalled by the antiseptic presentation of the fighting, which was attributable to the "professional culture of distance" which comes from "models and convictions without experience." Robbins notes the similarities between this essay and another retirement lecture that appeared the following year in the *London Review of Books*, in which Williams invoked distance as the very basis of the discipline of literary criticism. Robbins argues:

> Rather than tracing a fall from modernism into professionalism, Williams suggests that in its essence modernism already *was* professionalism. And that is what is wrong with it. Without commitment, old or new, to local culture or community, the professionalized intellectual remains estranged, free-floating, cosmopolitan... "I can feel the bracing cold of their inherent distances and impersonalities and yet have to go on to say that they are indeed ice-cold." (p. 58)

While Robbins clearly has great admiration for Williams, he points out the problematic aspects of this concept of distance which is tied to the opposition between experience and models:

> "Experience" in his loaded sense—implying that someone engaged in battle fully understands the meaning of the actions in which he or she takes part—presupposes its own model. The experience of combat, an extraordinary collective enterprise, functions in his essay as a radical simplifier, temporarily effacing social differences and divisions and gathering what might ordinarily seem to be a chaos of private actions into a single publicly intelligible whole. Behind the hypothetical immediacy of the battlefield, that is, lies a model of the natural, rooted wholeness of the "organic community," a bounded and knowable society assumed to be capable, like a battle, of rendering individual experience fully meaningful because it is united against its outside and innerly transparent, harmonious, consensual. (p. 60)

The relationship between intellectuals and professional academics, as well as the relationship between experience and models, depends upon notions of community and the knowability of what seems like chaos, specifically the alleged chaos of postmodern cultural production. The conflicts between two types of cultural authorities—journalistic critic, posing as as gifted amateur speaking from the front lines of actual experience, and the professional academic as mere model builder who keeps his/her distance—continue to intensify as journalist attacks on the insularity of elitism of the academy grow increasingly commonplace. I wanted to introduce a representative example here in order to examine the specific linguistic-ideological games being played in these diatribes, but the quotation of virulent attacks on academics I respect seemed completely counterproductive. No matter how I would take up their cause, I would still give greater circulation to the hatchet jobs directed against them. So I decided to use such a review of my own work that takes up Williams's later essays explicitly and reveals just how contingent the opposition between "experience" and "models" can be. In the August 27,

1989 edition of The *London Times*, Brian Appleyard reviewed two books in tandem, Raymond Williams's 'The *Politics of Modernism* and my first book, *Uncommon Cultures*. He begins by questioning Williams's attempts to broaden literary criticism, a discipline that "could never quite contain the ambitions of its teachers" into the realms of "social and cultural analysis." According to Appleyard, this is "dangerous and occasionally comic…when he brings in the 'children of struggle'—the students of the sixties—and the Vietnam war just after Brecht, Lawrence and Auden, one has the odd sense of meeting Terry Thomas bubbling around in the midst of the Tet offensive." The main problem for Appleyard is that, "the entire project is undermined by the nagging uncertainty as to why we should believe all this. Unquestionably one finds oneself agreeing with many insights, primarily because underneath the grand political structure a perfectly decent literary critic is struggling to be heard."

Here Appleyard begins a series of critical sleights of hand. Williams's desire to speak to broader cultural issues is alleged to be a case of overwhelming ambition that ends in absurdity, but somehow Appleyard runs no such risk—he can speak confidently as a public intellectual because, as an amateur who resists models and grand superstuctures, he speaks the language of the folk. Cultural theory has become an "industry" that speaks in impenetrable professionalized languages, and he offers as proof of this new lunacy the work of yours truly:

> To see how far the cultural theory business has escaped the bounds of sense it is necessary only to sample a sentence of Jim Collins' *Uncommon Cultures* with its suave and baffling jargon. 'The investigation of aesthetic ideologies is a first step in a much larger project of developing a theory of decentered cultures predicated on the conflictive heterogeneity of cultural production.' Sure, Jim.

Appleyard's colloquial, aw-shucks manner apparently guarantees his amateur status, allowing him to pose as peculiar cross between Will Rogers and an Allan Bloom wannabe. He clearly realizes something that we professionals fail to see—that popular culture is, after all, just for fun:

"Yet some of his examples suggest Collins is capable of quite enjoying himself and can be likeably perceptive. But for the benefit of the industry, this must be concealed beneath the chaos of a language designed to exclude all but the most rabid initiates." The study of popular culture has been misguided since "American academia first sank its claws into Bob Dylan."

Now as an overly ambitious, rabid bird of prey who speaks impenetrable languages, I could of course take issue with these points, but I've fixed my gaze on bigger game. You see, folks, Brian concludes by suggesting that I would see the error of my ways if only I read Alasdair MacIntyre's *After Virtue,* that I would stop celebrating heterogeneity and fragmentation and stop babbling when I realized that all this chaos stuff was the result of the "failure of the Enlightenment to find a rational basis for morality." This point is particularly interesting because it reveals so-dang-much about Appleyard's assumptions regarding his commonsense-amateur approach, his ability to speak for the interests of the public sphere in a way that professional academics couldn't hope to, and the notion of consensus which acts as the implicit guarantee of his entire discourse. As an alternative to the madness of the contemporary academy, Appleyard would offer a world of enlightened amateurs unencumbered by grand superstructures or specialized languages, who could all agree on basic values and say "it is good," or "it is just entertainment," or "he is a rabid academic" and know what they all meant by it.

But there are problems with this consensus business and the amateurism its supposed to justify, because the world just don't work that way, Brian. You see, Alasdair and I teach at the same university, and we compete for the hearts and minds of a lot of the same graduate students on a regular basis. In fact, we disagree about lot of stuff but most especially about consensus—how it's achieved, whether it allows for the toleration of difference, and whether that's important. I'll give you a specific example of why I persist in believing in the positive dimensions of dissonance and heterogeneity and why I'm dubious about this consensus business. You see, last year I was a member of our Faculty Senate, and there as a great deal of debate about one of the recommendations

that the president made in his report on the future of the university—
that in order to maintain the Catholic character of the university, every
effort should be made to ensure the predominance of dedicated and
committed Catholics on the faculty. This generated weeks of debate
concerning the wisdom of such a policy—how would a Catholic quota
system effect the quality of the faculty; how does one determine what is
"dedicated and committed" when there are such profound differences
between the conservative and social-action wings of Catholicism; was a
numerical superiority really necessary to insure this character, and so
on. The debates over these questions, which were played out in open
meetings, letters to the campus newspaper and organized debates,
became a remarkably good example of how a consensus might be
formed within a localized, but still decidedly heterogeneous public
sphere. Yet MacIntyre's suggestions regarding how consensus might be
achieved in all of this debate revealed quite clearly what consensus actu-
ally means, on the ground. In a letter that appeared in the campus
newspaper, he acknowledged other opinions had been advanced in the
Faculty Senate:

> But Catholics have to remember that for them the norm for
> Catholic universities in this respect has already been laid down in
> the Apostolic Constitution on Catholic Universities of August 1990,
> *Ex corde ecclesiae*, II, 4, 4.... And elsewhere it is made clear that
> the Catholic teachers are to be dedicated and committed Catholics.
> Vatican II taught us in *Lumen gentium* (25) that judgements made
> by the Pope "are to be sincerely adhered to," whenever his mind
> and will is evident.

Consensus, then, appears to a relatively simple affair after all, since it
depends on Papal decree which renders all other voices insignificant, a
point MacIntyre makes uniquivocally in his conclusion:

> So neither the views of the Committee on Academic Life nor those
> of the Faculty Senate can be of primary importance. To suggest
> otherwise would be to imply that this university is free to ignore

both *Ex corde ecclasiae* and *Lumen gentium*, that is, that it has already lost its Catholic identity.

To summarize, the tensions between authority and sovereignty in the determination of cultural value necessarily involve questions of professionalism and the imagined publics spheres whose interests are spoken for, but that consensus which the critic claims to either represent or disturb (and which, in the process, is made to serve as the rhetorical/ideological justification of that position) should, in postmodern cultures of the nineties, also involve, just as inevitably, questions concerning the *manageability* of information. In other words, the authority that a given critic or institution may claim, speaking as amateur or professional, to give voice to an imagined consensus depends on the degree of imagined mastery over the array, the imageability or mappability of the postmodern cultural terrain. These issues were raised in Chapter One in reference to notions of self-location and self-identity, but they should be every bit as important in the discussion of cultural authority, since they are so thoroughly imbricated in the determination of value, professionalism and imagined consensuses. Whether contemporary cultures are envisioned as chaos, the once-and-future organic community, a sprawling but still systemic matrix, or as an endlessly reconfigurable array of globally discontinuous but locally manageable information, the degree of totalizibility of "all that stuff" has a massive impact on what can and can't be said, from which position of authority, on behalf of which public sphere, even if it remains an unarticulated given within most public discourse.

Jon Savage's and Simon Frith's "Pearls and Swine: The Intellectuals and the Mass Media"[19] provides a useful case study, since they examine the antagonistic relationship between journalists and academic critics, but in contextualizing that relationship they also insist on another dichotomous relationship within the academy. They begin by making a crucial point regarding this antagonism and the types of authority that are in question, arguing that the:

hostility between academics and journalists has its own history,

but what is taken for granted nowadays is not only that acade-
mics, in their jargon-patrolled cloisters, don't understand life—as if
they didn't themselves have parents and children,disappointments
and debts—but that journalists do.... Experience turned into moral
authority— the newspaper columnist's trade—reflects most signifi-
cantly an attitude toward one's readership. If the academic's task
is to tell people what they don't know, the journalist's is to tell
them what they do. (p. 6)

Savage and Frith then situate this opposition in reference to the Thatcher
Administration's promotion of "intellectuals in right-wing think tanks
that lay outside the intellectual establishment. Their challenge to acade-
mic common sense was conducted in the name of some deeper,
instinctive popular knowledge." But in their detailing of the various fac-
tors that shaped this anti-intellectualism they also include the emergence
of cultural studies, which they believe is one more of these "populist
poses" which "construct 'the people' as a mythical site of authority." They
site approvingly Jim McGuigan's argument in *Cultural Populism*[20]—that the
media version of popular culture and the academic status of popular cul-
ture within cultural studies are remarkably similar in that both define
the popular in sales terms, both focus on the consumer, and both stake
their critical authority on an identification with "the people." The main
fault of cultural studies is that it fails to be sufficiently critical, and its pop-
ulism makes it "journalistic." Savage and Frith enumerate the various
dichotomies used to characterize popular culture (ordinary versus elite,
conservative versus progressive, and so on), but:

We would summarise all such dichotomies under a more general
heading: the culture of self-satisfaction versus the culture of the
dissatisfied. From the dissatisfied position the argument always
has to be that life could be different, could be better, could be
changed—both art and education rest on such premises; they are
meant to make us see things differently. They are designed to
show us through the imagination, through reason, the limitations
of our perspectives, to doubt our common sense. Against this, all

versions of populism, left and right, are organized less to reflect what people do think (most people are muddled) but rather, to enable them to think without thought. (p. 16)

By failing to remain sufficiently critical, "populist" academics are made to appear anti-art, anti-education, anti-change, and to do all this in a form of non-thought. And just in case there was any doubt left about the potential value of this scholarly work, they conclude, "It is time to reclaim pop from the populists: they have said much of nothing, but their chit-chat still poisons the air" (p. 18). Throughout all this populist-academic-bashing, one can't help but be reminded of the journalists demonization of the academic. Just to sum up the various indictments—according to journalists like Appleyard, academic critics of popular culture are rabid birds of prey spouting professionalized gibberish, and are so distanced from the real world that they have no grasp at all of how real people actually have fun with popular entertainment; and, according to genuine *critical* academics, this same lot of monstrous academics specializing in popular culture are far too "journalistic," not nearly distanced enough from the marketplace, and appear to be utterly opposed to "thought" in general. Given the shrillness of the rhetoric in each case, one can only wonder why the study of popular culture, when it isn't done the way it's *supposed* to be done, should provoke such hysterical posturing?

Perhaps it's because the very unmanageability of popular culture threatens the professional certainty of both journalist and dissatisfied academic critic—to get the study of popular culture wrong is to fail to apply the proper axiomatic criteria which get the unrulier forms of cultural production under discursive control and further justify the professional status of the critic. What is the mythical site of the dissatisfied intellectual's authority? If the "populist pose" depends on "the people," what does their own pose depend on—"Critical theory"? Critical theory as a transcendently oppositional power base unto itself, translated into professional terms, becomes an entrenched *left professionalism* which is endlessly self-justifying and self-perpetuating. In the concluding section,

Savage and Frith call for an alternative to populism, a "new language of popular culture; one derived from anthropology, archetypal psychology, musicology, one which has a grasp of pop both as an industrial and as an aesthetic form." The appearance of "archetypal psychology" on this list reveals a great deal about their alternative to populism. When I first read this list I was surprised to see it there; after all, how could they be advocating the adoption of an approach to myth study founded on such thoroughly asemiotic principles, believing as it does in the existence of a universal, cuturally transcendent language of myth which would claim to tell us not just what we already know but what we've always known, from way back. Using a critical language founded on such static, primordial notions of the self and representation seemed like a rather peculiar way to make sense of contemporary popular culture, but then it struck me that this was perfectly appropriate to their project, that what in fact was being advocated as an alternative to the poisonous chit-chat of populism was a form of *archetypal Marxism* in which popular texts, as commodities, function as materialist archetypes, possessing negative intrinsic value wherever and whenever they may be found.[21] To see "anthropology" on the same list, then, is rather puzzling; why advocate ethnographic analysis when the highest priority is to evaluate as axiomatically as possible, when the greatest horror is that the critic might actually "go native" and leave the values of the academy behind like some latter-day Kurtz, thinking without thought in the jungles of postmodern cultures. For Savage and Frith, the pursuit of pleasure seems to be synonymous with superficiality and promiscuity:[22] "There is no sadder sight than the fortysomething ex-leftist, the thirtysomething ex-punk, the twentysomething ex-Stylist, burying their disappointments in the their search across the surface of popular culture for pure sensation" (p. 17). But surely no sadder than the sight of left professionals singing "Give Me That Old Time Religion"?

That this oppositional posturing must be maintained at all costs as a guarantee of professional legitimacy is nowhere more obvious than in denunciations of cultural studies, which must, of course, be imagined as the new dominant or at least as the new hegemonic power that will allow

the critical intellectual the requisite degree of alienation needed to secure their own cultural capital. Sande Cohen [23] makes the compelling argument that:

> The dominant mode of contemporary criticism remains devoted to Adorno-style denunciation—cultural analysis (and production) as anything other than a 'negative dialectics' is barely discussable among progressive academics.... The critical artist and intellectual is embedded in the imaginary but ruthlessly enforced equation between 'serious' culture = critical consciousness. The more 'we' expose what the system is through cultural works, the more 'we' bring political consciousness into alignment with 'historical' and 'critical' consciousness, thus initiating opportunities to offset the 'system' and its ideological codifications. Put another way, Western intellectuals are more than ever expected to reclaim a territory called 'public space.' To do this, we must colonize as effectively as possible: practically, this demands the radical positioning so as to make claims in the future concerning what is worth knowing. (p. 244–245)

What serves as the basis for those claims about what is *worth knowing* depends, in the case of left professionals, on the stated assertion that they seem to be the only ones left in the academy who really want to *know* anything (since they're the only ones interested in "thought" as opposed to mindless celebration). The attempt to seize the higher academic ground while characterizing that which is the public sphere in terms of corruption and falsification inevitably results in the homogenization of that counterfeit sphere. Pierre Bourdieu has, for example, has been dismissive of cultural studies as well, but interestingly enough, he feels its chief fault is not that it fails to advocate change but rather that it overestimates the capacity of new forms of popular culture to change the distribution of symbolic capital: "To exaggerate the extent of change is, in a sense, a form of populism. You mystify the people when you say 'Look, rap is great'...you forget what remains the dominant form."[24] Bruce Robbins's analysis of how Bourdieu can be so dismissive of populist media scholars

describes the dynamics of left professionalism most effectively:

> What is the source of Bourdieu's striking assumption that there
> indeed exists and has always existed a single "dominant form" of
> culture, a single source of "symbolic profits," a single set of "social
> games" that counts? From New York, this assumption looks
> counter-intuitive, and even in centralized Paris it can hardly be
> taken for granted. It is hard not to notice, therefore, that
> Bourdieu's interest in defending the notion of a single "dominant
> form" coincides with an interest in defending the "symbolic profits"
> that he himself has drawn from analyzing this dominant form, that
> is, from the invention of "cultural capital." The threat to cultural
> capital posed by cultural studies is clear.... If culture's contents
> were not arbitrary..., if "the people" had some special access,
> competence, or authority where culture is concerned then the
> system could not work as he describes.... In discovering or
> inventing the notion of cultural capital, in other words, Bourdieu
> was not only professing a faith in a superhuman power, but
> seizing the massive scale or scope of the injustice it produces as
> the measure of his own legitimation. Its ability to persist in
> evil-doing becomes the guarantee that the arc of his own social
> ascent will not droop, that he will stay aloft. (p. 208–209)

Critical distance is inseparable from issues of cultural capital, but what does "distance" mean in information cultures defined not just by new technologies of access and storage which completely alter who is a collector and what is collected, but also by shifting taste cartographies which reflect profound changes in the nature of cultural authority and what it's supposed to accomplish? Distance remains a vital category in determining professional identity, yet in the early nineties it seems necessary to ask a number of elementally simple questions: distanced from whom, by which mechanisms, for what purpose? In Chapter One I surveyed the ways in which new notions of cultural identity are defined in reference to spatial and/or historical coordinates which challenge the ontological status of any fixed reference points, so that geography and history become meaningful in the cause of self-location only as they are rendered contingent

by the stakes of that self-location. The academic's own self-location depends all too often on a foundational narrative, featuring the ever popular critical distance equation, in which Intellectuals resist the Marketplace, fighting a desperate battle against Mass Culture as the last defenders of critical discrimination. But that narrative grows ever less compelling, as it becomes increasingly clear that there are other players involved in the evaluation game, individuals who are neither critics, journalists nor marketeers who perform their own forms of "cultural airlifting," those listeners, viewers and readers engaged in their own archivization of their cultural histories. Just as the semiotic excess of information societies has produced the need for new forms of cultural mapping, the developments in the technologies of access, retrieval and storage *and* the rejection of the monopoly on critical discrimination claimed by academics and journalists alike should lead to the construction of new narratives of cultural authority.

But what would such a narrative be like? What kind of narratives could provide academic critics of popular culture with convincing arguments for their professional legitimacy without predicating that legitimacy on antiquated notions of "distance"? How might their pedagogic authority be asserted without reasserting monopolist positions regarding critical discrimination? In the conclusion to his analysis of *Dead Poets Society* Henry Giroux argues that an emancipatory notion of pedagogic authority:

> should be fashioned in pedagogic practices rewritten in terms that articulate the importance of creating the conditions for students to take up subject positions consistent with the principles of equality, justice, and freedom rather than with interests and practices supportive of hierarchies, oppression, and exploitation. Central to this notion of authority is the need for critical educators to develop those spaces and practices that engage but don't erase the identities, compassion, or willingness of students to challenge the discourses of authority.[25]

The old "critical distance" narratives must be resisted at all costs, since they maintain hierarchies of taste and knowledge that function in such

oppressive ways that they preclude the possibilities of equality, except within the carefully proscribed terms of those hierarchies. Students can be encouraged to challenge authority, while still maintaining the legitimacy of our pedagogical authority, but only if the variability of all cultural value becomes a primary concern of this new pedagogy. At its most basic level, pedagogic authority should depend on the academic critic's ability to offer students insights into the cultures of their day-to-day life that they otherwise don't receive from journalist evaluation or, for that matter, from others disciplines within the academy. To engage in taste-wars with journalists, in which one set of axiomatic principles is set forth which instantly invalidates all others, hardly allows for a critical examination of hierarchy or the intricate, overlapping factors which determine evaluation.

The academic critic can indeed offer a site from which to view the complexity of cultural power relations that is not available elsewhere, by moving *across* the institutions and discourses which are responsible for the production, circulation and evaluation of popular culture. I emphasize "across" here because I'm not recommending the adoption of some nonpartisan, metacritical position *above* the fray of the array but rather one that sees the pedagogical utility of moving across the bar of all of the inside/outside dichotomies, in and out of the divergent evaluative criteria in order to understand both the mechanisms and the stakes of critical evaluation in cultures defined by the proliferation of conflicting taste cartographies. The study of cultural evaluation was, as Barbara Herrnstein Smith has argued so convincingly in her seminal work, *Contingencies of Value*,[26] largely ignored in the otherwise extensive reformulation of what constituted textual analysis in poststructuralist theory. Within the past few years there has been increasing interest in questions of value, but the vast majority of this work fails to come to terms with either the contingent nature of the critic's own authority vis-à-vis the other agencies of evaluation that operate simultaneously, or the changes in information and media technologies that now constitute some of most significant contingencies of cultural life in the last decade of the twentieth century.

Coming to terms with both of these factors depends upon the construction of different sorts of critical and pedagogical narratives that will account for the ways that culture is now accessed and evaluated accordingly. Throughout this book I've discussed the utility of aggregate narratives, and in this chapter I've tried to construct one, albeit in a rather shaggy-dog fashion. Investigating the ways in which, for instance, popular films are assigned varying degrees of value involves a host of interconnected factors not usually considered together: the conflicting ways film is framed by the popular press, from auteurist masterpiece to hot star-vehicle; the ways in which the "authority" of the film is shaped by changes in film financing and promotion (how the move toward flexible specialization in Hollywood demands new forms of branding that produce *auteurs* of commerce); the ways in which the formation of two distinct film cultures determines the evaluation of popular culture in reference to the struggles for critical authority and professional legitimacy; the ways in which the film may be contextualized by historians, journalists and individual viewers alike in reference to their own archivization of culture.

The goal of this aggregate narrative is to reveal not just the diverse mechanisms involved in the determination of value but their *partiality*, in both senses of the word, since investing films, buildings, books or rock songs with value is a fragmentary, discontinuous process animated by the intensity of personal preference. In *Postmodern Education*,[27] Stanley Aronowitz and Henry Giroux argue for the development of a "border pedagogy" that would reject the transcendentalist, universalist dimensions of Enlightenment thinking that served as the basis for modern educational theory. This border pedagogy would pose alternative forms of knowing based on historical contingency by emphasizing cultural specificity and partiality.

> Partiality becomes, in this case, the basis for recognizing limits
> built into all discourses and necessitates taking a critical view of
> authority. Within this discourse, students must engage knowledge
> as border crossers, as people moving in and out of borders con-

structed around coordinates of difference and power. Border ped-
agogy decenters as it remaps.

While they conceive of partiality here in terms of limits, I believe the pro-
ject Giroux and Aronowitz outline can be amplified very productively if it
can address the other dimension of partiality, specifically by focusing on
the ways in which different types of cultural authority harness various
evaluative economies in their attempt to shape the basic terms of critical
discrimination which are so crucially important in the formation of iden-
tity. In other words, understanding the dynamics of cultural life involves
more than enumerating textual practices and social identities and empha-
sizing the importance of difference in each case; it should also try to
account for difference in evaluative economies—some originating with-
in the marketplace, some within the academy, still more shaped by family
histories, sexual preference or generational affiliations—which determine
not just the value of things, but the extent to which individuals feel
empowered to pass judgment on the stuff that forms the fabric of their
daily existences, as well as the stuff their dreams are made of.

Arguing for the primacy of partiality and the usefulness of aggregate
narratives in envisioning the discontinuities of cultural authority does not
mean that alternative pedagogies must be a matter of micropolitics and
local narratives, in which totality can only serve as a model of how not to
collapse difference. Peter McLaren insists that certain conceptions of total-
ity certainly universalize to the detriment of specific subcultures, but that
understanding the totality of cultural production, if only in relational
terms, should be one of the primary objectives of radical pedagogy.[28] He
cites Peter Murphy's distinction between master narratives and metadis-
courses in this regard: "A master discourse wants to impose itself on all the
other discourses—it is progressive, they are reactionary; it is right, they
are wrong. A metadiscourse, on the other hand, seeks to understand soci-
ety as a totality."[29] Murphy develops this sense of totality in reference to
Robert Venturi's vision of culture as a "difficult whole," a formulation in
which totality depends on the juxtaposition rather than the homoge-
nization of fragments. Envisioning cultures as totalities in ways that

respect their complexity and contradiction will become an ever more pressing critical imperative as societies become increasingly multicultural and multi-informational. Metadiscourses rather than master-narratives can become vitally important in accounting for these new infrastructural forms of difference in a cohesive manner, provided that this cohesion isn't secured by the old critical narratives, which recognize difference only as long as it's reducible to one evaluative criteria, at which point they become meta-master-narratives. In Savage's and Frith's analysis of television programs devoted to the arts they contend, quite rightly, that the journalistic imperative is one in which, "In the end, which ever way you look at it, everything has to be *wrapped up*. And what escapes the program is what can't be so wrapped" (p. 13). The academy's imperative would appear in many ways to be exactly the same—everything worthy of study must be wrapped up within one or another discipline's "talk show." That which escapes the academy is the unmanageablity of contemporary cultural production, the divergent flows of information and evaluative energies that cannot be measured or contained by existing forms of cultural analysis, except in the forms of binary oppositions and summary judgments. That which appears to be remain virtually unthinkable is the potential loss of professional authority that might result if critics and teachers begin to move across disciplines in order to learn just how difficult that "whole" really is. Delineating the factors which shape critical discrimination is part of a much larger interdisciplinary project which this book has only begun to address— the development of new forms of pedagogy which can envision the array of postmodern production, the forms of cultural authority that attempt to master it, and, just as importantly, the evaluative energies which animate the "drama of choice" within that excess.

Notes

Introduction

1 Manuel Puig, *Kiss of the Spider Woman* (New York: Vintage Books, 1980).

2 Tony Kushner, *Angels in America* (New York: Theatre Communications Group, 1993).

3 Anne Rice, *Interview With a Vampire* (New York: Ballantine 1976), *The Vampire Lestat.*(New York: Ballantine, 1985), *Queen of the Damned* (New York: Ballantine, 1988).

4 Stephen King, *The Dark Half* (New York: Viking, 1989).

5 Kurt Andersen, "Are Beavis and Butt-head Arty?" *Time*, June 21, 1993, p.75.

6 John Leland and Mark Peyser, "Wayne's World," *Newsweek*, March 2, 1992.

7 Umberto Eco, *The Name of the Rose* (San Diego: Harcourt Brace Jovanovich, 1983).

8 John Zorn, *Spillaine* (Electra Nonesuch 979172, 1987).

9 Jon Scieszka and Lane Smith, *The Stinky Cheese Man* (New York: Viking 1992).

10 *Elle*, May 1992, p. 166.

11 *Time*, April 12, 1993, p. 53.

12 Louis Shiner, quoted in *Cinefantastique*, December 1987, p. 28.

13 Peter Fitting,"The Lessons of Cyberpunk," in *Technoculture*, ed. Constance Penley and Andrew Ross (Minneapolis: University of Minnesota Press, 1991).

14 Larry McCaffery, "An Interview with William Gibson," in *Storming the Reality Studio* (Durham: Duke University Press), p. 266.

15 Bruce Sterling, ed., *Mirrorshades: The Cyberpunk Anthology* (New York: Ace 1988).

16 Andrew Ross, "Cyperpunk in Boystown," in *Strange Weather* (New York: Verso, 1991); Claire Sponsler, "Cyberpunk and the Dilemmas of Postmodern Narrative: The Example of William Gibson," *Contemporary Literature* XXXIII, 4 (1992).

17 Paul Alkon, "Deus Ex Machina in William Gibson's Trilogy," in *Fiction 2000*, ed. George Slusser and Tom Shippey (Athens: University of Georgia Press, 1992).

18 William Gibson, *Storming the Reality Studio*, p. 271.

19 William Gibson, *Mona Lisa Overdrive* (New York: Bantam,1989).

20 Wayne Koestenbaum, *The Queen's Throat* (New York: Poseidon, 1993).

21 Terence McNally, *Lisbon Traviata* (Garden City: Fireside Theatre, 1990).

22 See especially Theodor Adorno and Max Horkheimer, "The Culture Industry: Enlightenment as Mass Deception," in *Dialectic of Enlightenment* (New York: Seabury Press, 1972), and Walter Benjamin, "The Work of Art in the Age of Mechanical Reproduction," *Illuminations* (New York: Schocken,1969).

23 Andrew Goodwin,"Sample and Hold: Pop Music in the Digital Age of Revolution," in *On Record*, eds. Simon Frith and Andrew Goodwin (London: Routledge, 1990), pp. 269–270.

24 John Ardoin *The Callas Legacy* (New York: Charles Scribners, 1991), p. xi.

25 John Berger, *Ways of Seeing* (London: Penguin, 1987).

26 *Chicago Tribune* Arts, Sunday, March 7, 1993.

27 Terence McNally, *New York Times*, February 19, 1993.

Chapter 1

1 Kevin Lynch, *The Image of the City* (Cambridge, MA: MIT, 1960).

2 Fredric Jameson, "Cognitive Mapping," *Marxism and the Interpretation of Culture*, ed. Cary Nelson and Lawrence Grossberg (Urbana: University of Illinois Press, 1988), p. 353.

3 Samuel Weber, "Capitalizing History" in *Institution and Interpretation* (Minneapolis: University of Minnesota Press, 1987).

4 Michael Sorkin, ed., *Variations on a Theme Park* (New York: Noonday Press, 1992).

5 Michel de Certeau, *The Practice of Everyday Life* (Berkeley:University of California Press, 1984).

6 Derek Gregory, "Chinatown Part Three? Soja and the Missing Spaces of Social Theory," *Strategies* No. 3, 1990.

7 Rob Shields, "The Individual, Consumption Cultures and the Fate of Community," *Lifestyle Shopping*, ed. Rob Shields (New York: Routledge, 1992).

8 Robert Venturi, Denise Scott Brown and Steven Izenour, *Learning from Las Vegas* (Cambridge, MA: MIT, 1972).

9 John Fiske, *Television Culture* (New York: Metheun, 1987).

10 Bobbie Ann Mason, "Love Life," *Love Life* (New York: Harper and Row, 1989), pp. 1–18.

11 H. R. H. The Prince of Wales, *A Vision of Britain* (New York: Doubleday, 1989).

12 Clive Aslet, "Classicism for the Year 2000," *Architectural Design,* vol. 58, No. 112, 1988.

13 Quinlan Terry, "Architecture and Theology," *Architectural Design*, vol. 62, No. 7–8, 1992.

14 Richard Rogers,"Pulling Down the Prince," *Architectural Design*, vol. 59, No. 5–6, 1989.

15 David Hallett, "Richard Rogers," *Design World*, No. 17, 1989.

16 For a discussion of this controversies surrounding the Cheapside and Paternoster developments see *Architectural Design Special Issue, Paternoster Square and the New Classical Tradition* (London: Academy, 1991).

17 Jim Collins, "A Clear Vista of the Edge of Civilization," *IRIS*, No. 12, 1991.

18 Anthony Vidler, "Counter-Monuments in Practice:The Wexner Center for the Visual Arts," *Wexner Center for the Visual Arts* (New York: Rizzoli, 1989).

19 Charles Jencks, "Interview with Peter Eisenman," *Architectural Design,* vol. 58, No. 3/4, 1988.

20 Simon Schama, *Dead Certainties* (New York: Vintage, 1992).

21 For an extensive analysis of the various forms of postmodern historical fiction, see Linda Hutcheon, *A Poetics of Postmodernism: History, Theory, Fiction* (New

York: Routledge, 1988).

22 Peter Ackroyd, *English Music* (New York: Knopf, 1992).

23 Charles Johnson, *Middle Passage* (New York: Plume-Penguin, 1991).

24 Saidiya Hartman, "Excisions of the Flesh," in *Lorna Simpson: For the Sake of the Viewer*, ed. Beryl J. Wright (New York: Museum of Contemporary Art-Universe Publishing, 1993).

25 Trey Ellis, *Platitudes* (New York: Vintage, 1988).

26 George Wolfe, *The Colored Museum* (New York: Broadway Play Publishing, 1987).

27 Trey Ellis, "The New Black Aesthetic," *Callaloo*, vol. 12:1, Winter,1989.

28 Donald Preziosi, "Oublier la Città," *Strategies*, No. 3, 1990.

29 Jeanette Winterson, *Sexing the Cherry* (New York: The Atlantic Monthly Press, 1989).

30 Steven Erickson, *Arc d'X* (New York: Poseidon Press, 1993).

31 Michel Butor, *L'emploi du Temps* (Paris: Editions du Minuit, 1956).

32 Alain Robbe-Grillet, *Les gommes* (Paris: Editions du Minuit, 1953).

33 Ruchi Miyake, "Material and Ideational Excess," in *G. A. Architect: Shin Takamatsu*, ed. Yukio Futagawa (Tokyo: A.D.A. EDITA, 1990), pp. 8–9.

34 David Stewart, "Poems and Words," in *Shin Takamatsu*, ed. Paolo Polledri (New York: San Francisco Museum of Modern Art—Rizzoli, 1993), p. 85.

35 Botond Bognar, "From Ritualistic Objects to Science Fiction Constructs: The Enigma of Shin Takamatsu's Architecture,"in *Shin Takamatsu*, p. 36.

36 Gilles Deleuze and Felix Guattari, *Anti-Oedipe* (Paris: Editions du Minuit, 1980).

37 *G. A. Architect*, p.23.

38 William Gibson, "The Gernsbach Continuum," *Mirrorshades*, ed. Bruce Sterling (New York: Ace, 1986).

Chapter 2

1 Michel de Certeau, *The Practice of Everyday Life* (Berkeley: University of California Press, 1984).

2 Claes Oldenberg, "I am for an Art…," in *Pop Art Redefined*, ed. John Russell and Suzi Gablik, (New York: Praeger,.1969), p. 97.

3 Andy Warhol, interview with G. R. Swenson, in *Pop Art Redefined*, p. 117.

4 Andreas Huyssen, "The Cultural Politics of Pop," in *Post-Pop Art*, ed. Paul

Taylor, (Cambridge, MA: MIT Press, 1989), p. 47.

5 Dick Hebdige, "In Poor Taste," in *Post-Pop Art*, p. 94.

6 Roy Lichtenstein, interview with G. R. Swenson, in *Pop Art Redefined*, p. 93.

7 Lawrence Alloway, *Roy Lichtenstein* (New York: Abbeville Press, 1983) p. 93.

8 Tony Hendra, *Brad 61, Portrait of the Artist as a Young Man* (New York: Pantheon, 1993).

9 For especially thoughtful analyses of appropriationist photography, see Anne Hoy, *Fabrications*, (New York: Abbeville Press, 1987); Kate Linker, *Love For Sale: The Words and Pictures of Barbara Kruger* (New York: Abrams, 1990); Abigail Solomon Godeau, *Photography at the Dock* (Minneapolis: University of Minnesota Press, 1991); Douglas Crimp, "The Photographic Activity of Postmodernism," *October* 15 (Winter 1980); Craig Owens, "The Medusa Effect or, The Spectacular Ruse," in the exhibition catalogue *We Won't Play Nature to Your Culture, Work by Barbara Kruger* (London: Institute of Contemporary Art, 1983).

10 Carole Ann Mahsun, *Pop Art and the Critics* (Ann Arbor: UMI Research Press, 1987), p. 96.

11 Richard Hamilton, "An Exposition of She," in *Pop Art Redefined*.

12 Judith Williamson, *Consuming Passions* (New York: Scribners, 1989).

13 Abigail Solomon Godeau, "Living With Contradictions: Cultural Practices in the Age of Supply Side Aesthetics," in *Universal Abandon?* ed. Andrew Ross, (Minneapolis: University of Minnesota Press, 1989), p. 201.

14 Robert Venturi, Denise Scott Brown, and Steven Iznevor, *Learning from Las Vegas* (Cambridge, MA: MIT Press, 1972).

15 Abigail Solomon Godeau, "Living With Contradictions," p. 202.

16 Patrice Petro, *Joyless Streets* (Princeton: Princeton University Press, 1988), p. 8.

17 Max Apple, *The Propheteers* (New York: Harper and Row, 1987).

18 Jay Cantor, *Krazy Kat: A Novel in Five Panels* (New York: Collier Books, 1987).

19 Manuel Puig, *Kiss of the Spiderwoman*, trans. Thomas Colchie (New York: Vintage, 1978).

Chapter 3

1 Caryn James, "*Demolition Man* Makes Recyling an Art," *New York Times,* October 24, 1993.

2 Claude Lévi-Strauss, *Structural Anthropology*, trans. Schoept Jacobson, (New

York: Basic Books, 1963).

3 Rick Altman, *The American Film Musical* (Bloomington: Indiana University Press, 1987).

4 Jane Feuer, "The Self-reflective Musical and the Myth of Entertainment," in *Genre: The Musical*, ed. R. Altman (London: Routledge and Kegan Paul, 1981), pp. 208–215.

5 Jim Kitses, *Horizons West: Anthony Mann, Budd Boetticher, SamPeckinpah: Studies of Authorship within the Western* (Bloomington: Indiana University Press, 1969).

6 Will Wright, *Six Guns and Society: A Structural Study of the Western* (Berkeley: University of California Press, 1975).

7 John Cawelti, "Chinatown and Generic Transformation in Recent American Film," in *Film Theory and Criticism*, eds. Gerald Mast, Marshall Cohen, and Leo Braudy (New York: Oxford, 1978).

8 Umberto Eco, "Postmodernism, Irony and the Enjoyable," *Postscript to the Name of the Rose* (New York: Harcourt Brace Jovanovich, 1984), pp. 65–67.

9 Stephen Holden,"Blood and Bonding in Hong Kong," *New York Times*, April 12, 1991.

10 J. Hoberman, quoted in Maitland McDonald, "Action Painter John Woo," *Film Comment*, vol. 29, No. 5, September/October 1993.

11 Maitland McDonald, "Action Painter John Woo."

12 Maitland McDonald, "Interview with John Woo," *Film Comment*, vol. 29, No. 5, September/October 1993.

13 Jim Collins, "Television and Postmodernism," in *Channels of Discourse, Reassembled* (Charlotte: University of North Carolina Press, 1992).

14 Julian Barnes, *A History of the World in $10^1/2$ Chapters* (New York: Knopf, 1990), p.240.

15 Allan Bloom, *The Closing of the American Mind: How Higher Education Has Failed Democracy and Impoverished the Souls of Today's Students*, (New York: Simon and Schuster,1987), pp.74–75.

16 Richard Schickel, "The Crisis in Movie Narrative," *The Gannett Center Journal*, Summer, 1989, pp.3–4.

17 Mark Crispin Miller, "Hollywood: The Ad," *Atlantic Monthly*, April, 1990, p.50.

18 Mathew Arnold, *Culture and Anarchy* (Cambridge: Cambridge University Press, 1963).

19 André Bazin, *What Is Cinema?* vols. I and II (Berkeley: University of California Press, 1971).

20 For an introduction to the work on the cinematic apparatus which critiques Bazin's idealism, see Philip Rosen, *Narrative, Apparatus, and Ideology* (New York: Columbia University Press, 1986).

21 Richard Schickel, "The Crisis in Movie Narrative."

22 Mark Poster, "Words Without Things: The Mode of Information," *October*, 53,.Summer, 1990,.p. 74.

23 Ann Cvetkovich, "The Powers of Seeing and Being Seen: Truth or Dare and Paris is Burning," Cathy Griggers, "Thelma and Louise and the Cultural Generation of the New Butch Femme," Sharon Willis, "Hardware and Hardbodies, What Do Women Want?: A Reading of Thelma and Louise," Ava Preacher Collins, "Loose Canons: Constructing Cultural Traditions Inside and Outside of the Academy" in *Film Theory Goes To the Movies*, eds. Jim Collins, Hilary Radner, and Ava Preacher Collins (New York: Routledge, 1993).

24 Sharon Willis, "Hardware and Hardbodies," p.

25 François René Chateaubriand, Vicomte de, *Atala* (Paris: J. Corti, 1950, 1801).

26 J. M. Barrie, *Peter Pan in Kensington Gardens* (London: Hodder and Stroughton, 1906).

27 Marshall Berman, *All That Is Solid Melts Into Air: The Experience of Modernity* (New York: Simon and Schuster, 1982).

Chapter 4

1 Herbert Muschamp, "The New Public Housing, French Vintage 1922," *New York Times*, April 8, 1993.

2 Jonathan Glancy, *The New Moderns* (New York: Crown Publishers, 1990).

3 David Hallet, "Richard Rogers," *Design World*, No. 17, 1989.

4 Jan Mukarovsky, *Aesthetic Form, Function, Value as Social Facts* (Ann Arbor: University of Michigan Press, 1970).

5 Paolo Portoghesi, *After Modern Architecture* (New York: Rizzoli, 1982).

6 *Metropolitan Home*, April, 1989.

7 *Metropolitan Home*, April, 1991.

8 *Elle Decor*, September,1992, p. 120.

9 Charles Jencks, *The Prince, The Architects and New Wave Monarchy* (New York: Rizzoli, 1988).

10 Architectural Monographs #24 *Peter Pran of Ellerbe Beckett: Recent Works* (London: Academy Editions, 1992), p.8.

11 Bernard Tschumi, "Parc de la Villette," in *Deconstruction in Architecture/Architectural Design* , vol. 58 No. 3/4, 1988.

12 *Elle*, April, 1992.

13 Michael Thompson, *Rubbish Theory* (Oxford: Oxford University Press, 1979).

14 *The Invention of Tradition*, eds. Eric Hobsbawm and Terence Ranger (Cambridge: Cambridge University Press, 1983), p. 2.

Chapter 5

1 Simon Reynolds, "The Perils of Loving Old Records Too Much," *New York Times*, December 5, 1993.

2 John Ellis, "Broadcast TV Narration," *Visible Fictions* (London: Routledge, 1982), pp. 145–159.

3 Paul DiMaggio, "Cultural Entrepreneurship in Nineteenth-Century Boston," in *Rethinking Popular Culture*, eds. Chandra Makenji and Michael Schudson (Berkeley: University of California Press, 1991).

4 Michele Lamont and Annette Laneau Lamont, "Cultural Capital: Allusions,Gaps,and Glissandos in Recent Theoretical Developments," *Sociological Theory*, vol.6, Fall, 1988.

5 John R. Hall, "The Capital(s) of Cultures: A Non-holistic Approach to Status Situations, Class, Gender, and Ethnicity," in *Cultivating Differences*, eds. Michele Lamont and Marcel Fournier (Chicago: University of Chicago Press, 1992).

6 Pierre Bourdieu, "Social Space and Symbolic Power," *Sociological Theory*, vol. 7, No.1, Spring, 1989.

7 Simon Frith, "The Good, the Bad, and the Indifferent: Defending Popular Culture From the Populists," in *Diacritics*, 21.4, Winter, 1991.

8 For a useful introduction to this work see Jim Hillier, ed.,*Cahiers du Cinema: The 1950s* (Cambridge, MA: Harvard University Press, 1985); and *Cahiers du Cinema: The 1960s* (Cambridge, MA: Harvard University Press, 1985). See also John Caughie, *Theories of Authorship* (London: Routlegde and Kegan Paul 1981) for articles which discuss authorship in reference to post-structuralist theories of artistic production. For more recent discussions of the state of auteurism in contemporary film cultures, see James Naremore, "Auteurism and the Cultural Politics of Film Criticism," *Film Quarterly* 44, No. 1, Fall, 1990; and Dudley Andrew, "The Unauthorized Auteur Today," in *Film Theory Goes*

To the Movies, eds. Jim Collins, Hilary Radner and Ava Preacher Collins (Routledge: New York, 1993).

9 Celia Lurey, Nicholas Abercrombie, Scott Lash, Dan Shapiro, "Branding, Trademark and the Virtual Audience," in Lurey, *Cultural Rights: Technology, legality, and Personality* (New York: Routledge, 1993); see also R. R. Faulkner and A. B. Anderson, "Short Term Projects and Emergent Careers: Evidence from Hollywood," *American Journal of Sociology*, 92, 4, 1987.

10 Timothy Corrigan, *Cinema Without Walls* (London: Routledge, 1992), p. 114.

11 Lance Loud, "Francis Coppola Goes for the Jugular in *Bram Stoker's Dracula*," Details, December, 1992, pp. 141–142.

12 Ellen Paul, "This Director's Wish List Doesn't Include Hollywood," *New York Times*, October 11, 1992, Sec. 2, p. 11ff.

13 Janet Maslin, "Is A Cinematic New Wave Cresting?" *New York Times*, December 13, 1992, Sec. 2, p. 1ff.

14 Martin Kihn, "The Vision Thing," *GQ*, vol. 63, No. 10, October 1992, pp. 166–170.

15 Jim Wood, "A Taste of the Holidays," *San Francisco Examiner Image*, November 22, 1992.

16 Dario Scardapane, "Winsome Winona," *Vogue*, November 1992, pp. 294–297ff.

17 Pierre Macherey, *A Theory of Literary Production* (London: Routledge and Kegan Paul, 1978); and Tony Bennett and Janet Woollacott, *Bond and Beyond* (New York: Methuen, 1987).

18 Bruce Robbins, *Secular Vocations: Intellectuals, Professionalism, Culture* (New York: Verso, 1993).

19 Jon Savage and Simon Frith, "Pearls and Swine: the Intellectuals and Mass Media," *Working Papers in Popular Cultural Studies* (Manchester Institute for Popular Culture) No. 2, 1993.

20 Jim McGuigan, *Cultural Populism* (London:Routledge, 1992).

21 For another critique of this attribution of negative intrinsic value to popular culture, see Ava Collins, "Intellectals, Power, and Quality Television," in *Between Borders*, eds. Henry Giroux and Peter McLaren (New York: Routledge, 1993).

22 For discussions of this equation of mass culture and promiscuity, and the academy's suspicions regarding pleasures offered by popular culture, see R. L. Rutsky and Justin Wyatt, "Serious Pleasures: Cinematic Pleasures and the Notion of Fun," *Cinema Journal*, 30, No. 1, Fall, 1990; Patrice Petro, "Mass

Culture and the Feminine: The Place of Television in Film Studies," *Cinema Journal*, 25, No. 3, Spring, 1986; Andreas Huyssen, "Mass Culture as Modernism's Other," and Tania Modleski, "Terror of Pleasure," both in *Studies in Entertainment*, ed. Tania Modleski (Bloomington: University of Indiana Press, 1986).

23 Sande Cohen, "Cultural Use-Value and Historicist Reduction: Reading the Inertial of Critical Theory," *Strategies*, No. 6, 1991.

24 Pierre Bourdieu and Terry Eagleton, "In Conversation: Doxa and Common Experience" *New Left Review*, 191, January/February 1992, p. 119.

25 Henry Giroux, "Pedagogy, Resistance, and Politics in Celluloid Culture," in *Film Theory Goes to the Movies*, eds. Jim Collins, Hilary Radner, and Ava Preacher Collins (New York: Routledge, 1993), p. 53.

26 Barbara Herrnstein Smith, *Contingencies of Value* (Cambridge: Harvard University Press, 1988).

27 Stanley Aronowitz and Henry Giroux, *Postmodern Education* (Minneaplois: University of Minnesota, 1991).

28 Peter McLaren, "Muticulturalism and the Postmodern Critique: Toward a Pedagogy of Resistance and Transformation," in *Between Borders*, eds. Henry Giroux and Peter McLaren (New York: Routledge, 1993).

29 Peter Murphy, "Postmodern Perspectives and Justice," *Thesis Eleven*, No. 30, 1991.

Index